The Unfinished Revolution

The Unfinished Revolution

The Status of Women in Twelve Countries

Doris Anderson

Doubleday Canada Limited

Canadian Cataloguing in Publication Data
Anderson, Doris
 The unfinished revolution: the status
of women in twelve countries

Includes bibliographical references and index.
ISBN 0-385-25271-4

1. Women. I. Title.

HQ206.A53 1991 305.4 C91–094424–5

Jacket illustration by Terry Dovaston
Jacket design by Leslie Styles
Printed and bound in the USA

Published in Canada by
Doubleday Canada Limited
105 Bond Street
Toronto, Ontario
M5B 1Y3

Table of Contents

ACKNOWLEDGEMENTS

T his book could never have been started without the help and encouragement of a few people, and certainly not finished without the combined knowledge and contacts of a great many more. It is my great pleasure, at the end of three years' work, to thank all the women who were so generous with their time and expertise, and who were so enthusiastic about this project.

I must begin by expressing my gratitude to the Canadian Department of External Affairs, its minister at the time, Joe Clark, and particuarly Peggy Mason, Ingrid Hall, and Frederika Gregory. Canadian embassy staff in the various European capitals I visited, as well as in Washington, D.C., made my task immeasurably easier by arranging interviews with the people whose names I had provided. I was especially grateful when enthusiastic staff suggested additional people to see. Without this kind of help my task would have been almost impossible to complete in the time-frame in which I had to work.

I want to thank in particular my friends Jill Vickers and Pauline Jewett, who read early drafts and who gave me valuable guidance in shaping the book.

There were also many, many women who generously shared names and made contacts for me: Kay Armatage, Pat Armstrong, Louise au Vandeluc, Isabelle Bakker, Linda Briskin, Mary Bruce, Leslie Caldwell, Paula Caplan, Arvonne Fraser, Margaret Fulton, Madeleine Gilchrist, Jane Jensen, Meg Luxton, Joanna Morgan, Nicole Morgan, Lindsay Nieman, Mary Nyquist, Maureen O'Neill, Tim and Julyan Reid, Geraldine Rhoads, Anna Stahmer, Kay Stanley, Ada Testaferri, Annis May Timpson, Jill Vickers, Ingrid von Beinum, Sheila Wilkinson, and Alice de Wolff.

And then there are the women who were kind enough to read the close-to-the-final version of the chapters on their own countries and offer me valuable suggestions and constructive criticism:

Belgium: Véronique Degraeve, Jacqueline de Groote, Nadine Plateau, Geraldine H. Wooley

Canada: Dr. Isabelle Bakker, Professor Marjorie Cohen, Professor Jill Vickers, Dr. Pauline Jewett

Denmark: Professor Drude Dahlerup

France: Nicole Morgan, Dr. Jane Jensen

Germany: Dr. Frigga Haug, Maureen Lofthouse, Marilyn Rueschemeyer, Dr. Hanne Beate Schopp-Schilling

Greece: Margarita Papandreou

Italy: Dr. Judith Adler Hellman, Professor Paola Bono, Dr. Jane Jensen, Dr. Luciana Ricciuetlli

Norway: Beatrice Halsaa, Torild Skard

Spain: Lidia Falcón, Julie Loranger

Sweden: Ingrid von Beinum, Annika Baude, Dr. Joan Acker, Dr. Yvonne Hirdman

United Kingdom: Professor Michèle Barrett, Dr. Ann Oakley, Margaret Williamson

United States: Dr. Joan Acker, Heidi Hartmann, Patrice P. LeClerc.

I would also like to thank all the many people I interviewed and the people who helped me in the different countries I visited:

In Belgium: Reina Asherman, Véronique Degraeve, Colette Detroy, Rebecca Franceskides, Jacqueline de Groote, Nadine Plateau, Paula Rose, Edith Rubenstein, Lieve Verhaeghe, Dr. Jo Walgrave.

In Canada: Dr. Linda Briskin, Dr. Paula Caplan, Susan Cole, Mary Eberts, Carolyn Egan, Dr. Margrit Eichler, Sylvia Gold, Christie Jefferson, Lynn Kaye, Michelle Landsberg, Dr. Lynn McDonald, the Hon. Barbara McDougall, MP, Hilary McMurray, Roxanne Ng, Maureen O'Neill, Glenna Simms, Kay Stanley, Louise au Vandeluc.

In Denmark: Suzanne Brøgger, Dr. Drude Dahlerup, Helle Degn, MP, Marianne Jelved, MP, Jytte Lindgaard, Lene Koch, Grethe Fenger Møller, MP, Yette Sandow, Anette Steen Petersen, Dr. Birgit Petersson.

In France: Monique Antoine, Michèle André, Dr. Françoise Basch, Marielle Boutonnat, Dr. Françoise Core, Dr. Hélène Gisserot, Senator Cécile Goldet, Simone Iff, Danielle Kergoat, Lise Lacosse, Nicole Martel, Françoise Michaud, Dr. Janine Mossuz-Lavau, Dr. Françoise Picq, Chantal Rogerat, Yvette Roudy, MP, Maya Surduts, Dr. Rita Thalmann, Anne Zelensky.

In Germany: Gisela Brackert, Anna Damrat, Dr. Orla-Maria Fels, Sabine Frohlich, Dr. Marianne Grewe-Partsch, Dr. Frigga Haug, Dr. Renate Lepsius, Maureen Lofthouse, Dr. Renate Mohrman, Melanie Langenberger, Hanne Pollmann, Eva Stabler, Undine Stricker, Dr. Helga Rimm, Dr. Hanne Beate Schopp-Schilling, Inga Wettig-Denielmeier.

In Greece: Lina Alexiou, Christina Antonopoulou, Athena Athanassiou, Katerina Daskalaki, Toula Dracopoulou, Dr. Marietta Giannakou, Anna Koroyannaki, Maria Kypriotakis, MP, Kaiti Lazaris, Alice Marangopoulou, Margarita Papandreou, Xanthi Petriniotis, Anna Psarouda-Benaki, Maria Saranpitis, Helen Stamiris, Sophia Spiliotopoulou, Eleni Vlachou, Zili Zakelaridis.

In Italy: the Hon. Tina Anselmi, MP, the Hon. Laura Balbo, MP, Carole Tarantelli Beebe, MP, Alessandra Bocchetti, Professor Paola Bono, Alma Cappiello, MP, Laura Cima, MP, Silvia Costa, MP, Franca Fossati, Professor Gioia Longo, Anna Maria Mammoliti, Dacia Maraini, Maria Luisa Moretti, Dr. Antonietta Ravasio, Senator Giglia Tedesco, Professor Gabriella Tornaturi, Dr. Marina Toschi, Luciana Viviani.

In Norway: Professor Berit As, Professor Edel Havin Beukes, Red Tulle Elster, Dr. Astrid Nockelby-Heiberg, MP, Fride Et-Henrikson, Sigron Hoel, Eva Kolstad, Bitten Modal, Dr. Ingrid Morken, Oddrin Pettersen, MP, Torild Skard, Hege Skjeie, Gerd Vollset, Birgit Wiig.

In Spain: Duca Aranguren, Cristina Alberdi, Ana Balletbó, MP, Professor María Angeles Durán, Lidia Falcón, Maite Gallego, Ana María Pérez del Campo, Pilar Perona, Lucia Ruano, Professor Marina Subíratz, Francisca Taragaza, Dr. Carmen Martínez Ten.

In Sweden: Karin Ahrland, MP, Annika Baude, Ingrid Bergander, Monica Boetius, Dr. Ingererd Broberg, Dr. Yvonne Hirdman, Karin Karlsson, Ami Lonnroth, Solveig Nellinge, Gun Neuman, Gunvor Ngarambe, Kerstin Rehnstrom, Ingrid von Beinum, Charlotte von Redlich, Margot Wallstrom, MP, Barbro Westerholm, Group of Eight: Felicetti, Ingela Blomberg, Inga-Lisa Sangregorio, Eva Lindguist, Inga Sangregorio, Margareta Persson.

In the United Kingdom: Professor Michèle Barrett, Leslie Caldwell, Carol Foster, Jane Grant, Mabel Ibkoh, Janet Jones, MP, Dr. Hilary Land, Jo Morris, Siroze Mookerjii, Lady Platt of Writtle, Dr. Ann Oakley, Jo Richardson, MP, Sheila Rowbotham, Lynne Segal, Mary Stott, Jenny Williams, Margaret Williamson.

In the United States: Dr. Joan Acker, Debra Bolands, Dr. Paula Caplan, Pat Carbine, Phyllis Chesler, Geraldine Ferraro, Dr. Joyce Gelb, Heidi Hartman, Dr. Catherine McKinnon, Professor Eleanor Homes Norton, Sherry O'Dell, Tamara Raphael, Geraldine Rhoads, Diana Russell, Sharon Rodine, Dr. Roberta Spalter-Roth, Eleanor Smeal, Loretta Ucelli.

Finally I would like to commend the patience of my editors, Anne Holloway and Jill Lambert, and my publisher, Doubleday Canada.

INTRODUCTION

This book was a labour of love, yet it was born out of frustration. The frustration was my own, as a feminist. Although I had spent most of my life deeply involved in the Canadian women's movement, I was constantly frustrated by how little we women knew about what was going on even in my own country, not to mention the rest of the world.

Nor was I alone. At the United Nations decade conferences, I saw women from different countries eagerly exchange information in informal gatherings. But those brief dialogues only tantalized us. We always wanted to know more. How had French and Swedish women managed to get such good child care? How had Norwegian women suddenly achieved great political gains?

This book is an attempt to bring those dialogues together—to watch from all our various backgrounds and experiences a family portrait of the sisterhood in the Western democracies at this point in history.

I chose the twelve countries I did—Belgium, Denmark, France, Germany, Greece, Italy, Norway, Spain, Sweden, and the

United Kingdom in Europe and Canada and the United States in North America — because they are representative of what has happened in the Western democracies. The Eastern European bloc is still in a state of flux. The Third World countries need several books devoted completely to them. Although I am not the writer for that enterprise, in my final chapter I have attempted to make it clear that the actions and policies taken by the countries covered in this book have profound implications for the Third World. We live more and more in an interconnected world. Whatever goals we women push towards, we must acknowledge our interdependence with, and our responsibility for, all our sisters.

I began my study by seeking out women in each country who had been involved in the women's movement over the past twenty years: feminists, activists, academics, bureaucrats, women politicians, and journalists. I interviewed at least three hundred women altogether, ranging from Margarita Papandreou, the godmother of the women's movement in Greece, to Yvette Roudy, who pushed through many of the equality laws for women in France in the early 1980s. I talked to women working in rape-crisis centres, as well as politicians such as Geraldine Ferraro, who ran for vice-president of the United States.

In most countries there was a remarkable amount of agreement among the women I talked to about what progress had been made and what still needed to be done. In other countries there was sharp disagreement. I have included both points of view.

There are compelling reasons for writing this book at this time, more than twenty years after the second wave of feminism began. The women's movement is not, as many people would have us believe, a peculiarity of the twentieth century—an irritating blip in history created by a small group of uppity women no longer content with traditional women's roles. Nor is the movement over, even though the press has been announcing its demise almost from its beginning. Nor is it true, in spite of a few women with alligator briefcases who partake of "power breakfasts", that women are now in a "post-feminist" mode.

A lot more has been accomplished than most women—particularly young women—realize. Yet we are still not even close to some of the original objectives. Now, as we approach the quarter-century mark, is an appropriate time to stop and take stock of where we have come from, where we are today, and where we still need to go.

The women's movement is a revolution spanning more than two hundred years, from the time Mary Wollstonecraft's *A Vindication of the Rights of Women* appeared in Britain in 1792, to the present. The revolution has come in two waves: the first from the 1850s to 1920s, and the second from the late 1960s to the present. On each occasion it was massively opposed by the established churches, governments, most men, and the majority of women. Even when women were fighting for such a seemingly obvious right as the right to vote, many women, including Queen Victoria, spoke out against it. Conservative women always support the status quo and fear change. Yet all women enjoy the benefits of what feminists have accomplished.

As in all revolutions, the movement was a response to a society in the process of transformation. In the nineteenth century, Europe and North America were democratized and massively changed by the Industrial Revolution. But women were not included. Under the centuries-old agrarian and cottage-industry system, women worked alongside men under extremely harsh conditions, with little opportunity for improvement for either sex. Under the protection of a lord or landowner, people toiled in small rural communities under hierarchical structures that were almost entirely male. The church, the elders, and the heads of individual families made almost all decisions for women, including when and whom they were allowed to marry.

With the Industrial Revolution, small farms were enclosed by landlords for sheep raising, and tenants were pushed off the land. They moved into the cities to work at the new factories. At first men, women and children all worked, as they had always done. Around the 1850s, however, laws began to be passed, supposedly to protect women, but in fact to make sure men got the jobs. Men were then to be paid enough to support women and

children. Yet poor women, who made up at least one-quarter of the female population, still had to find work outside the home, and always at the lowest wages.

During the nineteenth century men's lot improved dramatically: they were given the vote and access to education. But the position of women worsened. They were more restricted than they had been during almost any century in history. They had no vote, no access to higher education, and no control even over their own money or children. The Victorian concept of marriage—a recent one in historical terms, and only attainable for the middle and upper classes—became the idealized norm.

It is almost impossible for a young woman of today to realize what life would have been like for her then. A little more than one hundred years ago, she would have been completely dependent on either her father, a husband or a male relative. She could not have voted, attended university, trained for a profession or, except in rare circumstances, stood for election, even for her own town council. She had no control over the money she earned herself or received from an inheritance. Her children could be taken away from her and she could be denied access to them. She could be beaten and raped, yet she could not even have turned to the legal system for help. In effect, she would have had all the rights of a child or a severely handicapped male.

Feminists from Mary Wollstonecraft to Betty Friedan have always campaigned for essentially the same things: social services for women to help make their lives easier, such as maternity leave, child care, and birth control; the rights men enjoy—access to higher education, property rights, the vote, control over their own bodies, and equality in the work-place. Above all they have wanted better relationships with men, from equal rights within the family to freedom from rape, battering, and incest. As reasonable as those desires appear today, two hundred years ago they were regarded as absurd by most people.

The first wave of the women's movement centred on winning the vote for women. This was achieved for most European women during the first twenty years of this century, although women in France, Belgium, Italy, Spain, Greece and Switzerland

had to wait another full generation. Along with the vote, many women also gained greater access to education, the professions, the courts, and some rights over their own money and children. But they still had no real power in the institutions where most of the decisions that affected their lives were made—the parliaments, the church, the courts, and business.

The first wave of the women's movement was followed by a depression and another world war. In the 1960s, a full century after the first wave of the movement, the discovery of the birth-control pill gave women some power over their pregnancies. Women began to work outside the home in larger and larger numbers. With the freer atmosphere of the sixties came student unrest at universities, and in the U.S. the battle for desegregation for African-Americans began. Women were actively engaged in these new movements but soon found themselves relegated to handmaiden roles: typing, making coffee, even being sexually harassed and exploited by male leaders. The stage was now set for the second wave of the women's movement.

It is hard to remember that even as short a time ago as thirty years most people thought it only fair that a man should automatically be paid more than a woman for doing exactly the same job. Wife and child abuse in the home were probably even more common then than they are now, but were taboo subjects, rarely even whispered about. Less than 2 percent of rapists ever ended up behind bars because the legal system put the victim—not the rapist—on trial. Divorces were almost always sought by men, who wanted to remarry. Few women had any means of supporting themselves outside of marriage, no matter how miserable they might be in it. Even if a woman's life was endangered by a pregnancy or she had been raped and become pregnant, a legal abortion was not an option.

Twenty years ago women either put up with sexual harassment on the job or in universities or left those companies and classes. Society was just beginning to admit that most women were badly underpaid, not because the work they did as secretaries, nurses, and clerks required any less training and skill than men's work, but simply because those jobs were done by women. Ten years

ago authorities recognized that one in four little girls was sexually abused, often by a family member or a friend. Although by the 1970s most women would be in the work-force for most of their lives, there was often no paid or legislated maternity leave, no automatic right to return to work, and no adequate child care.

The second wave of the women's movement focused on all these issues. It was like no other revolutionary movement in history. Having been at the bottom of male hierarchies for most of recorded time, women insisted on working in small groups with as few rules as possible and no leaders. Unlike most large revolutionary movements it was almost completely non-violent.

Not surprisingly, there were still many political factions, varying in importance from country to country. In general terms, social feminists believed the present system was capable of reform, and worked to that end. Radical feminists, on the other hand, believed the system was irretrievably patriarchal and beyond hope. They preferred to work only with women, often went in for communal living, and frequently worked in rape-crisis and battered-women's shelters. They wanted nothing to do with political parties or the church and distrusted all male-dominated institutions.

The shape and pace of the movement has differed widely among countries. Generally, there was an intense period in the 1970s when the second stage of the women's movement "peaked" with the abortion issue as the main rallying point. But in Sweden women were already so integrated in the decision-making process that the women's movement was much less important and less widespread. In Spain and Greece, society itself was experiencing such turbulent political upheaval that women did not begin to assert themselves until the mid-1970s. In Canada and the United States there has been a well-organized backlash from both men and women—a phenomenon hardly noticeable in Europe. In many countries such as Italy, Belgium, Germany, and Britain, the women's movement, having achieved a number of reforms over the sixties and seventies, seems relatively quiet today. But in other countries such as Greece, Canada, and the United States, the movement continues to draw on new waves of energy.

New businesses and activities have arisen because of the women's movement: publishing houses, women's bookstores, women's studies in universities, and women's music and women's magazines. History, philosophy, psychology, science, medicine and women's health have all been re-examined from a completely different viewpoint—the women's viewpoint, not the historical male angle. Slogans such as The Personal Is Political have become catch-phrases.

I have been involved in women's issues since before the movement's formal beginning in Canada. I started out in 1958 as the editor of a rather run-of-the-mill Canadian woman's magazine, which I gradually turned into a quite radical, for its time, feminist magazine. Then I became the head of a government-appointed advisory council for women, a body that most countries have put in place to deal with the woman question. After that I was president of a large umbrella organization made up of almost six hundred voluntary women's groups, whose purpose was to lobby legislators. And all this time I have continued to write and comment on the women's movement in Canada and elsewhere. I certainly haven't seen it all, but I have seen enough of government structures, volunteer initiatives, lawmaking, and pressuring to form some idea of what works—and what doesn't.

As I talked to women in each of the twelve countries dwelt with in this book, five indicators emerged, by which to gauge what has been accomplished:

1. On the most elementary level, how well do services for women and children work? Is it possible for the majority of women who now work outside the home to have children without being penalized? Is parental leave available for both parents with no loss of salary or job? Is good, supervised, subsidized child care available, so that a woman has a choice about whether to work outside the home?

2. How accepting is the work-force of the different needs of women? What proportion of the work-force is made up of

women? How many women work part-time, and are they covered by benefits? What is the wage gap between the average man's salary and the average woman's? Are women clustered in sex-stereotyped jobs, or do they have access to both the better paid, traditionally male jobs and the new technological ones? What measures does the government have in place to help women get rid of inequalities in the work-place—and how well are they enforced? Do unions support parental and sick leave for the care of children?

3. As an indicator of the extent to which different societies have responded to the basic philosophy of equality, is it possible for women to walk safely on the streets in large cities? Can women decide themselves to end a pregnancy, or must they get permission? Is rape in marriage illegal? How difficult is it to obtain a conviction in a rape trial and how stiff is the sentence? Are wife battering, child physical and sexual abuse, and incest acknowledged and dealt with? Was legislation supporting maternity leave and child care passed out of a recognized need in society or to try to boost a falling birth-rate? Is tax legislation designed to encourage one kind of family over another—for example, one-income families headed by a male? Are protective laws in the work-place designed to safeguard everyone—men and women—or to keep women out of better paying jobs?

4. Are women present in numbers in the power elites? What percentage of women are in the parliament? The cabinet? What percentage of women are judges, university professors, in top positions in business and the media?

5. Finally, how difficult, or easy, is life for ordinary women, compared with the lives of their mothers or the lives of average men today?

Countries seem to have responded similarly to the women's movement. For example, there is a remarkable likeness in the machinery that different governments have put in place to deal

with women's issues. Often, however, the advisory councils, ombudsmen, and commissions on equality have had serious structural flaws. Almost always they have been underfunded. Often governments appointed "safe" women to prominent positions. The irony is that often they quickly became converts and champions.

Many countries have splendid-sounding laws and equality charters that make for great reports at international conferences. However, few of the laws are enforced. Other countries have been rather slow to pass laws, but once passed have enforced them well.

The cultural climate in each country has had an undeniable impact. Often national attitudes and customs lag far behind new laws. Reform is always easier in a racially homogeneous country than in a country with a mix of cultures and classes. In some countries fierce regional and linguistic differences are barriers to a strong national women's movement, as in Belgium and Spain. In other countries class and race get in the way, as in England.

Some countries are still tied into systems that ignore the fact that well over half of all women work outside the home for most of their lives. Schools let out children at two in the afternoon. Shops often close shortly after six at night and on Saturday afternoon, making life as difficult as possible for wage-earning women.

Differences in political style also have a decisive influence. In the Scandinavian countries collective action has a long, honourable history. In the United States freedom of the individual is a cherished national ideal, making it difficult to put in place government programs in health, housing, and child care.

Finally, there are many examples in this century to remind women that their hard-won gains are quite fragile. Progressive legislation has frequently been swept aside by neo-conservative or military-style governments. In every instance these backwards measures have been supported by large numbers of people and bolstered by fundamentalist and, often, traditional religious forces.

For European women a new element that will certainly affect them is the European Community, which is racing towards

economic unity by 1992. The union has already had social advantages for women. For example, it has sharply spurred almost every member nation to strengthen legislation on equality. And the Court of Justice in Luxembourg has served as a court of last resort for women who have failed to get justice in their own countries on such issues as equality in pay and pensions. But there are potential disadvantages, and women worry that they might also lose in the union. Will Denmark's health and safety laws and France's excellent child care be dragged down to a minimum standard for everyone?

In my travels and as I talked to all the remarkable women who have energized the women's movement, I found great diversity, as well as remarkable innovation, dynamism, and strength. Admittedly, this unfinished revolution of women still has some distance to go before we completely resolve all our present problems, even within our individual countries, not to mention the global stage, with its larger questions of world-wide equality, a safe environment, and peace for everyone! But I believe it is one of the most powerful instruments for change that has appeared in the history of the world.

By acknowledging our cultural differences, overcoming them, and learning from one another, we are seeking the commonality of all our experiences. In doing that we empower one another in our efforts to achieve the kind of world we want to live in.

That is the purpose of our dialogues—and of this book.

GREECE, SPAIN, ITALY—
UP FROM UNDER THE SHADOW
OF THE DICTATORS

Greece, Spain, and Italy have been grouped together because they are southern European countries and the idea of liberation for women there is a fairly recent one. In all the countries of southern Europe the church's heavy hand has held women back. For years the Holy See adamantly opposed giving women the vote. This meant that in almost all Catholic countries women got suffrage a whole generation later than in Protestant countries. Many of the brightest, most active women found their vocation and some autonomy as nuns, but they could never rise to the top echelons of the church as women, and they had almost no influence outside their own orders.

Another big handicap for women in southern Europe was the Napoleonic Code based on Roman law, which was set in place in France by Napoleon I in 1804, and influenced most European countries except Britain. Men were deemed the indisputable heads of their families. Women became minors under the law, with no rights over their salaries or children, and in some countries no right even to make simple decisions such as taking a job or joining a union.

In these southern European countries the family has always been the centre of most women's lives. Until recently they had little experience, and no tradition of, working in independent women's groups. When they began organizing they often found that regional differences, language, and party politics created insurmountable barriers.

Greece, Spain, and Italy, besides being southern European countries with Catholic or Greek Orthodox religions and a heavily patriarchal code of law, have all experienced extremely turbulent political times for most of this century. Greece and Spain both had civil wars. All three countries have had long periods of dictatorship, from which Greece and Spain have emerged only in the past twenty years.

The dictators were kept in power by the secret police and the army and bolstered by close alliances with the most traditional, conservative elements in society—the church, big landowners, and business. Organizations of any kind—including women's organizations—were banned, except for those approved of by the state. Traditionally, almost all fascist governments have been pro-natalist and against any liberation for women. Although many women in Greece, Spain, and Italy fought valiantly against such regimes and many of them died, the majority accepted their one approved role as silent, obedient baby breeders.

The long periods of military regimes strengthened already well-entrenched macho traditions and attitudes that remain to this day. Men expect, and often still get, all the customary services they have been used to from mothers who kept house full-time, even though today a majority of women in these three countries work full-time outside the home. Men rarely help around the house or mind children.

In the aftermath of dictatorships, democracies often have a precarious hold. Often corruption and under-the-table dealings are fairly common. Law enforcement can be sporadic—people don't pay taxes or child support, and don't obey laws on equal pay. Such an atmosphere makes it difficult for women to have their demands recognized, let alone met.

Under regimes where politics means influence and pay-offs, it

is particularly difficult for women to make any headway, since few have the business connections that will fund campaigns and businessmen generally don't feel women will have the political clout to hand out rewards once they are in office. Certainly the kind of lobbying that works in some Western countries is less effective here.

Greece, Spain, and Italy are now members of the European Community, and racing to compete in manufacturing and trade. Women are the beneficiaries of the new rules on equality and social supports being laid out by the European Commission. But many reforms for women in these countries have been hastily pushed through, and although they look impressive on paper, much of the legislation isn't enforced.

Women in these countries are regarded as one of the most promising sources of future new workers, since the birth-rate has dropped dramatically in all European countries. In Greece, Spain, and Italy women make up the majority of the workers in the "black" economy, where they work out of their homes for low pay, no benefits, and no security.

In each of the three countries progress made by women and the course of action they adopt have been influenced by the response women have got from those in power. When government machinery is set up to deal with women's issues, they have often responded enthusiastically and co-operatively. Then, as the reforms they ask for don't materialize, disillusionment sets in. Finally, faced with unresponsive political systems and unchanging attitudes in society, some women opt to work outside the system as much as possible.

GREECE:
FROM HAMLET TO HIGH TECH IN ONE GENERATION

FACTS

Population: 9.9 million

Government: Unicameral

Vote for women: 1929 in local elections; 1952 in national elections.

Percentage of women elected: 3.5 percent—the lowest in the European Community. But five women are in the cabinet.

Education: Coeducation since 1983. Schools crowded, many on split shifts. Many girls drop out, although at universities women comprise 50 percent of the students.

Percentage of work-force women: 34 percent, but unemployment is high. Ten percent work part-time. Greece has the highest percentage of women working on family farms or in businesses in the European Community. Women earn 78 percent of what men earn.

Abortion: 1978 law allows for abortion up to twelve weeks for health reasons, rape or incest. From 1984 it has been covered by the health scheme. Birth control only on prescription. No sex education in the schools, although teenage pregnancy has doubled in the past five years.

Child care: Almost half of women with children under ten work outside the home. There are spaces for only 5 percent of the under-three age group in centres financed and run by the government. A little more than half of children aged three to five and a half are either in publicly funded kindergartens, which are open all day, or pre-primary schools, which are open three and a half hours a day. Many women still depend on grandmothers and neighbours. No tax deduction for child care.

Maternity leave: The law allows for fourteen weeks' leave with full pay, seven weeks to be taken after the birth. However, pregnant women are often fired on some pretext or other. The civil service is the only place where the law is enforced. By law women can also take time off to nurse babies, have an unpaid parental leave of three months for each parent and six months for single parents, and take unpaid sick leave to look after children. None of these laws is enforced.

Birth-rate: 10.7 live births per 1000 population

Family law: 1983 laws allows for divorce after one year with mutual consent, and after four years without consent. Women are supposed to get one-third of the assets of the marriage, but men can easily hide their assets. The husband's pension and business are excluded. Child support is not enforced. Dowries are outlawed but are still fairly common.

Achievements: Laws are progressive, and have resulted in great changes in a very short time. Women's organizations are strong.

Problems: Greece is the poorest of all the countries in the 12-member European Community. It has the highest debt, highest inflation, the lowest per capita income, and the highest infant mortality rate. Many of the laws are not well enforced, and there is still a high rate of illiteracy among women. The women's movement is divided by party politics.

THE BACKGROUND

Greece is famed in history as the cradle of modern democracy. Indeed, Athenian culture and philosophy became the well-spring for much of Western thought.

Under Alexander the Great, Greece conquered most of the known world. But by 146 B.C. the Greek states had all fallen under Rome's domination, only to be later conquered by the Turks, and from the fifteenth to the nineteenth century under Turkish rule Greece was a poverty-stricken, feudal, backwards society. In 1832 after the war of independence a monarchy was set up. In the next one hundred years more islands and territory were added. But political unrest followed World War I. A republic was declared; however, it collapsed ten years later, when a dictatorship took over.

During World War II Greece was occupied by the Nazis. Afterwards civil war tore the country apart. This was followed by another democratic period, then a military dictatorship. It was only in 1975 that democracy was finally restored, and many people think it still has only a precarious hold on the country. Nevertheless, the huge gap that exists between a small number of very rich people and the impoverished majority is slowly being closed and a middle class is emerging. Still, one Greek diplomat put it this way: "Greece is just one generation away from being a Third World country."

The first wave

Throughout Greek history there have been many women poets, philosophers, and artists. In the Greek war of independence against the Turks in 1821 a woman pirate, Boubouline, fought and won many victories at sea.

By the late 1800s there were many groups—such as the Union of Greek Women and the National Council of Women—working for better education and rights for women. Greek women started to campaign for the vote vigorously in the 1920s, and were just as vigorously opposed by the Greek Orthodox church. Women were finally allowed to vote in local elections in 1929. It wasn't until after World War II, in 1952, that they got national suffrage.

The second wave

From 1967 to 1974 the military junta that controlled Greece abolished all women's organizations. After the fall of the junta, women's groups re-organized. Several of them aligned themselves to different political parties. In 1981 the socialist government of Andreas Papandreou came to power. Pressured by the Women's Union of Greece, which was headed by his wife, Margarita Papandreou, and pressed by other women's organizations, he instigated many reforms. Among others: a Council of Equality was set up; family law was completely overhauled; and a Centre for Research Studies on Mediterranean Women was created.

The situation today

Greece is a tiny country that reaches out into the Mediterranean Sea like a three-fingered hand. Islands make up one-fifth of it and 75 percent of it is mountainous. When I arrived there in the middle of the 1989 election, the world was following, day after day, the Prime Minister Andreas Papandreou's affair with a much younger airline stewardess.

Helen Vlachou, who ran her family's highly respected, independent (by Greek standards) right-of-centre paper for years, thought the scandal wouldn't hurt Papandreou, but his mismanagement of the economy would. Of Margarita Papandreou she said somewhat patronizingly: "His wife has raised his four children and been a good mother."

She went on to say that one of Greece's major problems has been the courts, where judges are appointed by the party in power and are under its influence. She thought that was now changing. "We celebrate democracy here, but we stop it anytime we can. Greeks don't have a respect for the law. The law is for other people. Taxes are for other people. To be honest, the only good thing is that we have the democratic right to howl about anything we want to howl about. Under the dictatorship you couldn't do that."

Television, which she declared was "awful", is also controlled by the ruling party. She added that the press was "bad, pornographic, and highly partisan." One paper would describe a rally as a huge success, and another paper would call it a disastrous flop. "You have to phone a cousin or aunt in that particular part of the country to find out what really happened," she told me.

When I explained that I was writing a book about the women's movement, she bluntly said that she had never been a feminist, knew nothing about the women's movement, and had no interest in it.

I couldn't help feeling a bit exasperated. Women like Vlachou—and I have met many of them—have enjoyed every possible privilege, including wealth and position, mostly through the men in their lives, yet they feel no obligation to help change things for other women. She ended the interview by saying she had a luncheon appointment and her driver was waiting downstairs.

Fortunately in Greece, where a few very wealthy families have exerted tremendous influence, some well-placed women are staunch feminists. One of the most prominent is Dr. Aliki Marangopoulou, president of the Greek League of Women's Rights, who has been involved in one way or another with almost everything that has happened to Greek women. A criminologist and a fighter all her life for human rights and women's rights, she had a great deal to do with getting an equality clause for women included in the 1975 constitution.

The right-wing New Democracy government was in power from 1974 to 1981. During that time women campaigned hard

for family law reform, and for other reforms such as pensions for farm women. They achieved few results but were successful in getting an equality clause into the constitution.

In 1981 the socialist government of Andreas Papandreou's PASOK party took office, and during its first term, from 1981 to 1985, a lot of legislation for women was passed. A Council of Equality, composed of nine members, was set up as an advisory group to the prime minister. In 1985, the position of advisor on equality was upgraded to secretariat.

Most of the new laws that have changed women's lives are less than ten years old. When you consider that until the new family law act was passed in 1983 a man was absolute king in his own home, the laws are progressive. Before the law was changed wives had to ask permission for even the most trivial matters, such as putting a child in school or taking a trip.

Just a generation ago, girls could legally be married off at fourteen. Now it's eighteen for both sexes. Women can legally keep their own family name and children can take either the father's or mother's name. A man or his family used to be able to force the family name on any illegitimate children, whether he bothered to support them or not, but today mothers not only have all rights over illegitimate children, they are entitled to full family benefits such as sick leave for child care, welfare, and, in theory, child support.

Compared with most other countries, the Greek divorce law still discriminates against women. Partners keep whatever they brought into the marriage, but the wife is entitled to only one-third of the assets of the marriage, and the man's pension and business assets are excluded.

And old attitudes die hard. For example, the widows of army officers lose their pensions if they remarry. One woman even lost her pension for having an illegitimate child. On the other hand, dowries, which were a tax dodge, have been abolished by law, although some families still secretly insist on them.

If a divorced woman is under fifty, she is given three years to take vocational training and become self-supporting. This is a hardship for women in Greece, as it is everywhere. If a middle-

aged woman has never worked outside the home, it is next to impossible for her to find anything but the most menial labour to support herself. This is especially true in Greece, where unemployment is high and support for one's ex-wife easy to avoid.

And in spite of all the legal gains, many practical problems persist. Child support isn't enforced and many men get away without paying anything. A journalist who is also a single mother raising a child alone said: "Going to court is very expensive. Poor women don't have the money. There is supposed to be legal aid, but really there is nothing. The kid could be through school and be in the army before you'd see a penny." She also complained that the courts, particularly at the higher levels, were dominated by older, traditional males who have been known to say to women in divorce cases: "You're not entitled to anything. If you want to complain, complain to your friends, the feminists."

Although today there are three times the number of publicly supported child-care spaces than there were eight years ago, there is almost no care for children under three and still not nearly enough care for older children. Greeks have always lived in close-knit families and communities, and many women still leave children with mothers or sisters or neighbours; still, eighteen thousand children are left on their own while their mothers work.

Illiteracy is one of the biggest handicaps for many Greek women. Of Greece's nearly ten million people, one in ten is illiterate, and since many families still consider educating girls a waste of time, two-thirds of the illiterate population are women. At age fifteen, less than two-thirds of Greek girls are still in school, compared to nine out of ten in most other countries in the European Community. I was told that women who have traditionally worked in the textile factories are now being laid off because they can't follow the instructions that come with the new technologies.

Boys and girls only started going to mixed classes in 1983. Today all children are supposed to attend school for nine years, but often, if the school is far away, they drop out after completing only three or four years. Because there aren't nearly enough schools, the schools operate on double shifts. Normally open

from eight to one or two in the afternoon, they are now also open from two to seven. Children are switched back and forth between shifts, which makes it almost impossible for women to arrange after-school care.

Abortion is legal during the first twelve weeks of pregnancy and paid for through social security. Young girls and unmarried women who want to hide the fact that they are pregnant, and women who are not covered by social security, generally have to go to the more expensive private clinics. In the past five years, teenage pregnancy has doubled, and teenage abortions are up 35 percent. A psychologist reported: "Teenagers still get pregnant because they don't know any better. In Greece a lot of women still don't even discuss such things as the pill. There are seventeen family-planning clinics around the country, but they are very short-staffed and always short of money. The PASOK government was always announcing that it was going to bring sex education into the schools, but it never did." The Conservative government has not promised any such reform.

Women are entitled by law to fourteen weeks' maternity leave, but only the civil service actually grants it. Most firms won't pay maternity leave and often the pregnant woman is fired on some other pretext. The six months' parental leave without pay provided by law is hardly ever taken by men, and many women can't afford to take it. To boost the birth-rate, the government recently granted women 34,000 drachmae (U.S. $216) a year for three years upon the birth of a third child. But it rescinded the statute allowing women to retire from the civil service with a pension after fifteen years' service.

Although the law on rape is tough, there are few convictions. In one recent gang rape, each man received only a one-year sentence. "If a girl goes to a bar, then goes back to a man's place for coffee and gets raped, the man gets off. The judge thinks she was "asking for it", I was told. Recently a law was passed so that third parties can press rape charges, but a bill to make rape in marriage a crime was defeated.

A psychiatrist in a government clinic estimated that one in every two Greek women is battered. Although government-

sponsored houses for battered women exist, two journalists I spoke to scoffed: "Maybe, but there are no details about where they are. The government doesn't advertise them, so no one knows where to go." In another survey 50 percent of women reported that they had been abused as children and one in five reported that she had been raped.

Chryssanthi Laion-Antoniou was the first secretary-general for women when much of this legislation went through. A practising feminist lawyer for several years before she joined the government, she admitted that enforcement of much of the legislation falls short of what she had hoped for, but she also pointed out the positive effect of at least passing it: "Now a man needs his wife's signature to put their children on his passport, or if he's making out a will he has to consult her. That makes him realize the marriage is a partnership and he's no longer the sole authority."

Two out of three married women work outside the home, but 200,000 of them work in the "black economy"—a common occurrence in southern Europe. The "black economy" is unregulated, pay is low, and there are no benefits. For a pittance—30,000 drachmas (U.S.$180) a month, these women often work out of one-bedroom apartments while they mind two or three little children. Unions aren't interested in organizing these part-time workers. Often the women even have to pay for their own sewing machines and repairs.

Many women still work on family farms, but in the past five years a few women have pioneered new professions, such as the army, the police, and now work as electricians, construction workers, painters, taxi- and bus-drivers. Helped by the PASOK government, a group of unemployed women got together and built a housing co-operative, which they now run profitably.

These advances notwithstanding, blatant discrimination flourishes. For example, a lawyer told me of a case she is handling: a bank gave all prospective employees a test. All the women were automatically ranked below the men, no matter how well they did, which meant that only men were hired. The lawyer won this test case, but she says such a practice is still widespread.

Everything in Greece is highly politicized. Women do a lot of

the day-by-day work in political parties. Most people work for parties because they hope to influence the government and reap political pay-offs in featherbedded civil-service jobs and other patronage appointments. Although some parties have promised quotas for women, there has been little follow-through. Parties make up the lists of candidates at election time, but few women are included, and their names usually appear only at the bottom of the lists.

The parties don't want women candidates, I was told. It costs three to four million drachmas (U.S.$20,000) to run a campaign and women can't afford that. It's hard for women to get money from businessmen because they can't promise the pay-offs men can.

A woman who had been educated in Canada and went to Greece after she married said: "The political scandals in Greece aren't comparable to anything anywhere else. There are no checks in the system. Here people condone bad behaviour. At least in North America a lot of the abuse is investigated publicly and people get punished openly. That rarely happens here."

Although six women were in the cabinet in the last PASOK government, in the 1989 election under the conservative New Democracy coalition no women were appointed to the cabinet. For the first time in its history, no woman was appointed to the board of the publicly owned TV and radio either. Women protested, signed petitions, held public meetings. There are now six women in the cabinet.

Although in other countries women often do much better in local than in national elections, in Greece this rule doesn't follow. In the heavily traditional countryside only five female mayors were elected. Another five were elected closer to Athens, but the overall percentage out of 359 mayors is 2.5. Only two women have ever been elected to parliament from the countryside. However, there was a bit of breakthrough when three women were elected to the city council of Athens as chair, vice-chair, and secretary.

Many of the major women's organizations are tied to political parties. I met with representatives of most of them: the Women's

Union of Greece (PASOK), the Movement of Democratic Women (Hellenic Left party), the Federation of Greek Women (Communist). The largest conservative party, New Democracy, has no separate women's organization, but a large women's wing within the party does a lot of the work in elections. New Democracy is also supported by a right-wing Panhellenic women's organization promoting the family and more children. Only the League of Women's Rights, which is funded by the family of Dr. Aliki Marangopoulou, is totally independent.

On all the major women's issues—equality rights in the constitution, abortion, family law, and the recent drive for quotas in political parties—women's organizations have been able to put aside their political differences and work together. For example, most of them took part in a rally to try to get the parties to put in quotas.

But it would be hard not to give a great deal of credit for what happened for women under the PASOK government to the influence of Margarita Papandreou, the ex-wife of the former prime minister and founder and president of the Women's Union of Greece until the spring of 1989, when she resigned. "There is no question that PASOK wouldn't have done nearly as much for women if Margarita Papandreou hadn't been pushing behind the scenes," I was told by many women.

Originally an American journalist from Minnesota, Margaret Chant met Andreas Papandreou in a dentist's office. After a stormy romance while both married to other people, they wed, had four children, and spent several years in the United States, where he was an economics professor at the University of California at Berkeley.

The couple returned to Greece in 1959, supposedly for just a year, but Andreas became so engrossed in politics that they stayed. When the military junta took over in 1967, the Papandreous fled to Canada, where he became a professor at York University in Toronto.

I had previously met Margarita Papandreou in Canada, and on this trip she was kind enough to invite me to a lunch to meet other Greek women at her home at Kastri, a wealthy suburb

north of Athens. Margarita is a tall handsome woman. She poured us white wine from a blue-and-white pottery pitcher and spoke briskly in a matter-of-fact voice:

"Women have found it easier to make it in the professions than in politics. Conservatives traditionally work to keep women out of politics, but men of all political parties function pretty much the same because politics is where the power is. The two most difficult areas of life in which to establish equality between men and women are politics and the family."

She explained that the women's movement in Greece continues to struggle towards those goals, but today less through demonstrations and rallies and more through specific projects, writing, and organizations. Then she pointed out that at a time when women all over the world were furiously organizing and demonstrating, between 1967 and 1974, and the women's movement was reaching its peak, Greece was under a dictatorship. All women's organizations were disbanded. For more than five women to meet, permission had to be obtained from the police. "It shows us how afraid they were of women," she remarked dryly.

Many women were active in the resistance, and some of them lost their lives. In 1974, after the junta was ousted and Papandreou and her family returned from exile in Canada, women's organizations sprang up all over.

She agreed that the Women's Union of Greece had been effective. For example, the men in the party were sure women in the villages would be against legalizing abortion, but the women in the union had talked to the village women. They knew that every woman had a mother, a sister or a cousin who had had an abortion, often under dangerous and unsanitary conditions. Some of them had died. The union was convinced women wanted birth control and legal abortion, and when the legislation passed there was little opposition.

She laughingly recalled how she marched against the government in 1986. She told her husband the morning of the demonstration. "I didn't want him to read about it in the papers or hear it over the radio. He shrugged and said, 'Well, I guess you have to

do what you have to do....' But he certainly wasn't pleased."

She explained that she had resigned when there was a split in the union over her stand on keeping the union independent. Party hard-liners who were members of the union wanted the organization to take an open, public position, aligning itself with PASOK in the coming elections. Margarita felt it would be ideologically incorrect for the organization to tie itself, and its fate, to a political party. Although the union was known to be sympathetic to PASOK, it had never been a party organ, and had had its own financing and its own decision-making bodies. When the party stalwarts managed to push through this affiliation at a panhellenic meeting, she felt obliged to resign. The rupture cost the union its independence, unity, and dynamism, she felt.

Most disappointing so far to her and to other women in this traditional society is the fact that women candidates haven't been able to count on the women's vote. Women vote separately and are counted separately in Greece. Women didn't support women in the two previous elections, which might be the reason the present minority government had no compunction about treating women so cavalierly.

Several of Greece's leading feminists have recently considered whether it is now time for Greek women to form a non-partisan umbrella woman's organization. Other women feel Greece is far too political for any such group to survive and avoid inter-party squabbling. In a country where politics influences everything, they are probably right.

A day in the life of...

Hariklea A., a 40-year-old mother of two, has seen in her lifetime profound changes in Greek life. A good-looking woman with strong features, large brown eyes, and curly blond hair, she was born in a village in a poor mountainous area of the north-west. Her father was a farm labourer, and the family of six lived in a tiny two-room house heated with a small coal-burning stove. There was an outdoor toilet, but no hot water or electrical appliances.

When she was five her mother had twins. Her mother washed everything, including all the diapers, by hand. For extra money—about 20 drachmas a day, a sum that amounted to about a quarter of the average wage at that time—her mother wove carpets and blankets.

During the past twenty years those picturesque little villages tucked between the rocky, wild-looking mountains have almost emptied of citizens. Athens is now bursting with almost half of Greece's population as people crowd into the metropolis, where the jobs are.

That happened to Hariklea's family. When she was fifteen her father could find no more work in the village. They all moved to Athens and he got a job in construction. They lived in three rooms, without heat or even hot water, and shared a toilet and shower. In spite of these hardships she was able to finish high school—an opportunity she would not have had in the village.

She started working, but like all Greek girls she continued to live at home until she married. Her husband, a clerk in the public service, earns 80,000 drachmas a month (around U.S. $480). Housing is expensive and scarce. They moved into his one-room apartment, which she described as "pretty terrible". The building was demolished a year later.

She worked until she got pregnant and then they moved back with her parents. Her father applied for a loan, sold the old house in the village, and bought a flat in Athens. With some extra money he was able to give them, the young couple moved into a new flat, where their second baby was born.

She went on working for three more years, while her mother looked after the children. In Greece businesses open at 8:00 in the morning and close for lunch at 2:00. Everything re-opens from 5:30 to 8:00, at which time women go home, make dinner, and do the household chores. Even with her mother helping, Hariklea was putting in an eighteen-hour day.

The new baby was sick with chronic bronchitis and caring for him became too much for his grandmother. Hariklea quit work and stayed home for a while to look after him. Now she wants to get back into the work-force, and to better qualify herself she has

been taking a computer course. With the money she hopes to earn, around 80,000 drachmas a month, she will pay a baby-sitter and have some left over.

Even though she still works very hard, she says: "My life is entirely different from my mother's life. She was a slave who did everything. She never got to bed before midnight and was up again at dawn. My father worked hard too, but after dinner he went out to the men's cafés to drink retsina or ouzo and play cards. Women never had time for that." She says her husband helps, but only under pressure. "Do you know of any king who wants to leave his throne?" she asks.

Vivi T. has had a slightly easier life. An only child whose father worked as a clerk in a supermarket, she studied to be a secretary but had to settle for a job as a hairdresser's assistant. When she married Dimitri, who has a job as a supervisor of cleaners in one of the hospitals, both sets of parents helped them get established. When their first child, Elias, now six, was born, she stayed home. Her parents built an addition on top of their own house and Dimitri did a lot of the work. It has two bedrooms, a kitchen, and a bath. They have a small stove, a fridge, TV, and vacuum cleaner.

A year after their second child, Andreas now two, was born, Vivi went back to work. She is upgrading her skills in the hope of getting into the civil service, where government regulations will allow her to leave two hours earlier until Andreas is four years old. In the meantime her mother looks after him while she sews piece-work for around 50,000 drachmas a month (U.S. $300).

Dimitri, an only son, didn't help at home in the beginning of the marriage, but Vivi persuaded him that if he pitched in he wouldn't be so tired and could listen to his problems at work and they could even go out occasionally. He now washes dishes and cleans floors, but balks at ironing. Sometimes he helps with the shopping. Her own mother, who did everything for her family, scolds Vivi and says she pushes Dimitri too hard. Vivi says she hopes to bring up their sons to be more co-operative.

I left Greece with no doubt in my mind that its women have experienced a legislative revolution in the past fifteen years. But

laws can only take them so far. The other essential change—a difference in attitude—is sure to come more slowly. "In spite of all the legislation the old patriarchal attitudes are still firmly rooted in Greek society," says Eleni Stamiris, a Canadian woman married to a Greek, who has lived in Athens since 1981. "The legal changes are like drops in a sea of discrimination. Yet there is change in the air. Even macho Greek men realize they have to change.

"But who wants to share this world that men have created?" she demanded. "I want another paradigm. I don't want a piece of the pie as it is. I want another kind of pie completely." This was a theme I was to hear over and over again as I talked to women in different countries.

Margarita Papandreou put it another way: "Feminism is the most powerful revolutionary force in the world today. Feminists have to have a vision of the kind of world we want to live in. We want to put women-centred values at the heart of society. What we're trying to do is achieve a true revolution—a revolution of the human spirit. And we're doing it through non-violent means, but it is a revolution nonetheless."

SPAIN:
BRIGHT BEGINNINGS AFTER THE POST-FRANCO REVOLUTION

FACTS

Population: 38.9 million

Government: Upper and lower chamber. Proportional representation. Quotas in some parties.

Vote for women: 1931—but exercised only for five years. Vote restored in 1977.

Percentage of women elected: 7.8 percent in the Chamber of Deputies; 5.9 percent in the Senate. Two women in the cabinet.
Education: Coeducation since 1975. Most universities are free, so that half the university students now are women. Five universities offer women's studies courses.

Percentage of work-force women: 30.4 percent (Lowest in the European Community. Half of them are unemployed at any one time.) Pay compared with men: 19 percent less for doing exactly the same job. A large number of women work on family farms and businesses.

Abortion: Legal in 1982, but the law is very restrictive: allowable only in case of rape, severe physical or mental stress, or a

a malformed foetus. Not covered by the health service. Health workers and doctors are harassed by anti-choice groups. In 1978, the sale of contraceptives became legal.

Child care: 28 percent of women with a child under ten work— one of the lowest percentages in Europe. There are no statistics on how many children under three are in publicly funded nurseries or primary schools, but it is estimated to be under 5 percent. Two-thirds of children aged three to five go to publicly funded pre-primary schools. In urban centres these are open from 9:00 A.M. to 5:00 P.M. and children are given meals. Parents pay a proportion according to their income, and after 1991 can claim the costs on their income tax.

Maternity leave: Sixteen weeks at 75 percent of salary. Ten weeks must be taken after the birth. Women with collective agreements often get better pay. Women may take time off to breast-feed babies. There is also unpaid parental leave for either parent. Parents with a child under six may work shorter hours for less pay. Parents with a sick child can take two days off without pay.

Birth-rate: 11.2 live births per 1000 population.

Family law: Divorce legal in 1981; granted after two years with mutual agreement and after five years' separation with no mutual agreement. Equal division of property on divorce, but this is hard to enforce. Child support not enforced.

Achievements: Strong individual women fought the system under Franco. There are many quite progressive laws, but they are not enforced.

Problems: Has the lowest number of women working outside the home in Europe, which makes most women entirely dependent on men. Majority of women are quite traditional. The women's movement is small and divided.

THE BACKGROUND

Modern Spain began with the marriage of Isabella I of Castille and Ferdinand II of Aragon. Together they drove the Moors out and financed Columbus's voyages to America. Spain then conquered most of South America and the southern part of North America. With its new-found riches, it had become the most powerful country in the world by the sixteenth century. But by the twentieth century, after almost non-stop internal and external wars, it had lost most of its colonies.

It was in Spain that the Inquisition reached its bloody zenith and held sway for almost four centuries with thousands of people—mostly Jews, Muslims, and so-called witches—tortured and killed in the name of Christianity. Spain's most famous sport, the bullfight, glorifies men gambling with death. It's not surprising that the word *machismo* originated here.

After a military dictatorship in the 1920s, the Second Republic took power in 1931. In a brief period of five years many reforms were pushed through, including the vote for women, the right to divorce, full civil and political equality with men, and, in 1937, one of the first, and most liberal, abortion laws, which was later abolished after the civil war. Frederica Montseny became the first woman minister—another first among the southern European countries of Italy, Greece, and Portugal, where women didn't even gain the vote until after World War II. All these reforms were the result not of a feminist movement, but of the socialist and worker's government in power during that time.

After a devastating civil war from 1936 to 1939, another military dictatorship under Francisco Franco took over. Until his death in 1975, Spain was an isolated backwater in the south-west corner of Europe. Today Spain is transforming itself with dazzling rapidity into a modern, industrialized country.

The first wave

The first woman graduate in medicine was refused a diploma to practise in 1871, then stoned. In the 1900s women's organizations began to agitate for more civil rights. In the 1920s, they succeeded in getting fifteen women appointed, not elected, to the National Assembly. When the Republicans came to power in the 1930s, women got the right to divorce, access to abortion and birth control, and the right to vote. But after Franco took over, the 1889 civil code was restored and all women's rights were revoked, including the right to their own wages. Only one large women's association was allowed—organized and controlled by the government and dedicated to teaching women their proper place in society as prolific mothers and handmaidens for their husbands and the state.

The second wave

By the 1960s Spain began to industrialize and women began to enter universities in large numbers. By the 1970s even the church was urging more democratic forms of government. Women were allowed to form consumer groups and parents' groups. Before he died Franco restored the monarchy, and Juan Carlos, grandson of the last Spanish king, took the throne. Two weeks after Franco's death the First Congress of Women's Liberation was held secretly. Several other big meetings followed. Soon there were more than ninety organizations. But at a 1979 conference in Granada, attended by three thousand women, no common ground could be found to unify the groups, and much of the momentum went out of the movement. Women's studies have been set up at the universities in Madrid and Barcelona and there are many bookshops, magazines, and self-help groups around the country.

A small department for women was established by the conservative government in 1977. When the socialists gained power in 1982 it became a full department, with ten times the budget. The socialists pushed through reforms for women that

had taken decades in other countries. Technically, women can now do anything except take the throne. But the changes have had little input from women themselves, and as is the case with hasty legal reforms, many of the laws are not enforced. As one feminist told me: "The law is not respected in the home, at work or anyplace else."

The situation today

The Instituto de la Mujer (Institute for Women) in Madrid, founded in 1983, is spanking-new by most European standards. It is typical of the kind of machinery governments all over the world set up when they first try to cope with "the woman question".

Located on a busy street in downtown Madrid, it occupies two floors of what used to be a grand private residence. Visitors enter a marble foyer through huge heavy doors and take a grilled elevator with brass fittings and a plush-upholstered bench up to the institute, where they are confronted by twenty-foot ceilings and elaborate plaster mouldings. In the hallway a big bright-red Coca-Cola machine stands out against its surroundings.

The office walls are lined with black-and-white pictures of famous Spanish women such as Frederica Montseny, minister of health in 1937, addressing a crowd through a large old-fashioned microphone that looks like the hubcap from a car, and Dolores Ibarruri, known as La Pasionara, who fought against Franco in the Spanish civil war, was exiled to the USSR, and died recently in 1989.

The imposing edifice dwarfs the women who work there, symbolizing the problems facing Spanish women today. Although the office vibrated with energy and enthusiasm, the building, with its heavy load of tradition, seemed to hover over its occupants.

The institute has a staff of eighty and an annual budget from the government of 1,400 million pesetas (14 million U.S. dollars). There is a library and a statistics centre, located in what must have been the mansion's dining-room, with an impressive

bibliography of absolutely everything that has been written on Spanish women, as well as two tomes, each the size of a big-city telephone directory, that summarize women's situation and list their organizations.

The women proudly point out that a council of representatives from the different ministries meets regularly to discuss the progress of women, and there is an independent board, comprised of government people and members of the public. The institute has energetically issued all kinds of booklets on the rights of women, which are sent out from Madrid office and its twelve centres scattered about the country, and it has researched why girls study for traditional jobs and why men don't help more in the home. As well, it has trained more than one thousand single mothers for new jobs, educated the police about wife battering, and helped women find jobs.

Carmen Martínez Ten, a 35-year-old gynaecologist, is the institute's director. The walls of her large corner office are covered with posters that the institute has published. One shows a woman wearing six hats, to convey the message that women can be anything; in another a little girl exuberantly conducts a symphony orchestra.

A small intense woman, Ten was raised in a traditional family of seven children. She attended a convent school in Madrid until, at fifteen, she insisted on going to public school. She campaigned both for women's rights and abortion. After studying medicine, she managed a health centre, and says she knows what she's talking about when she addresses the subject of working women. Once a member of the Communist party, she is now with the ruling Socialist Workers' Party. She is married with two children.

The evening before our interview, I had seen Ten on television, publicizing a program the institute was launching to help women get into private enterprise. She was meeting with the managers of eighty-seven businesses to persuade them to promote women and to include them in training programs. The institute was also conducting seminars to help women become managers.

I asked her whether she felt the business community would actually carry through on its commitments. Businessmen are

never averse to appearing on television for the publicity, but was there going to be any way to enforce the promises and measure the results?

Sensing my doubts, Ten launched into an impassioned speech on the Plan of Action for Women, which the government passed in 1987. As she talked she kept pounding the document, as though willing the recommendations into reality by sheer force.

"Ten years ago the fertility rate was 2.3 per 1000 women of child bearing age, but today it's only 1.5. We need a rate of 2.1 just to replace the population," Ten expounded. "Right-wing politicians want to keep women at home, having children, but the institute wants to encourage women to work outside the home and also have children, by increasing the number of child-care spaces—which are too few."

She went on to explain that the institute is urging the government to pay firms a subsidy for women who leave their jobs to have children. Another idea is to have public schools take in all children at three years of age. I expressed some doubt that with high unemployment, especially among women, the government would move very fast on child care. She was fairly confident. And she was certainly right. If Spanish women are to work outside the home and become more independent, they will need child care.

As I took my leave of Ten, I wondered how soon the government would replace her with someone less dedicated. Politicians and bureaucrats often make very good appointments to women's councils in the beginning but, as time goes on, find it more comfortable to fill such positions with tame women who won't "rock any boats" and who are more devoted to the ruling party and to their own futures than to the cause of feminism.

Later I talked to a former member of the institute's board who had resigned in frustration. She told me the institute has done some excellent things—seminars, campaigns, research, but as I suspected, she didn't think it had any real power, or that there was any real commitment from the government. Since that meeting the government has launched its second plan—for equal opportunity for women—which is even more ambitious,

considering this chauvinistic country. It focuses on getting men to share family responsibility and begins pragmatically by trying to get support for divorced and separated wives and their children.

Spanish women face plenty of problems. Even though Spain is an industrial country and most women would like jobs, the majority—eleven million—are still housewives, most of them completely dependent on their husbands. Older women with no husbands get a tiny pension of 18,000 pesetas (U.S. $180) a month for people over sixty-five who live alone and have no money. Typically, some of the legislation that is being pushed most vigorously will help men, not women—the act to allow men to inherit their wives' pensions, for example.

Today most middle-class families have a car, a TV, perhaps even a video recorder and a washing machine. What drives women out to work is their desire to own a house or an apartment. Even in the suburbs of Madrid, a modest two-bedroom apartment costs ten million pesetas (U.S. $100,000) and a modest house twelve million pesetas (U.S. $120,000).

One woman reported that her firm used to hire no women, but now almost one in ten employees are female and almost all of them are married. A few women are even making it into middle management. Men are afraid of other men, but they recognize that women work hard and are no threat for the top jobs. There is even the odd case of nepotism. Sons are often rapidly advanced by influential fathers. One prominent banker recently promoted his granddaughters. "But you can count on the fingers of one hand the women in top jobs in Spain," I was told.

Unemployment is high for all Spaniards, so that a lot of Spain's business takes place in the "black economy", which means the work is low paid and not covered by either benefits or labour regulations. Half that work—sewing in the home, for instance, making artificial flowers, or assembling parts for radios and television sets—is done by women.

As usual where there is so much unemployment, sexual harassment is a common problem, and with women afraid of losing their jobs, it largely goes unreported. As an example of how unimportant it is considered, a nurse recently won a court

settlement for a measly 10 percent of her salary for having to undertake twenty-six weeks of therapy after being raped by a co-worker. Yet this was regarded as a landmark settlement in Spain!

Like women all over the industrial world, Spanish women need more child care. School hours, as in many European countries, especially in the Mediterranean, couldn't be more awkward for working women. Schools generally run from nine to one and from three to five, but many women work from nine to one, then from four to seven or eight at night. The public service works from eight to three, and when children come home in the middle of the day, there is no one to look after them.

Private child care runs around 20,000 to 30,000 pesetas (U.S. $200–$300) a month, which is much too expensive for someone on an average monthly salary of 80,000 pesetas (U.S. $800). Some women can afford to hire a woman to do housework and mind children for around 30,000 to 40,000 pesetas (U.S. $300–$400). Others depend on mothers or relatives, but willing grandmothers the world over are getting scarce, because they too are often in the work-force.

Today in Spain, all but two or three universities are public and fairly cheap, so that even poor families can afford to send children. Women started to attend university in large numbers in the 1960s, and today half the students are women, but most of them are in the arts, with few in the booming fields of science and math. Even today many parents don't think daughters need a university education and want them out working as soon as possible.

The Catholic church still exerts a heavy influence on women's issues, particularly in rural areas and small towns. Although Spain finally legalized abortion in 1982, access is very restricted. Doctors can easily opt out of performing abortions as a matter of conscience, and illegal clinics are expensive. Teenage pregnancies are rising alarmingly, yet there is almost no sex education or information about birth control in the schools. Consequently, out of more than 100,000 abortions a year, only one in ten is legal. Spain recently banned use of the new abortion drug RU-486.

In every country I visited I met extraordinary women who, in spite of many obstacles, have fought for women's rights from the

beginning. Lidia Falcón is certainly one. A lawyer, writer, and staunch advocate of women's rights, she was jailed by Franco for six months in 1972 for daring to publish articles about the oppressive situation of Spanish women. She was jailed again in 1974 on trumped-up charges involving Basque separatists who had tried to blow up a police station. She wasn't involved in the plot, but the Falangists used the incident to round up twenty-two intellectuals and anti-fascists and throw them in jail for nine months.

Falcón has written a major philosophical and political thesis on the struggle of women in the world. As well, she is a renowned author of novels, short stories, and plays. She is the founder of the Spanish Feminist party, although it hasn't run any candidates as yet. She also edits, art-directs, and publishes a feminist quarterly with three thousand subscribers.

"One of our biggest problems," she explains, "is violence against women—about 300,000 cases a year. [There are no official statistics.] There aren't nearly enough hostels and very little sensitivity on the part of the police and social workers. A lot of women just put up with the abuse because they think it is their lot. There are fourteen rapes a day, but few are reported. Often the woman is pressured to 'pardon' the rapist. Only recently was the law changed so that she doesn't have to prove she put up 'heroic resistance'.

"As for splitting up the assets of a marriage, the law says one thing, but the justice system says something else. It's a bad process—Spanish justice." She adds that it took her, a family-practice lawyer, ten years to get a settlement in her own divorce. Men are supposed to support their wives and children, and business assets are supposed to be divided. Ninety percent of women lose out because they don't know their rights. Half a million divorced women are raising children alone with no job, no social security, and on welfare. Often men sell their business or property to avoid paying, and nothing is done about it.

Divorce has been legal in Spain only since 1981; before then couples had to go to Rome for an annulment, an option open only to the extremely rich and influential. Today there are 100,000

divorces a year, but a lot of people don't even bother because the process is so long and expensive. More and more divorces are initiated by women; one observer estimated the number to be as high as 90 percent. In 1975, full legal rights were extended to illegitimate children.

Seventy percent of fathers pay no child support. Although failure to pay is a criminal offence, no defaulter has ever been sent to jail. Thirty percent of judges are now women. (In Spain you study and pass special exams to be a judge, but salaries are lower than in legal practice.) But under a legal system that is rigid and conservative, women judges can sometimes be even harder on women than their male colleagues. Yet there is hope. In the past, Spaniards rarely paid their taxes. Recently the state started cracking down on delinquents. Feminists hope the same attitude will in time extend to those who renege on child support.

Spain is a country that seems to cry out for a strong women's movement. Spanish women did manage to work together briefly for an abortion law and a divorce law. Many women organize locally to help battered women and rape victims. But on a national level, organizations are weak. There is a new group, the Red Feminists, in Madrid, and the Federation of Women, a group of forty organizations working on such projects as a law outlawing rape in marriage. But at present no strong umbrella women's movement in Spain exists. When I asked the reason for this, most Spanish women shrugged and said, "Because we're Spanish." But the real reason is that after centuries of being directed by the church and harsh, undemocratic governments, women have little experience in working together irrespective of class and regional barriers.

One woman described a meeting she had attended where a woman from the Democratic Centre party had been asked to speak. The woman arrived with an entourage of one hundred women from her party. The women from the other parties boycotted the speech. After the speaker left with her supporters, the other women returned. Needless to say, the organizers were very disheartened by such partisan tactics.

María Angeles Durán is director of Women's Studies at the

University of Madrid and is presently conducting a research project with a staff of eight on the future needs of Spanish society. She has been a frequent lecturer in North and South America, as well as in Europe. She studied to be a judge but didn't take her degree. She is married to a professor and has three teenage children.

Durán says there has never been a tradition of women's organizations in Spain. Even today only about 2 percent of Spanish women belong to any organization—an astonishingly low figure compared with many other countries. Only about 1 percent of Spanish women even belong to a political party, according to Durán. She says that unlike nations that evolved out of the Anglo-Saxon political tradition, where rights were granted as early as 1215, when the Magna Carta was signed, Spain is not only conservative with a short history of democracy, but its people are anarchistic by nature and accustomed to solving their problems through the family and within the community.

She doesn't even think women enjoyed being members of a big movement while it was at its peak during the fight to make abortion legal. "There are fifteen different regions in Spain and many different regional dialects. Basque and Catalonian, two of the most obvious, are quite dissimilar. Women organize in their re-gions. It would be an advantage to have a national organization like the U.S. National Organization for Women (NOW) in Spain. But at the moment one of the biggest national organizations for women is unfortunately totally anti-feminist and conservative."

It's not surprising that Spanish women, who were kept completely out of the political scene, isolated in their homes and dictated to by the church, have not made much progress politically. They got the vote in 1931, but since there were no elections under Franco, few women ever voted. Today women make up only 6 percent of the elected members of both houses of government and only 6 percent of managers in the public service.

But there is hope, in that Spain has a system of proportional representation, something that has helped women in other European countries. Under this system, instead of the country being divided up into electoral districts where candidates

compete against one another to represent their party, as in Canada, the United States, and the United Kingdom, each party puts up a list of candidates for whole regions. The number of candidates elected in each region depends on the number of votes the party garners. Under such a system parties can be pressured to include a quota of women on the lists.

The Communists have a 35 percent quota and the Socialist Workers' party ran 25 percent women in the recent election for the European parliament. The more conservative Democratic Centre Party hasn't yet accepted quotas, although it recently named two women vice-presidents—which, women told me, wouldn't have happened without the acceptance of quotas by other parties.

Ana Balletbó is a member of the lower house for Barcelona. We met at the parliament and had lunch in the dining-room. An exuberant, outgoing woman, she told me she had put herself through college, first becoming a journalist, then a TV star, and later teaching journalism at the university, where she met her husband, a history professor. She has four children: thirteen, eleven, and twins who are eight.

After Franco's death in 1975, she drove all over the country organizing women. She ran unsuccessfully for election in 1977 but won in 1979. At the time of an attempted military coup by civil guards in February 1981 she became the focus of a lot of publicity. Pregnant with twins, she walked out when the lower house was taken hostage, gambling that the rebels wouldn't shoot a pregnant woman.

A typically Spanish joke resulted: the leader of the coup, it was said, had so much machismo that when he stormed into the Chamber of Deputies a woman walked out pregnant with twins a few minutes later.

When we met she was in the process of getting a separation from her husband and was more interested in talking about Spanish men than about politics.

"Men from Catalonia are used to strong, independent women, but although my husband said he accepted what I was, sub-consciously he didn't. If a woman has to ask for help in the home,

then the man gives her only token help. He doesn't share the real burdens of the home and raising the family. You keep on in the marriage because you know other women are worse off, but the worst condition is to say you're sharing and you're really not."

Under Spain's civil code, women were treated like children. They had to get permission from their husbands for everything, even if a child desperately needed an operation. Ana María Pérez del Campo was one of the women who changed all that as the founder and president of the Association of Separated and Divorced Women. "Things were so bad," she said, "you had to be a rebel. We were treated like unpaid nurses for our own children."

We met early one morning in the former meeting rooms of the Sección femenina, the only women's organization allowed under Franco. Covering one wall was a huge mural of women sewing, cooking, and looking after children—the only suitable jobs for women under the dictatorship. The other walls were decorated with witty contemporary posters, one showing a woman's arm and clenched fist emerging from a scrub bucket with the words inscribed below: "Women! Liberate yourselves!"

As we sipped a lemon drink, she recalled her well-to-do conservative upbringing. "I was educated to marry," she said with a wry smile as she described the severe traditional boarding school she was sent to. University wasn't even an option. At nineteen she was married in a big church wedding.

After three children in quick succession she decided in 1961 that she wanted a separation—divorce was impossible in Spain under Franco. Scandalized, her mother cut her out of her will. Spanish women who leave their marriages almost always get custody of the children, but often they can't collect support. When her husband threatened to sue for custody of the children, she replied: "Take them." He took the eldest, who was four, for two weeks, then quickly returned her. Although he never paid support, there was no more talk of custody. She supported herself and the children as a hospital therapist for children with polio. Fifteen years ago she started a small stationery and tobacco business. She went to university to learn about marriage laws, and studied the piano for her own pleasure.

In 1972, she and other politically conscious women formed an association for separated women. "Just reading the legal texts enraged people," Pérez del Campo recalled. "Now it's more difficult because the discrimination is still there, but it's less evident."

Today her organization of four thousand members supplies moral and psychological support and tells women where to go for help. Members have attended the trials of ninety men who have murdered their wives, to make sure such cases are taken more seriously.

Pérez del Campo thinks that the trend towards the feminization of poverty will only be reversed when women stop being ruled by their emotions. She believes that women's conviction that they must keep their children at any cost is a result of cultural conditioning. "Motherhood is a myth invented by men," she says. "Mother love is driving children into lives of poverty and privation. It's not mother love but self-love, and it's allowing men to walk away and make new lives for themselves without any problems. Children aren't heroes. They see their father with his new family and a lot more money and they want to go with him. Meanwhile women looking after small children can't take a job and they lose the children anyway."

I pointed out that this attitude might work in a macho-oriented society like Spain, but in North America so few men actually want custody—only 15 percent—that a man who seeks it is often regarded as a model father by judges simply because he wants his children at all, and he wins custody. But I think she had a good point: that by fighting so hard for their children, more and more women lose everything—their share of the marriage settlement, and eventually the children too.

A day in the life of...

In Spain women who give the outward appearance of a sophistication often are almost unaware of all the changes taking place in the society around them that deeply affect them. María R. is almost thirty, with a good job as a secretary to a lawyer in one of Madrid's top legal firms. She earns 125,000 pesetas (U.S.

$1,250) a month—well above the average. She met her husband, José, at a discothèque, where they were introduced by a mutual friend. José makes 200,000 pesetas (U.S. $2,000) a month as a machinist making metal parts. With some help from his parents and working overtime, he got together the down payment on a three-bedroom flat that is now worth four times what they paid. The mortgage will be paid off in twenty years.

Four years ago they married. It was a big wedding with two hundred guests. María wore a long dress and veil and there were flower girls. She was given away by her father (although she's not religious and they don't attend church). They own a four-year-old Ford Orion, a fridge, TV, washing-machine, and a dishwasher, which she doesn't use. José manages all their household finances.

Their only child, Enríque, is three, and they hope to have at least one other baby. María took three months paid maternity leave (the entitlement has since been raised to sixteen weeks), and later hired a young woman to look after Enríque and do cleaning for 35,000 pesetas (U.S. $350). But most Spanish girls no longer want to do domestic work, and Maria couldn't get another maid after she left. Maria now takes Enríque to a nursery school in the morning and José picks him up at night and feeds him, since Maria doesn't get home until 7:30 or eight. The school costs 18,000 pesetas (U.S. $180) a month. On weekends the family visits friends, and for one month every summer they holiday at José's parents' home near the ocean.

Although María knows nothing about the feminist movement, she believes her life is a big improvement over her mother's. She says she can enjoy life more and that her marriage is more open and "sincere". She has no plans for the future, and is not interested in politics. The propensity of Spanish men to take mistresses as their wives grow older is not a thought that she has allowed to disturb her peaceful domesticity. She seems unaware of how vulnerable she is by letting her husband handle all the money and do all the planning for the future.

The pace of change in Spain over the past fifteen years has been swift, but I found that it has left many Spaniards disoriented,

even yearning for the safe rigidity of Franco's regime. Many people complained in a way that could be summarized as follows: "What's the use of democracy? There are no jobs, and it isn't safe to walk at night in Madrid. Under Franco you could walk anywhere at two in the morning."

The same feelings of disillusionment are shared by Spanish feminists, who look around and wonder from where the next wave of reform will come. They feel like a small, rather beleaguered little group, and that the majority of women were not touched very much by the movement. University of Barcelona professor Marina Subíratz reflected: "Spanish women are not used to power, and still don't think they can get it in either politics or jobs. People are tired after the fight to get rid of Franco. We need a new generation to take over. Women of my generation are exhausted. Young women today have so many problems finding work that they're not sure social action will even help. They are disenchanted. We finally got democracy and it's not that different."

With changes happening so quickly in Spain, little coverage in the media about what is actually happening to women, and no national women's movement, the future for Spanish women is questionable. Such a high proportion of housewives, who may want change but are deeply afraid of losing even the security they have, could easily precipitate a backlash, particularly if there is a recession or a more conservative government takes power.

The last night of my stay in Spain, I dropped into the bar of my hotel for a drink. No matter what I did, I couldn't seem to catch the waiter's attention. A kindly, tired-looking old man, he glanced past me quickly to the men to carefully make sure they were being looked after. I, being alone and a woman, didn't count. This is an attitude that pervades the whole of Spanish society and one, I'm afraid, that will take a long time to die out.

ITALY:
THE REBELLION OF THE ITALIAN MAMAS

FACTS

Population: 57.3 million

Government: Two chambers: a 630-member Chamber of Deputies and 315-member Senate with five life members.

Vote for women: 1945

Percentage of women elected: 12.9 percent in the Chamber of Deputies and 6.3 percent in the Senate. Two women in the cabinet.

Education: Present generation the first to have equal education with men. Half of university students are women, but they are mostly in the arts. Only 12 percent are in engineering.

Percentage of work-force women: 35.5 percent—9.5 percent part-time. A lot of unemployment. Women in unionized jobs earn 84 percent of what men earn.

Abortion: Paid for by the state in first ninety days of pregnancy, and afterwards with the approval of two doctors if health is

endangered, pregnancy is the result of rape or the foetus is malformed.

Child care: Only 5 percent of children under three are in publicly funded crèches. But more than 87 percent of three-to-five-year-olds are in publicly funded pre-primary schools run by the government, the municipality, the church or a lay organization. By law these are open eight to ten hours a day. Parents pay according to income—roughly one-third of the cost. Much better services in the industrialized north than the agricultural south, as the government no longer earmarks money for day nurseries and local governments often spend money on other things or cut back on services. No tax deductions for child care.

Maternity leave: 42 percent of women with a child under ten are employed. Three months' post-natal leave at 80 percent of pay and additional six months' leave at 30 percent of pay. Women in unions are often better off due to collective agreements. Women are entitled to two hours' rest a day for the first year after birth and unpaid leave to care for a sick child. Men entitled to parental leave if the mother dies.

Birth-rate: 9 live births per 1000 population—the lowest in Europe.

Family law: Divorce legal since 1972. Assets supposed to be divided, but this is difficult to enforce. Child support laws are widely flouted.

Achievements: Strong women's movement in 1970s that fought for good legislation on divorce, family law, and abortion. Generally good social supports for women.

Problems: A chaotic and fairly corrupt political system, and a law-enforcing structure that is weak. High unemployment. Violence high. Women's movement scattered.

THE BACKGROUND

Italy was the centre of the Roman Empire from the fifth century B.C. to the fifth century A.D. In the Middle Ages its city-states created commercial enterprises that dominated European trade, but it wasn't until 1861 that it became a united nation.

In World War I Italy fought on the Allied side, but following a period of unrest, Benito Mussolini seized power in 1922 and set up a fascist totalitarian state. Under the fascists the ideal mother produced at least twelve children and obeyed her husband, who, as head of the family, could legally "discipline" her. A woman passed from domination by her father to domination by her husband. For example, a married women couldn't travel or get a passport without permission from her husband. There was no divorce, no sex education, no abortion. It was illegal even to discuss birth control.

Only a generation ago in southern Italy, where the Mafia are still a force, a man could kidnap a girl, rape her, and force her to marry him, because, as a non-virgin, she was a damaged piece of property and unlikely to find another husband. Although men carried on open affairs without much censure, they could kill an unfaithful wife and escape punishment because such a murder was deemed "an act of honour."

Mussolini entered World War II on Hitler's side and in 1943 was defeated by the Allies. He was executed along with his mistress by the Committee of National Liberation, which took over after his defeat.

Today Italy is prosperous, with some of the world's greatest designers, musicians, writers, and artists once again affirming the extraordinary creativity of the Italians. However, another characteristic of post-war Italy is its bewildering succession of short-lived coalition governments.

There are actually three Italies today: the prosperous northern plain, with its rich farm lands and booming industries; central Italy, with its ancient cities that draw so many tourists; and the south, which is hot, dry, mountainous, poverty-stricken, and, except for branch plants from the north, almost feudal and where the Mafia is still powerful.

The first wave

Many women were active during the period of Italy's unification in the mid-nineteenth century. In 1859, women got the right to become teachers, and in 1883, technical schools were opened to women. In 1905, the first organization for women's suffrage was formed. By 1911 the first Feminist Congress of women in Rome advocated legal divorce and non-religious schools.

But when the fascists came to power under Mussolini all constitutional gains were abolished. Quoting Augustine and Aquinas, Mussolini declared that women were by nature inferior. The ideal woman had at least twelve children. The most prolific child bearers were awarded medals, met Mussolini, and received a citation from the Pope, who had declared the vote for women "a perversion".

At the end of World War II, 70,000 women partisans took part in the resistance movement, and partly in recognition of their contribution, Italian women finally got the vote. In the 1948 election twenty-one women were elected—eleven of them from the Communist party and members of its new women's organization, UDI.

The second wave

By 1968, feminist groups had begun to meet. The concept of wages for housework in recognition of all the unpaid work women do in the home originated in Italy. From the beginning the Italian women's movement was vigorous and militant. Women in Torino occupied a housing project in 1972. Cashiers

in a Naples department store refused to smile at customers until they got a wage increase.

Italian women had one of the strongest women's movements in Europe during the 1970s. Considering how backwards the country was as far as women were concerned, how conservative the Christian Democratic governments were, and the almost total opposition of the Catholic church, Italian women accomplished a miracle. And unlike women in other countries, they resorted to civil disobedience and frequently broke the law to achieve what they wanted.

The situation today

"What you have to realize about Italy," said my Canadian friend who has been living there for several years, "is that everything here is chaotic—but somehow it works! Railways go on strike on a day's notice. Telephones work some days and not others.

"The bureaucracy is bloated, inefficient and full of bottlenecks," he complained. "Bureaucrats turn up in the morning, carry on another business at work, and leave for a completely different job in the afternoon. There are pay-offs and corruption all over the place.

"The government is always getting defeated. Politics is a soup-of-the-day exercise as Italians try to figure out what coalition might work—even though the players are always the same. In fact, the country almost gets along without a government."

I'd collected a few facts about Italy myself. It has a deficit close to that of the U.S., although it has only one-fifth the population. Unemployment normally runs around 12 percent, and is up to four times that in southern Italy. Tax evasion is a fine art and a "black" economy flourishes.

My friend wasn't nearly as sure of himself when I asked him about Italian women. He took refuge in cliché: "Ah, those wonderful Italian women! Whenever an attractive woman enters a room, all conversation just stops."

That irritating stereotype—which says more about the fantasies of men than the actualities of life for Italian women—is

still current in Italy today, along with two other common ones: the prolific Italian mama with a huge brood of children, and the passionate, tempestuous Italian sexpot. Both are as out of date as a recording of Enrico Caruso on a wind-up gramophone.

It's true that in Italy today the family is still extremely strong. Down through history Italian women have always wielded a great deal of influence within the family. Now there are more than eight million home-makers out of a total population of fifty-six million, and the family is still a central fact of Italian life. But in the past twenty years a complete revolution has changed this former "land of mothers". The current birth-rate is—to the consternation of the Italians and the astonishment of other countries—the lowest in Europe.

And the birth-rate isn't the only change. Only forty years ago one out of two Italian women was illiterate. The present generation of women is the first to be as well educated as men. Italians leave school at the age of fourteen, but more Italian women often stay in school longer than men today.

Considering that Italy was a country where women were kept barefoot and pregnant just a generation ago, it is remarkable that her social programs are superior in many ways to those in Canada, the U.S., and some of the other more prosperous European countries. Italy rates behind the Scandinavian countries and France in the progress it has made concerning women's issues, it is well ahead of former West Germany and Britain. This is due in large part to the vigour of the Italian women's movement in the 1970s.

Most of Italy's children are in state-run nurseries by the age of three. Only a little more than 35 percent of Italian women are in the paid work-force—one of the lowest percentages in the European Community. But Italians obviously believe in looking after children, and if mothers are working, children need child care. There is never enough child care, of course, especially in cities such as Rome and Milan, particularly for babies.

Half the workers in Italy are unionized. There are very few women—about 3.3 percent in top executive positions. Sexual harassment on the job is supposed to be dealt with through the

unions, but until lately it wasn't taken seriously. I heard of one case in which a woman journalist only got her union to act when she hid a tape recorder in her blouse and taped her boss threatening not to publish her articles if she didn't sleep with him.

The unions have brought women close to equity in wages, but many firms are reluctant to employ women because they are entitled to long maternity leave. Unemployment in Italy, epecially among women, is high—the second highest in Europe next to Spain. There isn't much part-time work in the country because the unions have opposed it. Consequently a lot of women work in the "black" economy, which means working for a small firm that sub-contracts work, isn't unionized, and pays low wages.

One woman striving for equality in the work-place is Tina Anselmi. A member of the Christian Democratic Party (DC), she was the first woman appointed to the cabinet as minister of labour in 1976, and one of the most important women in Italian politics today. I found her in her office, a former nun's cell, in an ancient convent the government had restored.

A big impressive woman with a motherly manner, she says she became a member of the resistance at sixteen after being forced to watch the hanging of eighty young men in her village by the fascists. She joined the partisans and began to read about politics. After the war she organized textile workers and joined the DC. She was elected to parliament in 1968, and served as minister of health. In 1981 she chaired the committee that investigated the banking scandals that rocked Italy. Today she chairs the National Committee for Equality, which was set up in response to a request from the European Community for its member countries to bring their legislation up to the standards set by the community. Anselmi has initiated a bill to introduce affirmative action in Italy. A vocational training program has been established and a National Committee to Implement Equality formed. All companies with more than 150 employees are to report on the progress of women in this area.

The only catch with this ambitious program is that Italy has been good at passing excellent legislation but very poor at enforcing it. In a country where people make avoiding taxes a

fine art, one has to wonder how well initiatives for women will be honoured. But Anselmi struck me as a strong, dedicated woman who at least was trying.

Senator Giglia Tedesco of the Communist party (PCI) confirmed my fears. "The laws for women in Italy have generally been good," she said. "In the U.S., the laws aren't nearly as good, but they enforce them better." Another senator, Laura Balbo, explained: "The U.K., Scandinavia, and France have strong public administrations. When laws are passed, they are generally enforced. But in Italy our public administration is weak. Because so much in Italy happens through the church or business, it's easy not to enforce the law."

For example, according to the law women aren't supposed to be fired when they get pregnant, but often they are—on some other pretext. In a country with 12 percent unemployment plenty of other people are available to fill the jobs of pregnant women. Taking a case to court as an individual is not an option. True, today for every three men who become lawyers there are two women, and more and more women are being appointed judges, but the courts are still too expensive for ordinary citizens, and too traditional to be a practical way to change Italian society.

If a man doesn't choose to pay support for his children after a divorce, it is hard to force him, in spite of a law that says his salary and pensions can be confiscated. It is also easier in Italy than in most countries for a man to hide his assets because so much under-the-table business takes place. Court cases are extremely expensive and can drag on for as long as ten years, and therefore are no solution.

Author and playwright Dacia Maraini, a celebrated feminist, told me that both her father and brother-in-law got out of paying any support for their families.

A woman alone raising kids lives in poverty. She'll always earn less than a man in the same job, even if the law says she is supposed to get equal pay. Marriage is no longer the aim in a woman's life. Many young women don't want to marry at all. They see marriage as a trap," said this founder of the revolutionary feminist theatre La Maddelena, which shocked

Italian society with its anti-clerical and lesbian plays.

Divorce and abortion were the issues that first got women moving. By 1974, thousands of couples who were separated from their original spouses were living in common-law relationships. A referendum on whether Italy should legalize divorce and let common-law couples legitimize their unions was held. The church and the Christian Democratic government were confident that the majority of Italian women would vote against legalized divorce. To their great surprise women voted for it.

That was the first clear signal that many Italian women were changing—and generally turning away from the church. In 1975, Anselmi introduced family law legislation decreeing that men and women were equals in marriage and that when they divorced, assets were to be divided equally.

Today divorce is three times as high as it was in 1971, although it is still low compared with other countries—one-sixth the rate of divorce in the United Kingdom, for example. Many divorces are started by women; yet in spite of the law many couples simply can't afford to separate.

But it was on the abortion issue that Italian women showed their tremendous energy and strength. Every year more than three million illegal abortions were performed and twenty thousand women died. Yet the political parties in this Catholic society chose not to address the issue. To jolt them into action, Italian women organized huge marches in all the major Italian cities during 1974–75. When, in 1974, sixty-three women were charged with having illegal abortions, hundreds of women signed petitions declaring that they too had had abortions. All told, half a million men and women signed. As well, planes were charted and flown to Holland and England to help women get the abortions they couldn't get legally at home. Illegal abortion clinics were opened.

Most of the feminists belonged to the Communist party and the left-wing union movement. They expected the Communist (PCI) party to push for a fair abortion law. But the PCI at the time was attempting to form a coalition with the Christian Democrats (DC). It came up with a proposed abortion law that was so far

removed from what women wanted that women again organized massive rallies all over Italy. Even UDI, the communist women's organization, was so disgusted, it broke ranks with the party and took part.

The Italian law is better than laws in Germany, Spain, and Belgium, and better than Canada's former law. It was a great triumph for Italian women, considering the resistance they had to overcome. But Italian women were deeply disillusioned when the issue of abortion wasn't left entirely to women. The law also contained a "conscience" clause—at the insistence of the DC— that allowed any doctor to opt out of performing abortions. Within six months, with considerable pressure from the church, 72 percent of doctors had exercised this option.

There was a further disappointment. Women had also campaigned for national, free-standing health centres, which they expected to control. The government dragged its feet in setting up these centres, then staffed them with bureaucrats. In the south and in Sicily, where they were needed the most, few health centres were opened at all.

After such enormous efforts met with what women saw as limited success, Italian feminists became disenchanted with reform through political action. This legacy of profound disillusionment lingers today. Although various small groups are still active, many women have turned to other ways to promote feminism: publishing magazines, making movies, working in women's studies or working for peace.

Today Italy has the same official abortion rate as Sweden, a far more liberal country. And in spite of much speculation that abortion would replace birth control—which is still only available with a prescription—the rates have gone steadily down in the past ten years. And because women under eighteen can't get legal abortions without the consent of both parents, most of those cases are not reported. There is still a great need for better information about birth control and for sex education in the schools.

The church made a great effort to have abortion re-criminalized in 1981, but it lost the referendum. In the

meantime, the government has been raiding clinics and seizing the records of women who have had abortions past the ninety-day limit, then prosecuting the doctors and the women.

Gynaecologist Marina Toschi is in the thick of the abortion battle. Toschi grew up listening to her family's house-maids talking about the beatings they got from their husbands and the lurid details of their many, then illegal, abortions. In her practice in Perugia, she sees many couples from the right-to-life movement, who, when they come in for an abortion, always say: "But our case is different."

The most recent major political battle for Italian women was the rape law. At trials rape victims had to undergo exhaustive questioning on every detail of their lives. Not surprisingly, few women chose to present themselves for a second assault in the witness box, and few men were ever charged. Rape in marriage was not a crime.

Feminists themselves were divided over the rape legislation, particularly the proposal that state prosecution of rape be mandatory, whether the victim wants to proceed with it or not. The DC was adamantly against any bill where men could be prosecuted for rape in the family. In the end the bill passed the house but was defeated in the senate. Today there are sixty reported rapes a month—fewer than what there were ten years ago. However, rape is even more common in southern Italy and Sicily, where gang rapes are quite common.

Italy's social attitudes lag far behind its good, but badly enforced, laws. Most men still expect to be waited on, even by working wives. Spoiled by their mothers, they don't help much with either the house-work or children. The younger men, according to a recent survey, will go shopping for groceries, might take the children for a walk or help wash up, but they rank second last to Spain in sharing chores. On the other hand, they complain if they don't find piles of freshly laundered shirts and ironed underwear in their drawers—although only 3 percent will do ironing. Whether they work outside the home or not, Italian women are still expected to iron clothes and do elaborate cooking and baking.

The news-stands reflect the macho society. Pornography flourishes everywhere. Photos portraying women as sexy come-ons "adorn" the covers of even the most serious magazines. In the mainstream press there are no women in important positions.

Italy is also a dangerous place to live for many women. Gabriella Tornaturi, who worked in New York before she returned to Italy to write for *L'Espresso*, the *Time* magazine of Italy, says: "The one thing I can't stand about this country is the fact that I can't go out alone at night. I'm far more frightened in Rome than I ever was in New York. Italy is so violent and macho. Groups of men roam around at night, and unless you have a car or have a cab waiting, you're not safe. At least in New York I could generally find a cab."

She once went to the police to complain about a group of men who had followed her. "The policeman only laughed and said, 'But you're such a beautiful woman'."

Life is hard for Italian women in other ways. Children get out of school at 2:00 P.M. and mothers with paid jobs must arrange for someone to look after them. Housing, especially in Rome, is very expensive. The public transportation system in Rome is primitive by London and Paris standards. As in Britain and several other countries, Italy is closing down institutions and dumping the mentally and physically handicapped back into the private sector, which will further increase the work-load for women.

A day in the life of...

Maria L., thirty-two, has a good government job, a university education, a two-year-old son, Valerio, and an unusually co-operative husband, but it takes a great deal of organization and work to make her life run smoothly.

She grew up in a traditional family in a small town where her father ran a bar and her mother stayed home and looked after six children. Even though Maria won a scholarship and graduated from university in sociology in 1981, she couldn't get a job in her field. To fill in, she took part-time jobs teaching and working as a waitress.

Eventually she sat for the government exams and won a place at the government school of administration, which qualified her for a civil-service job, one of the best options for young Italian women today. She lived in a *pensione* run by nuns, with ten women to a room, while she took her course. She's worked for the government since 1984. Her salary is now 14 million lira (U.S. $11,000) a year. Her husband, also a university graduate, works in the administration office of the University of Rome.

When they were first married, they were lucky to find an apartment to rent in the same building as her in-laws, for $20,000 lira (U.S. $133) a month and 300,000 lira (U.S. $200) key money. But because of rent controls, landlords want a high turnover in tenants and don't like to rent to young couples. Although they had a four-year lease, their landlord claimed he needed the apartment for himself and forced them out.

Like many other young couples, Maria and her husband wanted to buy an apartment. The cost of their co-operative was 120 million lira (U.S. $80,000), half of it in cash. They borrowed from every relative they could for the down payment.

Today Maria's mother-in-law looks after Valerio, since Maria's salary is too high to qualify for subsidized under-three child care. Around seven every morning, one of them picks up the grandmother and takes her home, where she stays in the apartment until Valerio wakes up. Then she feeds him and takes him home to her own apartment. At night on their way home from work they pick Valerio up again. The grandmother is paid for the food for Valerio's lunch but not for baby-sitting. This arrangement is very common in Italy and a lot of women couldn't work without a *nonna*'s help.

They used to travel the forty kilometres to work by bus and subway. Although they now have a car, they still have to leave by 7:30, as it takes an hour to get to work. They eat dinner around 8:00 or 9:00. Maria used to have to work Saturdays, but now she puts in extra hours twice during the week and has week-ends free. The couple holiday at the seaside near her family's home.

Maria thinks she is unusually lucky to have found a job in her own field and to have a mother-in-law who can baby-sit. She says

her husband, who helps her do everything—cleaning, cooking, shopping, looking after Valerio—is an exception among Italian men. They would like another child but not right now.

The power of the Catholic church in Italy is declining but still strong, and the church continues to act as an extremely conservative, restraining influence. It advocates only one role for women: motherhood. All the recent popes, with the exception of John XXIII, have blamed society's problems, from terrorism to the drug trade, on working mothers and the decline of the family.

In its campaigns against birth control, abortion, and AIDS the church offers only one solution: total abstinence, a remedy that all but a few Italians completely ignore. The Italian attitude to sex is delightfully casual. Adultery and the private lives of public figures evoke little interest in Italy, which makes for few political sex scandals.

The church consistently urges women to support the conservative Christian Democratic Party (DC), the party most closely linked with the Vatican. The DC, consequently, has been powerfully represented in all the various coalitions for the past forty years.

Although the DC has been supported by a strong women's vote for most of that time, it has paid the women's movement no more than lip service. It runs few women candidates. It appoints hardly any women to government boards and commissions. In forty years, besides Tina Anselmi, only five women under-secretaries—junior cabinet positions at best—have been appointed to the cabinet.

For years the huge 630-member Italian Chamber of Deputies and the 315-member Senate were only about 7 percent women. In 1987 the percentage rose to 12. Since the country has a system of proportional representation, the big struggle now is to get more women on the party lists and to have them placed near the top so that they will be elected. Although both the Communist and Social Democratic parties have quotas for female candidates, the DC still rejects quotas, although it recently passed a resolution

that 20 percent of party executive positions must go to women—hardly a generous concession.

The Communist party (PCI) with its strong union ties is the biggest Communist party in Western Europe. It has always had a good women's platform and one-third of its elected members are women. Unfortunately, although it's the second biggest party in Italy next to the DC, the PCI has never been able to take power because the DC has always been able to form alliances with smaller parties, usually the Social Democrats. Acknowledging that it long ago severed its ties with the Communist party in the USSR, the PCI changed its name in 1991 to the Democratic Party of the Left.

I was told by an American: "The PCI today has no connection at all with the old-line Communist party. Anyone in the U.S. who was a supporter of the Democrats and Jesse Jackson in the last U.S. election would have no trouble casting a vote for the PCI party in Italy."

Carole Tarantelli Beebe, an elected member of the PCI and a psychiatrist, married an Italian economist who was killed by terrorists of the Red Brigade. She says quotas in political parties haven't worked as well for Italian women as in other countries because unions and business have a great deal of influence about who gets on the party lists. Men also have an advantage over women because they usually have more money. Only the PCI pays for the campaigns of its candidates; in other parties election funds must be raised privately.

Even in local government, where women often find it easier to run, Italian women trail behind other countries, with only a 6.7 percent representation. Italy's first woman mayor was elected in Palermo in 1983. Today only 2.2 percent of Italy's mayors are women, although a woman was elected deputy mayor of Rome in 1989 for the first time.

Most departments in the Italian bureaucracy are bloated with relatives and friends of influential politicians. But Italy's bureaucratic machinery to deal with the "women question" is particularly short-staffed and underfunded, even compared with other countries. There are only ten employees responsible for the

department that looks after women, children, the elderly, and the handicapped.

The department has mostly a reporting function. It keeps the minister of Labour informed about changes in international laws affecting women and about complaints that come into the department from more than one hundred social workers and inspectors in the different regions of Italy. But the department has no power to act on these complaints. It is up to individual women to take their cases to the union or to the management of a company. Without some mechanism like an ombudswoman, as in the Scandinavian countries, or an Equal Opportunity Commission, as in the United Kingdom, women are not likely win. Frequently the woman just loses her job.

Following their experience with the issues of abortion and rape, many feminists were turned off politics as a route to change. Today they want nothing less than fundamental radical changes, and think that tinkering with the current corrupt political system a waste of time.

Instead they work on other problems that need to be tackled in a country where most social problems are left to the church. For example, the church doesn't see that battered women and child abuse are urgent problems. It lumps battered women, if they must have help, in with the homeless and the handicapped. In Milan an office has been set up by a woman's group to offer women advice. The first battered women's shelter was opened in Bologna in 1990.

Italy has the biggest drug problem in Europe. Women in Genoa, Padua, and Naples have set up systems of patrols in the worst areas of the city to fight the problem. The Italian union of metalworkers has established telephone help lines to tell women about their rights in the major Italian cities. In Rome there is a similar line, called the Pink Telephone, instituted and operated by feminists. On March 8, International Women's Day, every year a tribunal helps women with special problems by offering free advice from volunteer psychiatrists, lawyers, and police officers.

If Italian women can work effectively on local issues and the movement was so strong during the 1970s, why, I wondered, is

there no longer a strong, united feminist movement?

The irony is that there was a large women's organization that once was dominant in Italy. For forty years the Union of Italian Women (UDI) was one of the most powerful women's organizations in Europe. It was started by the Communist party after the war to attract women to the cause. In response, the DC started its own women's organization, the Centre for Italian Women (CIF). By the 1970s UDI had more than a million members, and branches in every town and village. It was even self-supporting, owning its own hotels and resorts and staging charity drives to bring in money.

During the 1950s and 1960s UDI had slavishly followed the party line. But in the late sixties, as an Italian feminist movement emerged, UDI underwent a remarkable transformation. In the fight over abortion, UDI actually broke ranks with the party and marched with the feminists. Then, in the 1980s, UDI—and *Noi Donne*, its magazine—completely severed its connection with the party and became an independent feminist organization. And then, inexplicably, it made a suicidal decision to dismantle itself.

Luciana Viviani was one of the women involved in making that decision. I found her in an old, spacious apartment off the Piazza Cavour that had one of the best views in all of Rome. I had expected an elderly, frail women, but Viviani flung open the door with great vigour and shook my hand firmly and energetically. A tiny woman wearing an expensive silk tunic, she was deeply tanned and had short, curly silver hair. Her father was a famous Neapolitan actor and writer. Her husband, a renowned war correspondent, is dead now. She has a son and a granddaughter living in Rome.

Viviani fought in the resistance during the war and later was a member of the Chamber of Deputies for the PCI from 1948 to 1968. She was on the national executive of UDI from 1949 on.

It was at the eleventh congress in 1982 that UDI dissolved itself, she recalled. "The organizational structure was too small a cage. It prevented communication between women. The leaders did all the thinking. Now each group is autonomous and decides what it will do itself. The fact that a group of people with power left that

power—only women would be capable of this," she said fiercely.

Today each group affiliated with UDI decides what issue it wants to work on and what position it will take. On the rape bill, for example, some groups, believing that all laws reflect male values, remained completely outside the debate. The groups meet in Rome every six months, and each decides whether to attend. About one hundred women generally show up. The agenda is set at the meeting and chairs nominate themselves. Four women run the central office, with their terms limited to one year. Each group contributes to the cost of the headquarters.

I asked her how UDI thinks it can change society in its present, much diminished state. She replied that women still live in an unfair, unjust society. UDI doesn't believe in the system at all, or that it can help women, or that it can be reformed. She and her group believe women have to work on themselves by themselves and grow strong with one another.

As a North American, however, I regretted the dismantling of an effective organization for women. I have often talked to North American feminists who want to dismantle large women's organizations and operate with a flat, non-hierarchical system, where all decisions are made by consensus. I think that's fine for small, closely aligned groups with specific agendas, but I don't believe umbrella organizations, which have been quite effective in North America in obtaining some major changes for women, can possibly function in such an uncoordinated way.

The Virginia Woolf group is one of the several small feminist intellectual groups in Italy. It split a few years ago into two branches, each of which regards the other as irrelevant. I met some of the members of one branch at a private club for women that operated in high-ceilinged, princely-looking rooms in an old quarter of Rome.

Alessandra Bocchetti, one of the group's leaders, explained that there are no formal women's studies courses in Italy. Women hold small discussion groups, usually with a professor affiliated with a university. This branch of the Virginia Woolf society explores the relationship of women and their mothers. Bocchetti pointed out that there are no strong female models for Italian

women. "We love our mothers and admire them and then we have to reject them because they are weak. Men, on the other hand, turn from their mothers to strong father figures."

The discussion around this point took up most of the evening. Although stimulating and persuasive, it seemed very remote from the plight of Italian women doing piece-work in their kitchens and pregnant women getting fired.

Paola Bono, a lecturerer at the University of Rome, and co-editor of two anthologies of Italian feminist writings in English, explained why feminists must work alone: "It's important to preserve areas where feminist thought can develop by itself."

Feminists who share her perspective believe the whole of society must change. "Lots of feminists in Italy want to do the same work as men. But women don't want to become men in order to succeed. If I want to be a lawyer, why should I have to become like a man to do it? Why should I lose my feeling of belonging to my own gender and my own body?" Bono asked.

A tenured professor, she is on the board of a feminist political journal and active in a small feminist library and research centre. She has been involved with a man for more than twenty years, but they maintain separate apartments because living together was "the source of most of our problems." She adds: "There are two worlds, and men and women have to find a way of living together. We know all the work of trying to eliminate poverty and achieve equal pay must go on. But we shouldn't be pushed into a cage of only solving practical problems or just working on issues of emancipation. Nor should I be obliged to have children because I am a woman."

On day-to-day problems such as getting more help from husbands and children, she shrugs and says: "If a woman refuses to cook, people in the house will have to learn to cook or starve."

Senator Laura Balbo is still fairly pessimistic. "We're being controlled by more and more sophisticated international mechanisms. Repressive regimes like Reagan's and Thatcher's are dangerous, but a sizeable part of the Italian electorate would vote for a much more right-wing government if they thought it would deal with drugs and abortion better."

I left Italy convinced that Italian women are secure and confident in their gender. Coming from North America, where women have often felt it necessary to turn themselves into pseudo-men to succeed, I envied the Italian women their strong sense of who they are. That they may feel the need to go through a period of profound introspection is understandable for women who have rebelled against such powerful forces and come so far so fast. And I hope that they will unearth ancient female strengths in their determined efforts to develop new insights into our womanhood.

GERMANY, FRANCE, AND BELGIUM—
LIFE WITH THE PATRIARCHS

Germany, France, and Belgium have been major battlegrounds of Europe for centuries. Although women can sometimes make gains during troubled times, as fellow revolutionaries or workers, they are often even more harshly restrained than ever in the political turmoil that follows.

For example, in the nineteenth century France experienced a long period of unstable governments. Women took part in the revolutionary movements of 1789, 1848, and 1871, and many of them lost their lives. After 1871, under the Third Republic, women gained access to schools and professions and the Napoleonic Code was modified. But following that brief period, suffragette organizations in this highly centralized and political society were harshly put down. In Germany, Bismarck, Germany's first chancellor and benevolent dictator, instituted many ground-breaking social reforms, but few benefited women.

France and Belgium are Catholic countries, and in addition to having to battle the church over votes for women and the right to birth control and abortion, French women were lumbered with the oppressive Napoleonic Code.

Class and politics presented additional problems and barriers. Independent women's organizations drawn from the middle and working classes and common in North America, the U.K., and

the northern European countries, were less common in Catholic-dominated France and Belgium and slower to organize. Most of the radical women came from the urban centres. Most of the activity in rural areas centred around the church.

Suffragettes in Germany, France, and Belgium tended to be either enlightened bourgeois women who believed in being non-militant and ladylike, or working-class women in socialist parties and unions. Working-class women had to contend with party and union dogma. All objectives, including feminist objectives, they were told, would be met when socialist parties took power. Therefore they must subvert their goals in favour of the party's priorities. Bourgeois women worked for both the vote and equal rights, particularly in education and training. Although many women also supported legislation regulating hours of work and night work for women, some of them saw protective measures such as maternity leave as handicaps that would discourage employers from hiring women. As a result, working-class and bourgeois women often were at cross purposes, despised one another, and saw no advantage in any alliance.

In France even among the groups working for suffrage there were many splits about what tactics to take, which led to internal fights and public accusations. Since such groups could rarely get together on a common policy or action, male politicians easily ignored them.

In France and Belgium women encountered another problem. Left-wing politicians, traditionally the allies of women's rights groups, were against giving women the vote. They saw women's suffrage as handing thousands of votes over to the local priest. Although fiercely protective of the rights of man, French men took a collective attitude when it came to women. Women were enitled to rights only within the family. Even France's Radical party was stubbornly conservative when it came to women. Feminists dubbed its members "Conservatives who don't go to mass".

Conservative men, of course, as they were everywhere else, were against giving women the vote because they claimed it would bring on all kinds of disasters. Women were too delicate, too spiritual to have their fragile natures sullied by politics, and,

of course, suffrage would sabotage the authority of men and undermine the family. The French political system itself moved tediously slowly. The senate could hold up legislation for years— and it did.

For all these reasons even getting the vote in France took until 1944. For Belgian women the right to vote nationally came only in 1949—making Belgium one of the last countries in Europe to give women suffrage.

In Germany women encountered another problem. Under the Weimar Republic in 1919 women got the vote. In the 1920s they joined the work-force in large numbers and enjoyed a degree of independence such as their mothers had never known. But this freedom scandalized many conservative Germans, who looked on the period as a time of moral decay and a threat to the family.

Possibly for this reason, women in France and Belgium, but not in Germany, enjoy good child care today. In all three countries maternity leave is quite generous. In France and Belgium good child care was put in place not only to help mothers who worked outside the home, but also, particularly in France, to give the state more influence over children at an earlier age.

The main objective behind these measures in all three countries, however, was to increase the birth-rate. From 1870 to 1910 diseases that used to kill many babies were drastically reduced, but even before that time French women had started to have fewer babies. In 1875 the birth-rate in France was 2.59 and in Germany 4.06. By 1913 the French birth-rate had dropped to 1.88—not enough to replace the population. The German birth-rate, on the other hand, had remained fairly high at 2.75. During World War I ten million men died, one for every five minutes of the war. Germany, France, and Belgium all worried about replacing their depleted populations, but France still lagged far behind the prolific Germans.

In 1890, France gave women maternity leave, but without pay, which meant very few of the women, who made up one-third of the work-force, could afford to take time off. In 1911, maternity leave with pay was finally legislated at the insistence of left-wing politicians. Instead of taking more enlightened steps to

encourage women to have babies, harsh laws were passed on abortion and birth control.

In France in the 1920s men got medals for having large families, but not the women. Women were guillotined for having abortions or helping other women get them. In Germany Hitler bribed families with rewards of houses for having many children. As well, he closed birth-control centres and prosecuted seven thousand women a year for having abortions. The birth-rate rose, but it took until 1939 for it to reach the same level it had in the Weimar Republic.

Today the worry isn't about fresh young bodies to swell the ranks of the military, but about rapidly aging populations. There are also concerns about the dwindling supply of future workers to pay for social services such as medicare and pensions. Almost one in three Europeans is over fifty. By the year 2000 two-thirds of the population will be old. The average birth-rate in Europe is 1.58—not enough to replace the present population which would require a birth rate of 2.1.

In Europe today there are twelve million immigrants and their descendants—mostly from the former colonies of France, the U.K., Belgium, and the Netherlands. They are there to do the jobs Europeans no longer want to do, such as domestic work and cleaning. More future workers for Europe could certainly come from those sources, but most European countries are hostile to that plan. In the past twenty years, to encourage women to have more children, more and more countries have been putting in place good child care and maternity leave, and the formula seems to be the right one at last. The birth-rate in France, for example, is now one of the highest in Europe.

Another concern dominating everyone's mind these days is the European Community. Over the centuries many people have attempted to conquer Europe—the Greeks, the Romans, Charlemagne, Napoleon, Hitler. But a united Europe is actually about to be realized by peaceful means as twelve countries— Greece, Italy, Spain, Portugal, France, Germany, Belgium, the Netherlands, the U.K., Ireland, Denmark, and Luxembourg— come together in 1992.

The European Community consists of 327 million people, who produce one-fifth of all the world's goods and services—more than either the U.S. or Japan. By 1992 people of the European Community will use one passport, have recourse to one high court, and probably rely on one monetary system. They may even move to political union in the future and incorporate Norway, Sweden, and the countries of Eastern Europe as additional members.

Although women presently make up a higher percentage of the European Parliament, 16.7 percent, than they do the parliaments in many of the member states, the real power in the European Community is in the twelve-member European Commission, which acts like the cabinet, or the executive, of the community. It is predominantly male, as is the council of ministers (heads of ministries of Agriculture, Trade, etc., from each member country). And of course the European Council, which consists of the heads of each country, is, except when Margaret Thatcher was a member, all male.

As the European Community approaches a single market in 1992, those countries with the strongest trade unions and the highest standards of living are worried that industries may relocate to low-wage countries such as Spain, Portugal, Ireland or Greece, or countries with weak labour and social legislation. Of particular concern to European women is the potential erosion of hard-won social programs. Will the good social services of the best countries be pulled down to accommodate the poorer countries?

Partly in response to this concern, the commission recently adopted a Community Charter of Fundamental Social Rights, with a mandate to attach the same importance to social progress as to economic progress. At the same time the Third Action Program for Women for the period 1991–95 was formulated. It has three main objectives: to consolidate and develop a legal framework to enforce European standards in the member states, to encourage women to enter the paid work-force, and to improve their status through the media and other means.

For some women the European Commission has been a source

of support and strength. Because of it, Britain has had to improve its Equality Commission, and court cases for women that were lost in national courts can now be taken to the European Court, where many decisions have been overturned.

GERMANY:
FEWER KINDER, LESS KIRCHE, BUT CHANGE?

FACTS

Population: Formerly West Germany—61.1 million
Formerly East Germany—16.5 million

Government: Two chambers. Proportional representation. Quotas in some parties.

Vote for women: 1918

Percentage of women elected: 22.5 percent, the highest since 1919.

Education: Coeducation since 1968; 38 percent of university students are women, but only 3 percent of professors are women. The percentage of women judges is 17.6, while 13.4 percent of lawyers are women. There are few women in engineering.

Percentage of work-force women: 38.9 percent; 29.8 percent work part-time. Women earn 73.6 percent of what males earn.

Abortion: 1976 act in the western part of Germany allows for paid abortion under the public health scheme, up to three months for health reasons or if the woman was raped; up to

twenty-two weeks if the foetus is seriously deformed. Consent of a doctor is necessary, and women must attend a counselling centre or they can be fined or imprisoned up to three years. In formerly East Germany abortion is available on demand.

Child care: Kindergartens began in Germany in 1837. Today half are private and half public, but only 3 percent of the number of crèches needed exist. Kindergartens are mostly private, and many only open four hours in the morning, with a break when children go home for lunch, then two hours in the afternoon. Only one in eight is open a full day. East German women, ninety percent of whom work outside the home, are accustomed to much better child care than West German women. Eighty-seven percent of all children over one year of age are in nurseries, and 94 percent of children over three are in kindergartens. Everything is free, but parents have to provide food.

Maternity leave: Six weeks before the birth and eight weeks following, on full pay. Parental leave for either parent up to eighteen months, with 600 marks (U.S. $411) per month as a child-raising allowance. This is adjusted after six months according to the overall income of the couple, which means it can be cut off for the remaining twelve months. About 40 percent get the full benefit, and most women take the full leave. Few men take any leave. Plans are to extend leave to two years and eventually three years. Mothers who see a doctor every eight weeks prior to birth receive 100 marks (U.S. $70) extra. Five days' leave for looking after a sick child is available to either parent. Family allowance of 50 marks (U.S. $34) per month for the first child, 130 marks (U.S. $89) for the second, and 240 marks (U.S. $164) for additional children is provided. Most couples still have only one or two children. East German women get twelve months' maternity leave: five months on full pay and seven months at 80 percent pay.

Birth-rate: 10.5 live births per 1000 population—the second lowest in Europe next to Italy.

Family law: 1977 law allows for divorce after one year with mutual consent, and after three years with no consent. Assets, including pensions acquired during marriage, are split equally. One in three couples divorces, and more and more divorces are initiated by women. Rape occurs in one out of five marriages. Efforts to extend the law on rape to cover marriage have stalled. The reason? Some legislators oppose aborting children of married couples.

Achievements: Quotas in some political parties are helping more women get elected.

Problems: One of the earliest and strongest feminist movements in Europe split into two factions, a division that continues today. Inconvenient school and shopping hours for working women. A very traditional society. Few men help at home. Both East and West German women may lose out in the coming union.

THE BACKGROUND

Germany didn't become a united modern state until 1871, when Bismarck, the premier of Prussia, brought the loose federation of German states together under the Prussian king, William I. Bismarck then became the new country's chancellor. He exiled the Social Democrats but brought in some very innovative legislation for the time, such as pensions, a health scheme, and an industrial code. He also got unions and business to co-operate— an idea that has paid off well for Germany to this day.

Bismarck's legislation for women also set a pattern for the future. Women were to be let off early from work on Saturday—

at five o'clock—so that they could prepare for the Sabbath properly, cooking and cleaning, after a full week's work. Like much future protective legislation, the aim was to get women out of the work-force, even though women were paid less.

United, Germany went through an unprecedented burst of expansion and emerged such a formidable economic and military power that it became a threat to the rest of Europe. This led to World War I. After the war, the Weimar Republic had one of the most democratic constitutions yet conceived, with universal suffrage, proportional representation, civil liberties, and enlightened social welfare measures.

But Weimar was saddled economically with huge debts from the Treaty of Versailles, which had ended the war, as well as an overabundance of political parties, which resulted in twenty-one different coalitions in the period 1919 to 1932. In an economic crisis in 1923, it tried to pay its crippling war debts by printing money, which caused wild inflation. Women carried shopping bags full of marks just to buy the daily groceries. Small businesses, widows, and older people on pensions saw their security melt away.

By 1928 the depression had begun in Germany. A 1928 law decreed that women had to be fired when they married. A small party called the National Socialists, the Nazis, which had been trying to get into power since 1920, began to attract to its black-and-red swastika banner all those people who were disenchanted with the economic situation, including the many men who believed that women had robbed them of their jobs and their virility.

Hitler capitalized on the widespread discontent by promising, in the manner of all populist dictators, to bring back order, stability, and old-fashioned morality, as well to uphold the family and the church and to restore the *volk* (the German people) to their former greatness. Once in power, though, he swept away all democratic institutions, sent women back to the home, and began to purge the country of Jews. His invasion of Poland in 1939 was the beginning of World War II, which ended with his defeat by the Allied forces in 1945.

The first wave

The German women's movement was one of the strongest and most vigorous in Europe in the nineteenth century. The League of German Women's Associations was formed as early as 1865. Spearheaded by professional and middle-class women, it worked hard for women's suffrage.

The other branch of the women's movement was working class, allied to Germany's unions and the Social Democratic party. Clara Zetkin, a woman with incredible energy, who raised two sons and tutored students in Paris to support her family when Bismarck exiled all social democrats, headed up this part of the German women's movement. She persuaded the men in the party to give the women their own organization, unions, and newspaper. But the cost was the suppression of feminism in the interest of pushing socialism. Women were told that their rights and concerns would be looked after when all workers were taken care of.

The two branches of the German women's movement despised each other. The League, appalled at Zetkin's aggressive women's marches, hired eighty tastefully decorated carriages to demonstrate their support for suffrage. Zetkin, who got March 8 designated as International Women's Day—still celebrated every year world-wide—disdained equal rights feminists. She wanted more protection for women workers on the job. The League feared protective measures would cause employers to strop hiring women—an old argument that continues even today in many countries.

In the Weimar Republic women made up 35.8 percent of the labour-force, a percentage not much lower than what it is today. One-third of them were married with children. Urged on by women in parliament, the Weimar government brought in reforms such as unemployment insurance, maternity benefits, and marriage counselling.

To cope with their double load of work, married women in the work-force became superwomen. House-work was organized like an assembly line. Even stay-at-home women had to prove

themselves superior housewives, enlightened mothers, experts at nutrition. In this country of engineers and technology, home-making was professionalized. It never seemed to occur to anyone, of course, that a more practical solution would have been to have men help!

But for young unmarried women in the work-force the Weimar Republic meant freedom and independence. Many of them wore make-up (which was associated with prostitutes) and were sexually active. They practised birth control and had abortions, both of which were illegal. They turned their backs on marriage, since for their mothers it had meant a life of constant pregnancy, never-ending work, and martyrdom. To this day, many Germans still associate women's liberation with degenerate, loose living and believe it a dire threat to the family.

When Hitler became chancellor the iron fist of fascism purged the work-place of Jews and women. Liberation was a product of communism and the "Jewish mentality", he declared. One of the last speeches Clara Zetkin made was to urge the Bundestag not to make Hitler chancellor.

Fascism organized women for the greater glory of the state, relieving them of their double burden as workers and home-makers. *Kinder, Küche and Kirche* (children, kitchen, and church) took over. Women were pushed out of top jobs and professorships to make way for men. Female school administrators and senior civil servants also got the jackboot. A quota of only 10 percent women was set for universities. Couples were given a marriage loan, which was written off if they produced four children. If they had nine children or seven sons, they got a special award. Mother's Day was inaugurated on Hitler's mother's birthday.

The second wave

In the post-World War II period the Christian Democratic party (CDU) ruled for a long period of time. Once again women were only allowed to occupy senior civil service jobs until men could be found for these positions. Anything to do with women was

submerged into programs to preserve and promote the "family".

The Social Democratic party (SPD), the main opposition to the Christian Democrats, came to power from 1968 to 1982. During this period the second wave of the women's movement got rolling. As in so many countries, the major issue for women in the 1970s was abortion. The CDU tried to insist that abortion not be paid under the health scheme, and required all women to undergo compulsory counselling. Women demonstrated *en masse*. Finally the present fairly restrictive act was passed in 1976, which allows abortions, but only if the woman first takes counselling and gets permission from a doctor.

Alice Schwartzer, who is often compared to the U.S. feminist Betty Friedan, started a feminist magazine in the early 1970s. Another feminist magazine, *Courage*, was published from 1976 to 1984. Women opened shelters for battered women, rape-crisis centres, and counselling centres for work, health, and psychological problems. Today there are one hundred forty state supported shelters for the twenty-four thousand battered women a year, although most big cities could use at least one more shelter. One battle German women did not win, however, was making rape in marriage illegal.

Until 1960 there was only one woman film maker in Germany. More women started to make films in the sixties and seventies. In 1975 state-controlled TV was forced to devote some time to women's programming. Now there are more than five hundred women film makers in Germany. With pressure from the women's movement, many other reforms for women were pushed through by the Social Democratic government. Easier divorce with split assets for each partner, and a decree that illegitimate children have full legal rights, including child support, were two of them.

The situation today

You can almost tell that Germany is run by engineers the minute you step into an average middle-class German house. It has a substantial look to it, from the solid brass fittings on the front

door to the chrome-plated catches on the windows. But it's the bathrooms, those shining marvels of moulded plastic and high-tech polished steel, with their hand-held shower heads, temperature-controlled water, and gleaming tile, that depict the German character best. No hanging plants, gold taps or flocked wallpaper here. You feel as if you could hose yourself down, then perform the same function to the whole bathroom, without causing any damage.

Engineering is Germany's leading profession, as it is Japan's, the world's other great exporting nation. Forty percent of the managers of Germany's businesses have an engineering background. Engineers make up 60 percent of the boards of most of the country's biggest companies.

The chair of Women in Engineering, a department of the Association of German Engineers, was dressed, the morning I met him, in a green plaid jacket and a pink shirt, with a pin in the shape of a car holding his tie. Assorted ballpoint pens were lined up in his breast pocket. A woman engineer and a volunteer member of the committee sat beside him. Although her English was markedly superior to his, he insisted on doing most of the talking.

He told me that the Association had been trying to get more women to take up engineering since 1964. "Girls can go directly to university from school," he pointed out, "but boys have to go into the army for fifteen to eighteen months."

He made this comment as if to prove girls already had an advantage.

Then why, I asked him, were there so few women engineers—only 15,000 out of 500,000.

"It's a different culture here" was his complacent reply.

I pointed out that in other professions German women made a respectable showing—nearly half the doctors, one-third of all lawyers, one in six judges, one-third of all architects, close to half the chemists, one-fifth of the mathematicians. But in engineering they made up a miserable 3 percent. This low female representation seemed especially deplorable, given that his organization had been promoting engineering for women for

almost forty years and it is the one career that leads directly to top jobs in German industry.

"The long hours…it's hard to have children and be an engineer," he explained.

Finally, baffled, I said to him: "You mentioned that you have just had a baby daughter. Would you like her to become an engineer?"

He looked shocked. "No. It's much too hard a life. She will want to marry and have children. Statistics show that women engineers have few children. No, it's all right for a son, but not a daughter." He went on to mention that he also wanted to be a grandfather and there was no way he planned to encourage his daughter to pursue a career that would get in the way of this objective.

The woman beside him, who had been looking more and more frustrated throughout the interview, seemed about to say something. She stirred in her chair, glanced out of the window, but then gazed mutely down at her hands.

Even more than in most European countries, in Germany there seems to be almost no middle road for women. They either follow a long historical tradition of working hard, doing what they are told, and hoping for small gains while men run things— or they rebel completely.

West German women make up only 38.9 percent of the work-force—a surprisingly low percentage for such an industrialized, highly educated nation. One reason might be that Germany is even more highly industrialized than the U.S. or Japan, with big exports in cars and tool making. In this traditional country those jobs are men's jobs. Germany's service sector, usually a big employer of women, is smaller than the U.S.'s. And in Germany you still see quite a number of men behind bank and post-office counters.

Life is not easy for West German women. In spite of Germany's prosperity, there is less child care than in Sweden, Denmark, the Netherlands, Belgium or Italy, and in social programs as a percent of the GNP, it ranks down among the middle of European nations.

Schools start at 8:30 in the morning and send children home at 2:00 in the afternoon, when mothers are supposed to take over and supervise their homework. If a woman works outside the home, she has to scramble to find after-school care. Dr. Renate Mohrman, professor at Cologne University, says she owes her Ph.D. to the fact that her husband was transferred to the United States while her children were small. She could study during the day. In Germany that would have been impossible.

For the one- to three-year-olds there is hardly any day care. Kindergartens for the three- to six-year-olds operate only half a day, and are not in every town—although politicians complacently predict there will be enough spaces by 1995 because of the declining birth-rate. The government offers a subsidy for each child if a company puts in child care.

Only one-third of women with children under three work, because Germans openly looks down on women in the work-force with small children. "Raven mothers", they are called. Politicians still say: "Alcohol and drugs come to the back door when women go out the front door to work." A member of the cabinet who recently suggested child care should start at age two was criticized, predictably, for "undermining the family".

A day in the life of...

Clara T. is a graphic designer who lives on the outskirts of Frankfurt. Her husband, Rolf, is a middle manager in a small family-owned woollen goods factory, and earns 3,200 marks (U.S. $2,300 a month). They bought their house with help from both their parents for 300,000 marks (U.S. $216,000) when their son, Max, now three, was born. It's a two-bedroom row house, with a small efficient kitchen and solid, modern furniture in the living room, which also features a large fish tank and several soccer trophies, testaments to Rolf's two hobbies.

When Max was born Clara took a year off, but found it difficult to get help when she went back to work. Working wives are discouraged by the Christian Democratic government, which taxes the combined salaries of couples, often tipping them into a

higher tax bracket. Clara and Rolf decided it wasn't worth her working at all while Max was small.

She managed to find some free-lance jobs to keep her hand in her profession and went back to work when Max started kindergarten. Even now she finds it a terrible pressure to get him to kindergarten at 8:30, then back at 12:30. She has employed a Greek woman, who comes in to look after him until she gets home. These arrangements, plus the taxes, take up a good part of her 2,800 marks a month salary (U.S. $2,017). Even when Max is in school full-time he, like all other German children, will get out at two.

She feels terribly stressed, but doesn't blame Rolf for not helping more. "His job is extremely pressured," she says. When he gets another promotion Rolf wants her to go back to part-time work, have another child, and do more entertaining to help him in his career.

Although she is not a feminist, she admits her life is much improved over that of her mother, who still cooks two hot meals a day—one for Clara's grandfather, who lives at home, and one for Clara's father at night. Her mother does a lot of ironing and washing and refuses to use a dryer, insisting on hanging her clothes outside. Clara's younger brother, who is away at university, sends his clothes home to be washed, ironed, then sent back by his mother.

Clara says frozen foods are not nearly as plentiful as they are in North America and Germans look down on them. Even German cake mixes require additional eggs or butter. Women, whether they work outside the home or not, are still supposed to do all their own house-work.

Shops close at 6:30 at night and 2:00 on Saturday. On Thursdays they stay open until 8:30, and on the first Saturday of the month until 6:00 P.M. In summer they are open till 4:00 P.M. Any suggestion that they stay open longer is opposed by the unions and the ruling Christian Democrats. The reason? Women have to get home to their families.

Today highly unionized German workers are well paid and formally trained for many jobs that North Americans expect to

·learn on the spot. Workers go to school or are apprenticed for two to eight years to learn to be shoe clerks, waiters, bakers, tool makers, and plumbers. Labour disputes are still generally settled through a loose system of consensus between unions and management and over months of meetings. There are few strikes and little room for North American-style tycoons like Lee Iacocca.

Contrary to popular belief, Germans, who top the world in exports, are not the world's most industrious workers. With all the long holidays they receive, they put in an average of only thirty-three hours a week, while U.S. and Canadian workers put in thirty-eight, and the Japanese forty-one. Germans are well informed—a result of their no-nonsense schooling and their dull, educationally directed, publicly owned TV. They rigorously attend lectures and read papers, magazines, and books.

Germans are sticklers for rules. "It takes ten forms to do everything," a Canadian friend told me. Some of their laws would horrify a North American. It's illegal to squeeze tomatoes in markets. Lawn-mowers can't be operated between noon Saturday and Monday morning. Children can only be called names that are on the official register.

With its careful affluence, its shops crammed with solid, quality goods, the western part of Germany has the highest rate of consumption in Europe, especially for cars. Yet Germany is still a nation of savers, domesticity, and conservatism. National habits haven't changed, which for women means a special hardship. It's as though the past fifty years haven't happened. The myth that every women is home cooking wiener schnitzel not only for dinner, but for lunch still prevails, and even has some basis in reality. German men often come home for a hot meal at lunch, and some banks and post offices close at noon.

Although German women frequently have the same or better qualifications than men, under such difficult conditions a high proportion of women—close to one-third of those who work—take part-time jobs. One-third of these don't put in enough hours to qualify for benefits. Lately, more and more employers are opting for home-based work because there is no overhead for them and no benefits to pay.

The 33 percent gap in the wages of men and women is one of the biggest in Europe, and women have made little progress in breaking into top jobs. Up until 1987, even in the civil service, where women make up half the labour-force, there was only one woman director-general. Now there are two. In universities, where women used to comprise 4 percent of the professors, now it is only 2 percent, according to Dr. Frigga Haug, political scientist and author. "The old boy's network works very well," she said bitterly.

Only 1 percent of business executives are women. Women are not part of those cosy lunches and dinners where unions and business work out their compromises. Although two-thirds of German society enjoy a high standard of living and pay higher taxes for their superior social services than they would in the U.S., women, immigrants, and old people make up the bottom third of the economic pyramid. "For old women and single parents the situation hasn't changed since the 1930s," says Dr. Haug. "In fact, there are fewer women in the political and public sphere than there were after the war. Women are not part of the system and are not powerful. They could be extinguished from one day to the next."

A few younger men say they don't want to be like their fathers, whom they rarely saw. Some of them even take parental leave. A few young women I talked to said their husbands helped, but they all admitted there is no such concept as a "house husband" in Germany. The majority of German men, judging from recent polls, don't help in the home at all.

Some German scientists in the past, particularly under Hitler, made a case for the biological—and inferior nature—of women. Today much is still made of the revered role of mothering in German society. But public behaviour belies this sentimental attitude. I saw a young mother getting off a train with a baby in a pram, a toddler, and a lot of parcels. Several businessmen hurried past her. Finally one of them stopped to help her get the pram down from the train, then hurried off. It was another women who carried some of the parcels and took the little boy's hand. My taxi-driver, a strapping man young enough to be my son,

picked up the smaller of my two bags, leaving me to carry the heavy one.

A young Canadian woman living in Bonn told me that although she holds down a high-level media job, a man who phoned her recently demanded to speak to her boss. "There must be a man over you," he told her curtly. A man she dates, who is also in the media, felt quite heroic when he ironed his own shirt for the first time in his life. In their relationship his job is all important. He ignores the fact that her job is senior to his and never asks her about it. He also assumes that she won't mind performing errands and services for him. "He says he wants to marry—but he makes it quite clear that I'm not his idea of a suitable wife. He told me, 'I need someone to organize me.' The trouble," she concluded, "is that a lot of German women still fall in with this kind of attitude. *Kinder, Kuche, Kirche* lives on."

As in other Western nations, the population in Germany is getting older, and to the horror of politicians, the German birth-rate which had always been higher than France, is now the second lowest in Europe Many of whatever reforms have been brought in for West German women have more children as their motive. The family allowance was doubled in 1985, and for each successive child a larger amount is paid. Parental leave has been extended to eighteen months for either parent. Women get an extra 100 marks (U.S. $70) if they see a doctor every eight weeks during pregnancy—which accounts for the low number of premature births. In spite of these measures, many couples stubbornly have only one child, possibly two.

In this chauvinistic society one of the burning topics is whether girls should be educated in separate classes for math and sciences. Although coeducation has been in existence since 1968, studies show that teachers still give two-thirds of their time to the boys. A tiny 3 percent of schools are all-girls schools, but 40 percent of girls who go into chemistry and engineering come from those schools.

A related problem that concerns women teachers in particular is the bullying attitude of boys towards girls, which is often condoned by male, and even female, teachers. Inge Wettig-

Danielmeier, a member of the Social Democratic executive committee and chair of the women's committee, told me violence in schools is accepted as normal. If a boy "beats" a girl, the teachers try to find out why he did it, bu they don't stop it. As the mother of two teenage girls, she says the pushing and shoving is far from the kind of friendly rough housing that might occur in any school. It's her view that the boys really try to hurt the girls.

When asked why teachers don't put a stop to this behaviour, she said the male teachers are "conservative", and female teachers "don't want to hurt the boys". She says even if teachers give exactly equal time to both boys and girls, the boys complain that the girls are being favoured. She says she still believes in coeducation but thinks the girls should be separated from the boys for science and have separate discussion groups in some subjects.

I was, frankly, shocked. If girls don't learn to cope with boys and vice versa in school, where are they going to learn? And in 1990, why are Germans tolerating such blatant discrimination in schools? A woman teacher who wrote on this subject for *Emma* magazine was criticized by her colleagues and even by many of her female students. She has since left the school because of the unpleasant atmosphere.

In recognition of the belligerence and danger women live under, specified parking spaces in underground garages are designated for women in Dusseldorf. Women can also book special women-only couchettes on certain trains.

In this rampantly chauvinistic society you would think a strong women's movement would be called for. But the movement is split between the middle-of-the-road German women's movement and the autonomous women's movement.

Deutscher Frauenrat is one of the biggest umbrella women's organizations in Europe and includes most of the large German women's organizations, representing an impressive ten and a half million women. It dissolved itself rather than become a Nazi organization under Hitler and started up again after World War II. With a staff of seven, it puts out monthly publications, holds seminars, and lobbies for women. It worked to get a clause on

equality into the constitution in 1949. A recent campaign was aimed at changing the law so that women could retire at sixty-five, as men do, instead of sixty. Because of early retirement and lower wages to begin with, most women pensioners live on less than 900 marks (U.S. $648) a month, while men's pensions average a third higher. The CDU is opposed to any change to pensions. Only recently did it allow women credit on their pensions for years taken out to raise children—a practice that has been standard in many other countries for years.

The issue of abortion continues to be a problem in Germany. In the west the restrictive abortion law is constantly being challenged as being too lenient. Recently in Bavaria the police raided a doctor's files and charged 156 women who had had abortions after the legal time limit. They were paraded through the courts one at a time. This charade stopped when it turned out that one of the five judges presiding over the cases had obtained an abortion for his girl-friend. Nevertheless the doctor was sent to jail for two and a half years and barred from practising for three subsequent years.

It is illegal to go out of the country for an abortion. In the spring of 1991 several women were detained by the border police, forced to have examinations and charged with having abortions in Holland. In what was formerly East Germany women still are able to get abortion on demand, at least until 1992 where a new law will be passed.

Unfortunately Deutscher Frauenrat hasn't been able to take a stand on reform of the abortion law because it can't reach a consensus itself. It works to promote legislation against rape in marriage and sexual harassment in the classroom and on the job. Hanne Pollmann, the executive director of the organization, says sexual harassment in the civil service is particularly bad and women have been terrorized for years.

Many German feminists scorn Deutscher Frauenrat as too conservative. They prefer to devote their energies to the auto-nomous women's movement, which consists of grass-roots organizations that want nothing to do with the government, political parties or other patriarchal male-run, status-quo institutions.

The autonomous movement is responsible for setting up and running two-thirds of the battered-women's shelters, most of the rape-crisis centres and therapy groups, and providing employment counselling, re-training, help for single mothers, and co-operative housing. For example, autonomous women in Berlin opened a Turkish bath and a café for immigrant women who felt isolated and needed a place to meet one another. It also organized all-women patrols in areas where rapes had occurred. Many of these projects now receive public support and money. Feminists fear that this intrusion by the state will cause the women working in them to be less radical.

In Hamburg there is a feminist university and a women's section in an old publishing house, Das Argument, which is run mostly by women and financed by the books sold. All the women who work there or write for it are volunteers and hold other jobs to support themselves. Any money that is made goes into new books.

"Women still turn out to hear about the women's movement," Frigga Haug says. "But the energy that was there in the 1970s has vanished. There is no organized women's movement in Germany as in North America." She says many young women today say they're not part of the movement and that they don't need it. "But they do. Although women are everywhere now, German society and men haven't changed. Although sexist language has been cleaned up, there hasn't been much change in textbooks or in computer or technical courses. Women can keep their own names when they marry. They can dress more informally. They can travel and go to night-clubs alone, have children on their own, and live in all-women communities. But this only happens in big cities—not in the more conservative Bavarian or Schwaben areas."

In this conservative society, there is a feminist political party, Frauen Partei, but it doesn't poll the required 5 percent of the votes to get any candidates elected. It's not surprising that the Green party, which dedicates itself to the environment, feminism, and peace, found support and flourished first in Germany.

The headquarters of the Green party in Bonn is a big, high-

ceilinged house decorated with avant-garde posters emblazoned with slogans such as Nuclear Power—No, Thanks, and Green Grows Best Along with Women.

The party's women's policy is that women must have economic independence above all. Women, including single mothers, must be free to pursue full careers with enough support to provide proper care for children. The party is for state-supported child care, longer maternity leave, more generous family allowances, and free access to abortion. The Green party also supports a shorter workday and week for everyone. It started quotas by insisting women comprise half the candidates on both election lists and the executive. Two-thirds, or twenty-nine out of forty-four, of the Green party's seats in the Bundestag were occupied by women. But although it had 6 percent of the members in the Bundestag in the old West German parliament, in the first election of united Germany in December 1990, the Green party polled only 4.8 percent, which was below the 5 percent minimum needed for representation in the Bundestag. But it does survive in most state governments, as well as in several town councils.

Germany's constitution, which was adopted after World War II, calls for proportional representation, but it differs from other countries in that each voter gets two votes: one for the party and one for the local candidate. The number of votes the party gets determines the number of seats it gets. But voters can influence who is elected by their individual votes.

The SPD has adopted a quota for women candidates, but it is a depressingly gradual one. It is aiming to have 20 percent of its members in the Bundestag and 30 percent of the party executive female by 1995. "If they ever get into power, they'll probably find some way to avoid carrying even this out," one female member of the party complained. The SPD did poorly in the first election for a united Germany.

The Christian Democrats were said to be considering quotas before the two Germany's were united, but that might now be postponed because there are so many other problems to consider.

The Bundestag now has its first woman speaker, Dr. Rita Sussmuth. But compared with other countries that have had

women's departments for twenty years or more, once again Germany has been slow. A woman's division in the Ministry of the Interior was set up in 1950, and another established in 1972 in the Ministry for Youth, Family, and Health. In 1979, a women's ministry was set up and the directorate was enlarged. But it's still small compared with other countries—37 employees. Dr. Hanna Beate Schoppe-Schilling, director-general, occupies a modest office in a grey marble monolith on Kennedyallee housing the Federal Ministry for Youth, Family, Women, and Health.

Dr. Schoppe-Schilling, who says her budget for research has more than tripled since 1986, carries out studies on battered women, homeless women, stereotyping and sexism in advertising, women's employment, and re-integration of women into the work-force after child raising. The department has the right to early participation in all new legislation—for example, it was consulted on changes to social security. In the future, the plan is that each ministry will have its own monitoring unit for women.

Some of the eleven West German states (Länder) have women's ministries, but none of them has elected a woman president. Equal opportunity commissions have been springing up lately like mushrooms after a rainstorm, around 460 at the federal, state, and local level. Their job is to tell women about their rights in the work-place and encourage them to complain about discrimination. In the five new East German states there are about 130 equal-opportunity offices and more than twenty shelters for battered women. But unless some enforcing mechanism for this new system is instituted, it probably won't do any more good than it has in other countries, except to provide jobs for some women.

More impressive is the fact that North-Rhine-Westphalia has put in an affirmative action program that appears to be quite effective. Women are to be given a priority over men in the civil service—if they have equal qualifications— until they comprise fifty percent of the employees. However, there is still a catch: who will make the decision on "equal qualifications"?

Both Professor Mohrman and Dr. Schoppe-Schilling told me that many women hold feminist ideas but don't want to be

labelled feminists, because in Germany the term is associated with a radical, man-hating image.

The European Community has been a great spur to countries like Germany and England, which have been retrograde in their treatment of women. Between 1975 and 1978 three directives on equal access to jobs, equal pay for work of equal value, and social security have forced the German and U.K. governments to pass legislation.

Today much of Germany's energies are taken up with the problems of re-unification, and Germans themselves, as well as other Europeans, feel some uneasiness. The idea of a united, powerful Germany with more than seventy-seven million people is daunting to some of Germany's ancient enemies and nearby neighbours. The knowledge that its neo-Nazi Republican party gained 7 percent of the vote in the Berlin senate election in 1989 is also disquieting.

For women there are additional concerns. Ninety percent of East German women work outside the home, but less than half of Western German women have paid work. The textile and food-processing factories where East German women worked were some of the first to be closed. Many people in former East Germany who had held government jobs such as school-teachers, police officers, and bus drivers are being vetted for their political connections.

Eight out of ten children under the age of three are in child care in the former eastern part of the republic. In the west less than 2 percent are in child care. In the east 82 percent of children between the ages of six and ten have after-school care, but in the west it's only 4 percent. In the east people marry more frequently and divorce more frequently. A lot of single mothers depend on child care.

West German women fear that their newly found lever to political power through quotas may be lost in re-unification. East German women who have had free access to abortion since 1972 fear the new abortion law may be much more restrictive.

Article 31 of the Unification Treaty pledges to improve equal rights and help both men and women combine their careers with

having a family. It also says the government will maintain child care in the five new states until the middle of 1991. New legislation on abortion is supposed to be passed in 1992. Meanwhile, counselling centres have been set up in the five new states.

In such turbulent times there is little reason to believe that the concerns of German women, which have never been at the top of the agenda in the past, will get much attention. It's much more likely that German women will once again be asked to lower their expectations, as they have had to do so often in the past, and be patient.

FRANCE—
THE MOST DIVIDED
WOMEN'S MOVEMENT
IN EUROPE

FACTS

Population: 56.5 million

Government: Upper and lower chamber. No quotas.

Vote for women: 1944

Percentage of women elected: 5.7 percent in the National Assembly and only 2.5 percent in the Senate.

Education: Schools segregated by sex until recently. Today there are more women than men in higher education.

Percentage of work-force women: 42 percent—23 percent part-time. Women earn 80.76 percent of what men earn.

Abortion: Up to twelve weeks the decision is up to the woman. After twelve weeks, a doctor's consent is required and there is a one-week waiting period. Girls under sixteen must have the consent of a parent. Abortions cannot comprise more than 25 percent of surgical procedures in any hospital. Since 1984 abortions are covered by the health scheme. France is one of the few countries in which the abortion pill RU-486 has been available since 1988.

Child care: Child care in France is excellent, mainly because the government wants to raise the birth-rate. Care for small babies is hard to find, although there are some publicly supported crèches. Most parents use private services and half of these aren't registered. But by the age of two-and-a-half, if there is room, and certainly by the age of three, almost all children of working mothers are in state-supported child care (*écoles maternelles*) from 8:30 A.M. to 4:30 P.M. Child-care costs are deductible from income taxes.

Maternity leave: Eight weeks' leave before the birth and ten weeks after, with 84 percent of the salary paid by the state. Parental leave until a child is three, either part-time or full-time, is available without pay. Women can take one hour a day off to breast-feed until a child is one year old. Family-allowance benefits are generous and increase with each child. After three children, either parent gets six months off with 90 percent pay. A special birth allowance is given if the mother attends a pre-natal clinic three times while pregnant. Time spent at home looking after children counts (up to a maximum of two years for each child, with a limit of nine years) towards pensions. Infant mortality and premature births are among the lowest in the world. There is no law granting leave to look after sick children, but 44 percent of all union agreements have provisions for it.

Birth-rate: 13.8 live births per 1000 population, one in five to unmarried parents.

Family law: 1985 divorce act splits the assets of a marriage evenly. One in three marriages ends in divorce. Forty percent of child support payments were not being paid, but under the 1985 law, the salary of the delinquent parent may be garnisheed.

Achievements: A long history of women fighting for their rights that dates back to the French Revolution. Some of the best child care and maternity leave in the world. Children are supported regardless of the living arrangements of their parents.

Problems: Hampered through history by the Napoleonic Code, which gave men all rights over women. A political system that is difficult to penetrate or change. Since the early 1970s the most divided women's movement in Europe.

THE BACKGROUND

Privileged women with property, mostly widowed or single women, could vote locally in France from the Middle Ages on. During the French Revolution women were present and active at the storming of the Bastille and in the bread riots of 1789. Olympe de Gouges, a playwright and revolutionary, wrote *The Declaration of the Rights of Women and Female Citizens* in 1791, a full year before Mary Wollstonecraft wrote *A Vindication of the Rights of Women*. For her trouble, Olympe de Gouges was guillotined in 1793 for "having forgotten the virtues of her sex". The Jacobins rewarded women for their help by declaring women's clubs illegal. The Napoleonic Code of 1804 gave men absolute power, while women were classed as legal incompetents.

The 1800s in France were politically very unstable, with eleven different constitutions between 1790 and 1890. Radical organizations were policed and censored, and often members were imprisoned. Long after boys got state educations, girls were educated by nuns, who trained them to be docile and obedient to their husbands and the church.

Yet French women have always worked, at first mostly in agriculture and later in manufacturing. The French government passed a restrictive law in 1892 to try to force them to stay home and have children or to take only low-paid jobs. Women fought back with strikes but finally had to accept their position as secondary workers.

The first wave

France has been called the intellectual birthplace of feminism. But practical results have been hard to secure. French women were to spend one hundred fifty years fighting both the left and the right political factions before they even got the vote.

As in the French Revolution, women were active in the revolution of 1848, and afterwards started agitating for more rights. One woman tried to stand for election and was imprisoned for her impudence. By the 1860s a small group of middle-class women were cautiously campaigning for the vote. The government forbade them to meet. In 1876, Hubertine Auclert refused to pay taxes until enfranchised. She started Suffrage de Femmes and a feminist paper. The government confiscated her furniture.

Although several men were active in the movement in the beginning, women couldn't even depend on their natural allies, the socialists, for help because the socialists believed the church would influence women voters too much. In 1895 women gained control over their own wages, in law, in the National Assembly, but it took another twelve years for the bill to be enacted because the Senate wouldn't give its approval. Married women in France were among the last women in Europe to achieve control of their own property.

Marie Vérone, who came from a poor family and became a lawyer, carried on the fight. A suffrage bill introduced in 1901 was allowed to die without even being debated. The National Council of French Women was formed out of forty organizations in 1901 and then taken over by feminists. But a march and a symbolic burning of a copy of the Napoleonic Code fizzled when more police turned up than women. Most women believed in working within the system and abhorred the militancy of Auclert, who broke into a polling booth and upset the ballot boxes in the 1908 election. French women persisted with ladylike petitions in spite of the fact that such tactics hadn't worked in other countries.

Before World War II the movement had fifteen thousand members, and women actually believed the vote was close. But war broke out and everything stopped. In 1919, after women had won the vote in most of the Western European countries, another bill was introduced, but after stalling for three years, the Senate rejected it. Marie Vérone, watching from the gallery, loyally shouted: "Long live the republic all the same." She was forcibly evicted by the guards.

In 1936, under Leon Blum's Popular Front government, three women were made under-secretaries in the cabinet. Women were allowed to open bank accounts, enrol in schools, and get passports without first obtaining their husbands' consent. Finally, in 1944, French women got the vote by an edict under de Gaulle. In 1945, thirty women were elected to the 545-member Chamber of Deputies.

In 1949, Simone de Beauvoir published *The Second Sex*, a ground-breaking analysis of the position of women. But at the end of the book she asserted that she was not a feminist. She believed women's liberation would come about through socialism.

Even when Planning Familiar (Planned Parenthood) was organized by male doctors and women in 1958, they had to emphasize family planning, not birth control, to get the approval of authorities. When birth control finally became legal in 1967, only the educated classes knew about it because advertising and giving information about it to teenagers was illegal. It was 1974 before it was legal for doctors to propose it and not just wait for people to ask for it.

The second wave

The modern women's movement in France grew out of the student movement of the sixties and the Paris *mobilizations* of 1968. Women found that they were expected to be the lackeys to male leaders and they revolted. The first action that grabbed the attention of the media was the laying of a wreath to the memory of the wife of the Unknown Soldier, at the Arc de Triomphe in

1970. Located in the middle of Paris, the tomb is one of France's most revered shrines, a symbol of war and the male order. The public was scandalized.

But the issue that really mobilized French women and brought them out into the streets to demonstrate by the thousands was abortion. In 1971, 343 women, including celebrities such as Simone de Beauvoir (who now was a declared feminist), actresses Catherine Deneuve and Jeanne Moreau and writer Françoise Sagan, declared that they had had abortions, then strictly illegal in France. They defied the authorities to arrest and charge them. This action was copied by women in many other countries.

The Bobigny case dramatized how unfair the law was. A poor single mother was on trial and threatened with prison for trying to obtain an abortion for her teenage daughter. Meanwhile, wealthy women flouted the law by getting abortions in Switzerland. To show what a farce the law was and to shame the authorities and shock the public, busloads of women left for Holland to get abortions, the buses plastered with signs announcing their destination.

In 1975, under a conservative government, women forced the government to finally legalize abortion. A bill was successfully introduced by the minister of Health, Simone Weil, who, over shouts in the house that she was a Nazi, argued that civil order was threatened, since the law was being broken daily. In 1974, under the same government, a small office for women, with a tiny staff and budget, was established to deal with women's issues.

The situation today

L'amour confronts you everywhere you turn in Paris. A young couple are locked in each other's arms on the bank of the Seine on a cloudless day in June. Oblivious to passing boats and gawking tourists on the Pont Neuf, they cling to each other as if they are about to be parted forever.

On the Métro, an older man with a worn briefcase gently caresses the bony knee of a much younger woman, who cries and pleads with him inconsolably as they sit huddled together on the

fold-down seats amid the late-afternoon rush. On Boulevard St-Michel a young girl in a leather miniskirt curls her body towards her companion, an insolent-looking young man, thumbs hooked through his belt, legs spread-eagled, and a fuck-the-world expression on his face that some women seem to find irresistible.

French men have long celebrated women as decorative objects. Bare-breasted statues hold the lamps around Place de L'Opéra. More modestly clothed matrons representing Wisdom and Justice ring the Place de La Concorde. Modern versions of this glorification of the female form emblazon every billboard and TV advertisement—most of them blatantly sexist.

Women dress up in Paris as they do in few other capitals. They wear elegantly tailored suits with cleverly placed pins and scarfs. My North American tourist gear of slacks, a raincoat, and running shoes, which had felt perfectly all right elsewhere, seemed gauche here. In self-defense I bought a bottle of perfume.

French feminists consider the time-honoured tradition of glorifying the female body a hoax on women. Activist Simone Iff says: "France men are romantic but also traditional. Love is a trap. Women in France spend a great deal of time dressing and working to please men." Simone de Beauvoir herself said: "Love can be a trap that makes women accept many things." And she was very much against the romantic cult of motherhood and an emphasis on the biology of women. Anne Zelensky, a friend of Simone de Beauvoir's, thinks the French emphasis on sexuality is one of the root problems of French feminism even today. "The tradition of French women as coquettes is a manifestation of the divisions between women. Sexism and naked women in advertising are an attempt to deny what women have achieved."

Women students from North America are often offended by the male chauvinism they encounter in France. "Men hold doors open for us but ignore what we say in class," they protest. They are also struck by the constant harassment of women wherever they go.

Not surprisingly, *feminist* is a bad word in France. Young women avoid it. And the concept of sisterhood, which North American feminists celebrate so joyously, is glaringly missing.

The only issue, I was told, that would still instantly unite women would be any attempt to curb a woman's right to control her own body. Today there seem to be almost as many divisions in the movement as there are French feminists. In the 1970s the movement actually broke out into a highly visible, much written about war, with screaming denunciations and public insults from the various factions.

To North Americans French feminism has always been more theoretical than practical, with much emphasis on the unconscious and the need to connect with the body. Many different groups have formed to focus on these concerns. MLF, for Mouvement pour la libération des femmes, was a loose term that the press gave to all these groups. Some were politically oriented. Others worked on women's centres, papers, and magazines. Still others concentrated on theory. But they all took pride in their lack of hierarchy, despite the media's insistence of feminist "stars". As early as 1971 one of the groups that clearly set itself apart from the others was Psychanalyse et Politique (Psych et Po), which had as its leader Antoinette Fouque, a charismatic psychoanalyst.

Psych et Po, based on the teachings of psychoanalyst Jacques Lacan, believes that little girls are programmed into patriarchy and that women must turn inwards to search for their own long-lost sexuality. In their zeal to promote their ideas, Psych et Po declared war on all other feminists, disdainfully labelling them "bourgeois". On the other hand, some opposing feminists feel Psych et Po's ideal woman is uncomfortably close to the revered model that has been used to keep women subservient to patriarchal ideals.

This split would have remained unremarkable, since there have always been competing theories among feminists, except that one of Fouque's clients was a wealthy heiress who turned her entire fortune over to Psych et Po. In 1972 Psych et Po founded a publishing house, which produced British, German, and U.S. feminist works, although not the work of other French feminists. In 1974 Psych et Po opened bookstores in Paris, Lyons and Marseilles, and began publishing a magazine.

Doris Anderson

The loose organization and the disdain for leaders that existed within the MLF left a power vacuum that Antoinette, who was in the habit of using just her first name only, was only too happy to fill as the self-declared leading advocate of the feminist movement. In October 1979 she legally registered the name of her organization as Mouvement pour la libération des femmes— MLF, which meant no other group could use it. Psych et Po began publishing anonymous feminist works as though officially those of the movement.

The factions still exist, but the whole affair has been so well aired and written about that most people, including the press, understand where the different groups stand. Today Psych et Po is far less important, although it still runs its magazine and bookstores. But the war between the groups sapped the energy of the French women's movement. The media covered only its conflicts. In the meantime feminists found it almost impossible to move on to other more important issues. Today any group's initiative is often interpreted as another power play, which still tends to immobilize everyone.

Maya Surduts was in the thick of the conflict. A founder of Maison des femmes, a Paris centre for women that showed films and held lectures, she says that many groups used the centre, although Psych et Po was barred. Staffed by volunteers, the Maison des femmes depended on help from the different user groups to keep it going. But the different groups often didn't turn up because they were afraid of ideological clashes with other groups. The centre finally had to close.

She says a lot of women today claim they made it on their own without any help from feminists. Young women ask: "What's the problem?" Many French people today don't believe in being active either in politics or in trade unions. A lot of them are convinced that change will only "be the same" and activism is pointless.

Says Maya Surduts: "The weakness of the French feminist movement is the lack of tolerance women have for one another's opinions. It's very French and traditionally Jacobinistic. Everyone knows better than everyone else. Besides, there are a

number of things already in place for women. There is good public health. The public health in the U.S. by comparison" [where Surduts worked in the 1960s, fighting segregation of the blacks] "is shitty. Child care and maternity leave are also good in France. The public service is pretty good for women. They can sit for exams to be judges and for places in the bureaucracy and win."

Surduts points out that in countries such as the U.S., Holland, and Germany, women had to organize alternative movements to help women deal with health issues. But that wasn't necessary in France, where the government, anxious that French women have more children, was responsive to their demands for child care. But the side effect has been that apart from abortion, no other issue has served to unify the French women's movement.

Anne Zelensky, who was one of the early feminists, says she doesn't believe a united women's movement in France was ever a possibility because characteristically the French are full of contradictions. Although she doesn't regret the past twenty years, things have moved much more slowly than she had hoped. "Because of feminism we have many new laws. Now we need to get those laws applied," she warns. "Society always resists new movements such as the women's movement. Historically society swings forward, then back. History has its own rhythm and life its own rhythm, and they don't coincide. The women's movement is at a standstill now. It's as though we've all had a big dinner and we need time to digest it."

A day in the life of...

Marie L., thirty-two, is a young clerk who is married to Maurice, a mechanic. They have two children.

She grew up in a family of five in a small town outside of Paris, where her father was a baker. From the age of two and a half she was educated in a local Catholic school by nuns.

At eighteen she moved to Paris to live with her married sister, who helped her find a job as a secretary in an export company. She eventually got her own place, a small room with a heater and

a shared bath but no cooking facilities, for 500 francs a month.

She and Maurice had a small wedding in Paris that "disappointed my in-laws". They then moved into a studio with a kitchen and private bath. One month later she was pregnant with Michel, who is now ten. A friend told them about a two-bedroom apartment for 1500 francs a month, which was very cheap.

When Michel was four months old Marie found a woman to look after him and went back to work. She would have preferred to put him in a public crèche, but there was no space, even though she had signed up before he was born. At three he went into the state child care and she went to work at her present job at a family-planning clinic.

Three years ago her daughter, Florie, was born, and the family moved into a subsidized three-bedroom apartment with bath and kitchen, for which they pay a very reasonable rent of 2,400 francs (U.S. $486).

Both she and Maurice earn 8,500 francs (U.S. $1,724) a month. After pension, hospitalization, and unemployment insurance are taken off she has 7,000 francs (U.S. $1,416). She has to be at the nursery exactly at 8:40 or they won't take Florie for security reasons. At night she must leave work at 4:00 PM to pick her up at 4:40 or she has to wait until 6:00, again for security reasons. Since both she and Maurice have a hot meal at noon they eat lightly at night. Maurice used to get home around 8:00 P.M. and rarely saw the children, but now he works closer to home and gets home between 6:00 and 7:00 P.M..

On Saturdays Michel goes to school and the couple shop and clean the house. Maurice usually vacuums and makes the beds. (A recent survey revealed that French men do only six more minutes a day of housework than they did twenty years ago.) On Sundays they seldom attend church, although there is one next door. Instead they take the children to a nearby park or to the Luxembourg Gardens, where there are lots of things for children to do.

For the month of August, when the whole of Paris shuts down for holidays, they rent a cottage on the coast. During July, when school is closed, Michel goes to a school camp organized by the

neighbourhood, which costs 3,000 francs (U.S. $608) a month; Florie usually stays with her aunt or a neighbour. Last year Florie went to a mini-camp for two weeks costing 60 francs (U.S. $12) a day and to her grandmother's for the remainder of the month. Like working mothers everywhere, Marie has problems finding care for her children when they are sick.

Although Marie works for a feminist organization, she is not engaged in any activity in the women's movement outside of her job. For her and her husband their children are the centre of their lives.

The centrepiece of the government's legislation for women, and what keeps women like Marie L. so content, is its child-care policies and maternity leave. A Parisian-born Canadian friend of mine used to complain bitterly about the lack of good child care and the grudging attitude Canadians had towards maternity leave. "Pregnant French women are treated like queens," she used to boast.

To find out why pregnancy is so valued in France I sought out Françoise Picq, a prominent author and university lecturer, who has written extensively about the French feminist movement. We met on a rainy morning in a charming loftlike apartment on the ground floor of an old building where she lives with her two daughters and her companion, a lawyer.

In her opinion, and in the opinion of every French women I talked to, good child care and maternity leave were put in place to encourage French women to have more children. France's natalist policy started one hundred years ago, according to Françoise Picq. "In the nineteenth century the birth-rate in France started to go down. In every country when deaths go down birth-rates start to go down. But France was different. The birth-rate went down before the death-rate did. After World War I, during which both France and Germany lost a lot of men, the German women had a lot of babies, but the French didn't."

Picq says the reason France had a low birth-rate in spite of the church and all authorities was that large numbers of women in

France worked. As early as 1900 women made up one-third of the work-force. In 1920, to force women to have babies, France passed harsh laws on abortion and birth control, but the French could never out-produce the prolific Germans. After World War II the birth-rate rose dramatically, but in 1964 it dropped again.

Over time, attitudes changed and natalism policies were less accepted. Authorities began to realize that women were not going to stop working and they would not have children unless facilities to help them improved. More child care and maternity leave were brought in. "Today French politicians continue to say we must have more children," Picq explains. "But the old notion of the mother at home, having children, is no longer being promoted, even by the right wing. Even they realize French women want to work, to be more independent and have their own money." There is no back-to-the-home movement, as there is in Germany, Spain, Belgium, and North America.

Other countries would be wise to learn from France's experience: that natalist policies that bully or bribe women by means of harsh birth control and abortion laws to stay home and have babies are doomed to failure, whereas providing generous parental leaves and child care for working parents will produce the desired effect. Today, even though women still say there isn't enough child care in some of the big cities, 95 percent of all French children are in it. France's present birth-rate is the second highest in Western Europe, right behind that of Sweden.

But in some ways the system still penalizes married women who work. Married couples make one tax declaration for the family (which means the higher earner, usually the man, pays more taxes if his wife works), and she gets cut off unemployment benefit supports earlier. "From a tax point of view, it's better not to be married," says Françoise Picq.

One French couple in three divorces, and in Paris, I was told, the rate is probably one in two. But the government does make an effort to support single mothers. It offers re-training and tries to find them jobs. Child support is enforced, or else the government garnishees wages. Official French policy makes no distinction between legal marriage and *concubinage* (common-law

arrangements). And unmarried mothers are not discriminated against. Child benefits are paid regardless of the living arrangements of the mother.

Although French women are among the best educated in Europe and pride themselves on their intellectual abilities, they have not been aggressive in taking the political route as a means of bringing about change. Today women make up only 5.7 percent of the National Assembly and only 2.5 percent of the Senate. One reason for this low participation might be the French first-past-the-post electoral system, similar to the British, U.S., and Canadian systems, which doesn't favour women being nominated for winnable seats. Another problem is France's highly centralized government, which is hard for women to penetrate. Proportional representation was brought in briefly in 1986 but removed by 1988.

Françoise Picq says: "Men put a lot of energy into politics. Feminists, on the other hand, believe the personal is political and what happens in government is not important. They want to change the whole system." Many feminists don't bother to vote at all. Even when a feminist ran for the Socialist party, many other feminists didn't support her—a phenomenon that always baffles women active in political parties elsewhere.

But there is a new breed of professional women making progress in gaining powerful positions. Bright and competitive, they usually don't get into *les grandes écoles*, traditionally the high road to positions of power for French men, but they can write the stiff exams for jobs within the bureaucracy and as judges. Indeed, one-third of France's lawyers and judges are now women.

One of the most powerful and influential women in France did choose the political route and was able to shove through a remarkable amount of legislation for women in the short time that she had some real power. I must have talked to more than twenty women in France, and there wasn't one, in this fractious country, who didn't agree—whether they liked her or not—that Yvette Roudy was very important for women in France.

Roudy is a Social Democrat, an author, and a life-long feminist. She translated Betty Friedan's *Feminine Mystique* into

French. When the Social Democrats put strong commitments to women in the 1981 party platform and the party won the election, the tiny women's secretariat, which had been established by the conservatives in the 1970s, became a full ministry with ten times the budget and Roudy as its minister.

To see Roudy at the Assemblée nationale, I had to pass through three security checks. When I finally got to her office on the third floor it was as busy and disorganized as most political offices are. A young man was rocking back and forth as he silently read what I decided must be the draft of a speech. Two women were talking on the telephone. A Socialist poster with a woman's head and a hand holding a rose, along with the slogan *La politique n'est pas qu'une affaire d'hommes*—Politics isn't only men's business, decorated the wall. Both the radio and TV were turned to newscasts.

After about ten minutes Yvette Roudy herself came bustling in. A short, rather stocky woman with a deep tan, strong features, and greying hair, she got right down to business.

"The women's movement in France isn't like the women's movement in the U.S. It's split," she said in excellent English. "French women have acted strongly when there was a strong motive in the sixties and seventies. In 1971, hundreds of women, myself included, declared publicly that we had had abortions and dared the government to arrest us. But right now women don't know where they are. Young women believe everything has been done and they aren't interested. The women's movement is flat."

While in the powerful women's ministry, she accomplished a lot. An ineffective equal pay law and an enforcement law had been passed in the 1970s. Roudy sorted out the tangled labour laws on women and brought in six new laws, dubbed by the media Roudy Laws, designed to close the gap between men's and women's salaries and eliminate discrimination everywhere. Training centres for non-traditional jobs were established all over France. Employers had to produce annual reports on what they were doing to advance women. (In March 1990 Roudy published a report showing that the number of companies complying was far from the objective.) Judges could make employers put in

affirmative-action plans. Measures to improve the position of women in unions, the professions, and the civil service were passed. In 1983, an Equal Opportunity Commission was set up.

Roudy also tried to get a law passed that no more than 80 percent of any party's candidates could be of one sex, but the courts threw it out as unconstitutional. She passed a law making it mandatory that a woman sign her husband's income tax form so that she knew what he earned. Women who worked in family businesses had to be partners or paid employees. She ran birth control ads in the Métro, something that scandalized some people. And although Mitterrand had wanted to reimburse only poor women for abortions, everyone was included under the health act. Roudy also granted government funding to special projects such as the Maison des femmes.

Conservative critics soon accused Roudy of going too far, too fast. Urged on by women such as Anne Zelensky, she tried to bring in a law against sexism in advertising in 1983, modelled after a 1972 law on racism. It would have meant women could sue newspapers, magazines, and advertisers if they ran material degrading to women. This brought down the wrath of the arts community, even though the bill excluded the arts. The press thundered on about freedom of the press and called Roudy a prude, if not an ayatollah. Simone de Beauvoir, who had backed the bill, wrote an article in *Le Monde* defending it. Nevertheless the government backed down and withdrew the bill. Roudy was demoted and the next year the budget for her ministry was cut.

When the Conservatives came into power in the next election they dismantled the Ministry for Women's Rights. Women raised such a hue and cry that it was set up again, but this time only as a department. The Conservatives gave it no power and little money, and according to Roudy, nothing much was done for the next two years. When the Socialists came back to power in 1988 they didn't re-establish the ministry but left it as a department. The present head of the department, Michèle André, has been very active in trying to help the two million women in France who are battered each year. Roudy says of her: "She has no power, no money, and can't do much."

But Roudy's actions paid off for the Social Democrats, who in 1988 garnered 37 percent of the female vote, much of it wooed away from the Conservatives, while only 31 percent of the French male vote went to the Social Democrats. Feminists now are critical of Roudy's laws. They say the enforcement mechanisms weren't strong enough. The government has now brought in a new Equity Act, in which companies will have to file plans about how they are going to advance women.

Although Roudy admits she may have tried to rush too much legislation through, she insists there is still a lot that didn't get done. "If there is no big women's movement to struggle, then the power is going to be in the hands of men. And men don't want to change. People have to pressure—for women's rights, workers' rights, ecology—everything. Politicians, right or left, obey only what the people say they want—and only if they say it loudly enough. After each battle a few feminists give up."

As I left, Roudy said somewhat sardonically: "They've done everything to try to make me disappear, but I know how to fight them."

In a recent poll 52 percent of the population thought women had too little power, and 77 percent said they would be willing to vote for a woman president. But the most discouraging fact to come out of the survey was that 66 percent of women would never consider running for public office because they didn't think they had the knowledge or the time, and 33 percent still felt men should be hired over women in periods of high unemployment.

Today in France many people are fearful of the future, especially in view of the unification of Germany, France's ancient enemy. France has always considered itself a cultural and political leader, referring to what it calls its "national destiny". Although inflation in France is one of the lowest in Europe and its Gross Domestic Product is second in Europe only to Germany's, it fears it may be losing status in Europe and the world.

And there are ugly local problems. The National party, headed by Jean-Marie Le Pen, with its hatred towards Africans and Jews, is unsettling. Homelessness and public violence are on the rise. Lately there has also been a backlash by French men and violent

verbal attacks on prominent women such as Simone Weil and Michèle André.

On the morning before I left Paris I was on the Métro. A drunk entered the car, big, lewd, and belligerent. We all tried to ignore him.

Moments later a middle-aged woman entered and passed in front of him. He made some remark; she moved up the car and sat down. He followed her up the car, sat across from her, and began to harass her. For some inexplicable reason she seemed to enrage him. A tiny old man with a ribbon in his lapel to indicate he had been decorated in the war stood up and urged three young men to deal with the situation. They appeared to be American tourists, and embarrassed, they muttered in stumbling French that they didn't speak the language—although what needed to be done was obvious in any language.

Suddenly the drunk rose and lunged at the woman. The old man, who was less than half his size and slightly built, came to her defence by placing his slight frame between her and her would-be attacker. The drunk cursed mightily but sat down. At the next stop he got off.

I adored that old man for his gallantry, and for a moment I understood what French women must cherish in being held in such esteem. But afterwards I wasn't so sure. I imagined the scene taking place in North America. A North American woman wouldn't expect a man to defend her. She would move away, or confront the drunk herself, or call the conductor. In some way she would handle the situation herself.

The scene reminded me of all those old movies that puzzled me so much when I was a young girl growing up. I used to wonder why the heroine stood around screaming helplessly while two men battled over her like a trophy to be won in a boxing match. Why didn't she pitch in and hit the villain over the head with a hammer? Why didn't she walk away from both those men, who could find no better way to settle their problems than to resort to fist fighting?

I came to the conclusion, as many feminists in France have, that the celebrated stereotype of French women as the most

cherished and sexiest in the world is indeed a trap that still holds French women back and keeps them divided against one another.

BELGIUM—
WHERE EVERYTHING COMES IN DUPLICATE

FACTS

Population: 9.87 million, one of the most densely populated countries in Europe.

Government: Upper and lower chambers. No proportional representation.

Vote for women: In local elections, 1920. In national elections, 1949—one of the last countries in Europe in which women got suffrage.

Percentage of women elected: 8.5 percent in the Chamber of Deputies and 8.3 percent in the Senate.

Education: Coeducation in French-speaking Belgium, but in Flanders many schools are segregated by sex. About half the schools are run by the church, but all schools are financially supported by the state. Some sex stereotyping still exists in texts and curriculum. School is compulsory until eighteen years of age.

Percentage of work-force women: 40.31 percent—22.6 percent work part-time. Women's salaries are 75 percent of men's. Women compromise 40 percent of union members.

Abortion: After many years and the defeat of more than thirty bills abortion was finally legalized in 1990, allowing abortions for

up to twelve weeks' pregnancy if the woman is in danger due to health, social or psychological circumstances, or if the foetus is defective. Under some circumstances the time may be extended.

Child care: Child care is very good. One in five children under three with working mothers is in a crèche, starting at three months. Crèches run by local authorities, and supervised and subsidized by the government. The remaining children are in private care or with relatives. Ninety-five percent of children aged two-and-a-half to five are in *écoles maternelles*, open from 8:30 A.M. to 3:30 P.M. Before- and after-school care may run from 7:00 A.M. to 6:00 P.M., but parents must make their own arrangements. Child care during school holidays is available. Eighty percent of private child-care costs are deductible up to 345 francs (U.S. $12.50) a day. Tax deduction of 10,000 francs (U.S. $362) a year given to all parents with a child under three.

Maternity leave: Fourteen weeks, eight weeks to be taken after the birth of the baby. Full pay for the first month and 75 percent for the rest. No parental leave, but workers may take six to twelve months' leave for family or personal reasons at five different times before retirement at a low flat rate—10,504 francs (U.S. $380) a month, or 12,504 francs (U.S. $425.50) for leave taken after the birth of a baby. Eighty-six percent of those taking this leave are women. Employees in the public sector can take eight days' paid leave a year for either paternity leave or to care for a sick family member, and an additional two months without pay. Public-sector workers can also work part-time for five years for family reasons.

Birth-rate: 11.9 live births per 1000 population

Family law: Before the new family law was introduced in 1976, there were many injustices, usually suffered by women. Where there were no marriage contracts, men often used to walk away with all the assets after a divorce; now goods are divided evenly. Divorce is as high as one in three marriages in urban centres, and

takes one year if there is mutual consent. If one party objects, the other party can start divorce proceedings after five years. Recent legislation automatically entitles spouses who work in family businesses to 30 percent of the salary of the other spouse up to 350,000 francs (U.S. $12,250) a year, and covers them for pensions and health care.

Achievements: Good social services—child care, after-school care, public health scheme.

Problems: Very conservative society. The women's movement is weak and disjointed, even though there are some links between factions. Like everything else in Belgium, it has always been divided by language.

THE BACKGROUND

After centuries during which it was a battleground for its warlike neighbours, including Spain and Austria, Belgium got its independence in 1830. It rapidly industrialized, as well as built a colonial empire in Africa. From the Middle Ages on, the French-speaking bourgeoisie in the south dominated the culture and government. This domination was encouraged by Napoleon, who forbade education and even street signs in Flemish.

The industrial revolution took place in the southern part of the country, where big blast furnaces and metal factories were established. Since World War II, however, those heavy industries have been in a decline, as they have been all over Europe. The north, with its Flemish population, has become more dominant with resentment on both sides. One million immigrants—Italians, Spaniards, Poles, Turks, and Moroccans—have been brought in to do the work Belgians will no longer do.

Women have always been a part of Belgium's work-force, but have always had to cope with a very conservative society

dominated by the Catholic church. Both socialism and feminism have always been suspect. To avoid drawing attention to its goals, for example, the Belgium socialist party, founded in 1893, took the name of the Belgium Workers' party.

Today Belgium's capital city of Brussels, with a population of more than a million, is booming. It is the headquarters of the North Atlantic Treaty Organization and the European Community. It is also an international financial centre for more than a thousand multinational corporations. As the twelve member states of the European Community rush towards the 1992 union that will make it the world's most powerful trading bloc, Brussels stands at the hub of the future.

The first wave

Belgium has had a parliamentary system of government dominated by the middle class since the end of the 1800s. In other countries this situation created ideal conditions for a spirited suffragette movement. This happened in Belgium too, but the church was adamantly opposed to women getting the vote, even though they had achieved the right to attend university and pursue careers. As was the case in France, even the left-wing parties, traditionally supporters of women, were against the vote for women, fearing that women would vote as the church dictated. Belgian women were not allowed to vote in local elections until 1920, and not permitted to cast ballots in national elections until 1949.

Women also had little success in getting laws altered. The church blocked any change in the old 1867 law that totally forbade abortion, calling it "a crime against public morality and family order."

The second wave

In 1968 women began organizing Dolle Mina groups copied from the Netherlands, but Belgian women usually date the movement's

big take-off to 1972, when a group of women invited Simone de Beauvoir to come to Brussels. Hundreds of women turned up to see her, overflowing the hall and spilling out into the streets. The day became known in feminist annals simply as November 11.

As in several other European countries, efforts to get the abortion law changed were the catalyst for most feminist efforts through the 1970s. Women used to hand out pamphlets on abortion in the market, which people took as though they were clandestine documents. An SOS hotline was set up to give pregnant women advice about where to go for abortions. They often received help in getting to Holland, where there were clinics performing the procedure, although technically abortion wasn't legal.

Polls showed that the majority of the Belgium population wanted abortion legalized. The Christian Democratic party, which was supported by the church, always blocked any change in the law, and since the Christian Democrats were always in whatever coalition was in power, no bill ever passed. Nevertheless, more than fifteen thousand abortions a year took place in Belgium. These were done at women's clinics. The first one was set up in 1977, and by 1990 there were fifteen clinics in Brussels alone, although only three are located in the Flemish part of the country. The clinics were supposed to be general women's clinics, but everyone knew they performed abortions—coded as D-and-Cs in Belgium's medicare health system. Occasionally when a couple separated a vengeful husband informed the authorities that his wife had had an abortion.

The final battle to get a bill through the parliament was carried on by doctors and politicians. In 1988, fifty-five doctors, nurses, and social workers employed in women's clinics were arrested as part of a church-supported campaign against abortion. However, they all received suspended sentences.

In 1989, an abortion bill was introduced by Lucienne Herman-Michielsens, a Flemish liberal senator who holds a doctor of law with a degree in criminology. It was the fourth abortion bill she had tried to get through the house, dating back to 1977. A number of delaying tactics were used to block its

passage through the Chamber of Deputies, but in 1990 it passed, ending the 123-year ban on abortion.

The situation today

Belgium gives the impression of being a comfortable middle class, conservative country with a respect for its past. My rather old-fashioned hotel in Brussels had a handsome stained-glass window thirty feet high in the lobby and elegant iron fretwork on the stairs. The elevator, which tended to be temperamental, was an antique wrought-iron cage trimmed with gleaming brass. Thick white towels were stacked in the bathroom. There was a shaving mirror, though there was no shower cap. Breakfast was hearty, with cheese, cold meat, thick coffee, hot milk, croissants, biscuits, and chocolate.

A recent survey taken by the European Commission, the regulating body of the EEC, confirmed Belgium's traditional deeply conservative nature. Although 50 percent of Belgian men prefer their wives to work, only 31 percent of all Belgians believe in an egalitarian marriage. Only 15 percent of men and women believe more women should be in parliament, and 35 percent of Belgian women have never voted for a woman. Yet only 24 percent of Belgian women feel they are at a disadvantage in society. Indicating how little impact the women's movement has had, Belgian women listed as the three things that had changed their lives the most: the pill (70 percent), the vote (29 percent), and the advent of the washing machine (28 percent).

The legacy of Belgium's conservatism is evident in the slow passage of many laws affecting women. Birth control was illegal until ten years ago. Until as recently as 1987, a woman who had a baby out of wedlock had to apply to adopt her own child to qualify for family benefits. A 1982 bill on rape didn't recognize rape within marriage. This was changed in a 1989 bill, which made rape within marriage as well as rape between people of the same sex a crime.

Because it takes a divorce five years to come through if one partner objects, the number of families headed by single parents

is relatively low compared with other European countries—only one in fourteen. In the early 1980s the government tried to cut off unemployment benefits for people who were not "heads of families"—mostly women. Women challenged this in the European Court and won. But even today heads of families, usually men, get a higher rate of unemployment benefits than single people, usually women. The European Commission has objected, but the government and unions are reluctant to make changes, although they can't defend the practice.

Government employees retire at sixty-five, but in the private sector retirement age is sixty-five for men and sixty for women. Women, who already earn 25 percent less than men, have smaller pensions because they are forced to retire early. Only since 1985 have women who take time off to raise children been able to count five years of that time towards their national pension plan.

The good child care Belgian women enjoy is a legacy of the enlightened ideas of a group of well-to-do women at the end of the nineteenth century. They decided that for children to be looked after properly while mothers worked there had to be good day care, and they were successful in persuading the government to set it up. After World War I, which devastated the country's male population, women were needed to work in the factories, but the state also wanted them to have babies in large numbers to replenish the population. This was an added incentive to provide good child care.

Today Belgian women admit the standard of child care is good but complain that there isn't enough of it—a lament I heard in every country I visited. A number of women in Belgium still look after other women's children in their homes. Still worried about Belgium's falling birth-rate—which is high compared with Germany's and Italy's but lower than what it is in France, the Netherlands, and the United Kingdom—the tax department allowed 80 percent of child-care costs to be deducted as a work expense in 1989. Companies are now being encouraged to set up crèches, whose operating costs they then may deduct as a company expense.

But women's problems, as in Canada today, are a minor

concern compared with the country's raging constitutional and language wars. Even after having lived in a bilingual country all my life, I was totally unprepared for the complicated arrangements and the savage infighting that characterize Belgium.

A French-Canadian who lives in Brussels described the situation to me: "Re-writing the constitution is a national pastime. This has been done three times in the past twenty years. The federal government is now fairly weak and has jurisdiction only over justice, finance, foreign affairs, and the army. There are three communities—the Flemish, the French, and the sixty-thousand Germans. Each of them has authority over its own culture, education, communications, and social life. In addition there is another layer of government—three regions—the French, the Flemish, and Brussels. Each controls its own roads, environment, tourism, and some trade. But the central government also controls some of the trade as well as the major roadways.

"So you have layer upon layer of government, which means there's a huge bureaucracy. One in every ten people in Belgium works for the government. There is one court that devotes all its time to just trying to settle disputes among the different levels of government.

"Each political party—and there are six of them—has its French and Flemish branch, and they rarely agree with one another. In all there are sixteen different political divisions. The government is always a series of coalitions. Even though the same prime minister, Wilfried Martens, has been in power since 1981, the government falls regularly about once a year, over either money or language.

"Everything in Belgium is political. If you work for the Flemish and get fired, you can't get into the French system. Teachers, sociologists, and social-welfare workers can't switch from one system to the other. To get anything done you have to know influential people in whatever political coalition is in power. If you are trying to do business in Belgium you have to negotiate with the French and Flemish separately.

"Children take four to six hours of either English or one of the other national languages a week. There isn't even one national

television network. Each community has its own. In such a political country where connections count for so much, women just aren't part of the old boys' network. They never get into the back rooms."

In such a complicated political system, dominated by male-run bureaucracies amid so much linguistic wrangling, it is not surprising that the Belgian women's movement has had more than its share of difficulties. The abortion issue was the catalyst for most of the feminist effort through the 1970s and 1980s in spite of total opposition from the king, the church, and many of the parties. In Italy and France, also overwhelmingly Catholic, many women became anti-church, but that has not happened in Belgium.

Today the Belgian women's movement is quiet. The National Council of Women, founded in 1904, encourages women to run for election, does some research, and puts out information booklets. There are also many small groups working on specific issues, but a good deal of today's activity is centred around two institutions, both centres for feminist research: Les Cahiers du GRIF and the Université des femmes. Typically in this deeply divided country, they were once united. A difference of opinion over ideology split them in the late 1970s.

Les Cahiers du GRIF is named after a magazine that is published by one group. Its office is located on the top floor of an elegant old building with a worn red carpet and brass riders for the first two floors, then a bare and narrow stairway to the third floor. Les Cahiers du GRIF was started in 1973 by Françoise Collin as an independent, feminist publishing concern, run on a non-profit basis. Over the eight years the magazine was published in the 1970s, two thousand women wrote for it. By 1980 it got some state grants to work on adult education. Since the mid-1980s it has received some money for research from the European Community.

In 1979, a more socially oriented group in the organization wanted more activism and emphasis on economic problems. Nadine Plateau, a language teacher, and Edith Rubenstein founded the University of Women. The university gets about a

third of its budget from the government and the rest is raised by activities such as seminars, film showings, and conferences. Les Cahiers du GRIF stopped publishing for a short time but has since resumed. The University of Women publishes *Chroniques féministes*. Both organizations operate as reference libraries run by volunteers.

A new women's organization, Comité de liaison, is attempting to bridge the gap between parties. It includes women from all parties, the trade unions, and some women's organizations. Its objectives are better pensions for women and better equality laws.

The government has done some things to respond to the women's movement. Married women have been able to keep their own names. Girls can now become military cadets. Standards of fitness have been set up for the police and the army so that anyone who qualifies—male or female—is eligible. A woman's studies course was introduced in Flanders, though it had to be taught by "neutral" professors. "The students knew more than the teachers," I was told, although I was also told that this has now been corrected. There is no women's studies course in French-speaking Belgium.

Belgium has had equal-pay legislation since 1975 and equal-opportunity laws since 1978, but, as in many other countries, these laws weren't being enforced. Under pressure from the European Community, Belgium passed the Equal Pay Act of 1984, allowing women to charge employers with discrimination and take their cases before an industrial tribunal. The National Women's Employment Commission was set up to give advice, mediate, and even sometimes pay complainants' legal bills; however, it can't charge companies with discrimination. In 1984, thirteen women at one firm who refused to be singled out from the male employees and put on part-time work received compensation but didn't get their jobs back.

Miet Smet has been a vigorous Secretary of State for Social Emancipation and the Environment. Although the ministry is a junior one, there is no shortage of targets for its efforts. Smet set up a Council for Emancipation in 1986 with a staff of ten people. She has been active in encouraging young girls to think of non-

traditional careers. She has waged a campaign against violence towards women. Miet Smet has tried to crack down on men who don't pay child support and alimony (more than one-third are delinquent). "Men will quit their jobs rather than pay their wives support," I was told. Smet recently put forward the radical proposal that a minimum income be given to the poor, and that the heads of single parent families, mostly women, be paid as much as women supporting families. She has also signed up several companies for a voluntary affirmative-action plan to hire and promote women.

In 1990, a royal decree stated that all government departments must promote equal opportunity for women. Affirmative-action officers were set up in each department. A report is being prepared and an equal opportunities plan is to be drafted. In the future all organizations that put forward names of people for advisory posts must have both a man's and a woman's name for each position.

One in every three Belgian women suffers from some sort of violence—rape, abuse, battering or sexual harassment. Wife battering was ignored until women brought it into the open and set up shelters. Now there are six hostels in Belgium that the government funds.

A day in the life of...

Lieve M. is a masseuse whose husband, Louis, runs a small contracting business. She earns around 70,000 francs (U.S. $2,450) a month—about 70 percent of what a masseur would earn. For about a year, while Louis got his business going, she supported both of them.

Although rents in Brussels compared with other European countries are low, young Belgians find low-cost housing hard to find in a city where twelve thousand officials from the European Community are stationed. Five years ago Lieve and Louis paid what they thought was an enormous price, 1.5 million francs (U.S. $52,500) for a three-storey house with three bedrooms, a dining room, kitchen, and a garden in a residential area in south

Brussels. Today the house is worth three times what they paid for it.

They have a two-year-old baby daughter who is in day care, which costs Lieve 600 frances (U.S. $21) a week. Her husband wants her to have another baby, but she is reluctant because she worries about losing her customers.

Lieve's biggest problem is exhaustion from her long hours. She works until nine almost every night. Louis looks after the baby, bathes and feeds her, then watches television. All the meal planning, grocery buying, cooking, making arrangements for the baby, and entertaining are Lieve's responsibility. Louis feels he does his share by paying the house expenses and doing the gardening. He never takes the baby to the doctor and seldom plays with her.

A lot is expected of Belgian women like Lieve. They are supposed to cook one meal at night for the children and another for the husband. Children go to school from 8:30 to 4:00, but they bring home a lot of homework and it's the responsibility of the mother to help them with it.

Belgian women feel they must entertain both sets of relatives regularly in high style, with lace table-cloths and home cooking. Husbands want wives to work, but they also demand ironed shirts and home-made pies and cakes. Although the government complains about the falling birth-rate, it is reluctant to make things easier for working women. Lieve says all of her friends are under the same pressure. "All we do is complain a lot," she says.

In spite of their complaints, few Belgian women think of running for public office as a means of changing things. At the local level, in 591 towns and cities only 2 percent of the mayors are women. Although one in ten city councillors is a woman, only one in sixteen makes it to the executive council. There are three or four female secretaries of state, but no women ministers. "The smaller parties are more open to women," I was told. But the smaller parties naturally elect fewer people. Both Flemish and French-speaking feminist groups as well as the National Council of Belgian Women are campaigning to have political parties

establish quotas for female candidates, but so far only the Christian Democrats in Flanders have even considered it.

Women have done better in the European Parliament, which consists of 518 members elected from the twelve member countries and there is proportional representation. Women make up 16.7 percent of the members. "It's new and there aren't so many men in place" was the one explanation for this modest success.

As in other European countries, the European Commission has been a useful court of last resort from Belgian women. In the 1970s a Belgian airline stewardess successfully complained to the European Court when she had to retire at forty, while male employees could keep working far beyond that age. It was also the European Commission that declared that Belgium's unmarried mothers should not have to adopt their own children to get family benefits.

Brussels is to be the headquarters of the European Women's Lobby. As Jacqueline de Groote, a Belgian economist, points out, the European community is moving rapidly towards union in 1992 without enough input from women on such subjects as surrogate motherhood, social security, flex time, and a host of other issues. "In the community there are twelve different systems of social security and twelve different kinds of employment laws. How will we harmonize them?" she asks. "We need to make sure we adopt the top standards and bring everyone up."

After several planning sessions dating back to 1987, the first General Assembly of the women's lobby was held in Brussels in September 1990. In preparation for it, forty representatives of national groups met over the course of two years to draft a constitution and by-laws. The European Commission put up the money for planning meetings and the assembly. The lobby will have four representatives from each country, plus one representative for each women's organization that has members in at least seven European countries. An executive of twenty from the twelve countries and eight from women's organizations will be elected for a two-year term. There will be a small secretariat

located in Brussels. It will meet to pressure the European Commission on social issues, much the way advisory councils have operated in individual European countries. The lobby has set as its first priorities: problems of women in the labour market, combating racism in the community, and advancing women into more decision-making positions.

The European Women's Lobby, combined with all the other influences from the community that are coming together in Belgium as 1992 approaches, offer a new lease for the Belgian women's movement, and open up this comfortable country to new, more liberal thinking and attitudes towards women.

THE U.K., U.S., AND CANADA—
HOW GOOD ARE FREE-MARKET DEMOCRACIES FOR WOMEN?

Women who live in the United Kingdom, the United States, and Canada consider themselves, with some justification, among the most fortunate women in the world. After all, these countries are three of the great English-speaking democracies. All of them have a high standard of living and all of them celebrate the importance of free speech, freedom of the individual, and the separation of church and state.

The three countries are linked historically, and they share English common law. Canada and the U.S. were once colonies of Britain. The U.S. fought the War of Independence to throw off its colonial status. Although Canada is still a member of the British Commonwealth, it has gradually been divesting itself of its ties to the mother country. In 1931 the Statute of Westminister broke the last legislative tie to Britain. In 1952 Canada appointed its first native-born governor-general. In 1965 it got its own flag. In 1982 it patriated the British North America Act from Britain and entrenched in it a Charter of Rights.

The fact that all three countries have been predominantly Protestant has meant that women got universal education and the vote at least a generation earlier than most women in Catholic

countries. In addition, North American women worked side by side with men to open up the vast western reaches of the continent, which won them the vote in local elections quite early. Eight states and five provinces gave women the vote before they won it federally.

Independent women's organizations and suffragette groups also got an early start. In North America women's organizations were often based on social, charitable or community interests, rather than being organized by the church, political parties or along class lines, as happened more frequently in Europe. This gave North American women some experience in working collectively. Splits are more frequently over tactics and ideology than religion or politics.

The women's movement in North America, in the past twenty years, has also received more public attention than it has in Europe. In fact, many countries were inspired by the U.S. movement. Even today Canada and the U.S. continue to have the strongest, most united women's movements in all the Western democracies.

Yet many European women could argue that the reason the movement is still so vigorous is that women in North America are still fighting for the services many European women achieved years ago.

Why, after a century and a half of women working so energetically for equality in these supposedly egalitarian countries, do the following problems still exist?

• Services for women such as child care, maternity leave, and after-school care are among the least provided for in all the Western democracies.

• The average salary of women is 66 percent of the average salary of men in Canada and the U.S.—the lowest in all the Western democracies. In the U.K. it is 69.5 percent.

• Only 5 percent of the House of Representatives in the U.S. and 6 percent of the House of Commons in the U.K. is female, while

many European countries have at least two or three times that percentage. (In Canada the situation is slightly better at 13 percent.)

• In the past twenty years there has been an alarming increase in the number of women and children living in poverty in all three countries.

• In these countries—dedicated to the free enterprise system, where individual effort and excellence are supposedly always rewarded—only 2 percent of women are in top executive positions in the large corporations, and even then they are paid less than men.

• At the other end of the scale, nurses—who are mostly women—are paid less than garbage collectors, who are mostly men. And child-care workers with three years of university— again mostly women—are paid less than attendants who feed the monkeys at the zoo. Also, despite being societies in which "market forces" predominate, this discrepancy in wages does not correct itself automatically.

The difficulty in getting bare-bones child care and maternity leave can partially be explained by the fact that governments in all three countries saw no need for the natalist policies adopted by countries such as France and Belgium to boost falling birth-rates. In Canada and the U.S. new immigrants have always filled the need for new workers. In all three countries politicians and many of the public are convinced that more generous child care and maternity leave only encourage the poor and minority groups to have more children. This belief is still strongly held in spite of research showing that when women have access to education and jobs they reduce, not increase, their families.

In the U.K. after World War II the government brought in a national health scheme, free milk and lunches for poor children, and copied family allowances from the French, an idea copied in turn by Canada. (The thought behind it was that women would

be encouraged to stay home and new money would be injected into the economy.) These were a help to women, but in both the U.K. and Canada family allowance has been de-indexed from inflation in the past few years, which means it is worth less and less. In the U.S. there is no federal law at all guaranteeing a woman maternity leave. The latest effort just to get unpaid leave was vetoed by President Bush.

In politics the system favours the status quo and is flawed for this reason. In one hundred sixty countries in the United Nations, only the U.K., the U.S., Canada, and New Zealand still use the first-past-the-post simple plurality system. The advantage of the system is that it's easy to understand. Each electoral district or riding chooses its own candidate, who is supposed to look after the interests of the people living there. The disadvantage is that the system tends to result in only two or three parties that represent a narrow range of opinion. Special-interest groups, minority groups, and small parties are not represented, are easy to ignore, and have no way into the system. In the nomination contests, there is often no limit on the amount of money that can be spent. The contests are undemocratic and tightly controlled by the local constituency organization. The advantages are always with white Anglo-Saxon males. In all three systems, once elected, incumbents are immensely favoured—more than 90 percent of U.S. incumbents, for example, are re-elected.

Under some form of proportional representation, which is common in the vast majority of democratic countries, lists of candidates are put up by parties. It is quickly apparent that mostly male slates of the various political parties are discriminatory against women. This has worked well for women, since it allows them to press for quotas quite successfully. Proportional representation also generally gives the electorate a broader range of political parties to choose from, although that may result in more frequent elections and less stable governments. In most countries it produces in a coalition of parties with the various party platforms more clearly defined.

Another problem is that in all three countries it is becoming prohibitively expensive to run for election at all. In the U.S., for

example, it may cost millions of dollars to run even for mayor. The only source of such funding is big business, which is not interested in women since they don't usually have the leverage to award big contracts and come through with prestigious appointments. Charles H. Keating, Jr., principal owner of Lincoln Savings and Loan Association, which recently created a scandal because of its lavish contributions to the campaigns of five U.S. Senators, was refreshingly frank when asked whether his political contributions were made to get favours. He replied: "I want to say in the most forceful way I can, I certainly hope so."

Socialist parties, common in Europe, have generally been more supportive of measures to help women. But any form of socialism is anathema in North America. In Canada the mildly socialist NDP has never come close to getting into power federally. In the U.S. even the word *liberal* was enough to help in the defeat of the last Democratic candidate for president.

Party discipline under the parliamentary system of government in the United Kingdom and Canada is rigidly enforced. This makes it difficult even for lobbyists to make much of a dent in how individual members of Parliament vote. In the U.S., women have been quite successful in changing crucial votes by lobbying, but the federal systems in Canada and the U.S. present another problem. State and provincial governments look after much of the social legislation that affects women, which means lobbying has to be done at both government levels.

Unions, another route through which women have penetrated the system in other countries, are weak in Canada, even weaker in the U.S., and predominantly male in the U.K, the U.S., and Canada. Unions were slow to organize women up until twenty years ago, when the power of unions began to decline and they looked to women to boost their membership. Even though one-third of the members are now women, few women make it to the executive level.

In all three countries the higher reaches of the judiciary, the civil service, and the professions have been safe, protected male inner sanctums. Except for lower-court judges in the U.S., who are elected, all appointees to positions of power tend to be

carefully screened and selected by the mostly male hierarchy, and few women have been chosen.

Feminists frequently accuse governments and business of deliberately plotting to keep women a source of low-paid, alternate workers. But the truth is probably not nearly as interesting or sinister. In the past century unions and the church fought for a "living wage" for men so that they could support their families. Wages for women were always minimal—bare subsistence for single women until they married. Even though from 10 to 25 percent of the work-force were women who worked from necessity, the ideal family became the father-knows-best Victorian model, with mother at home.

Women did become "back-up" workers, to be called on when needed—for example, during both world wars—and to be sent home afterwards. But although many women lost the better paying, traditionally male jobs they had held during the war, many of them resisted getting out of the work-force. Instead they tended to move to lower-paid service jobs. By the 1960s more women were needed in the work-force. Women had access to better birth control. They were having smaller families than their mothers. There was pressure for a better standard of living to pay off mortgages, improve children's educational opportunities. Divorce also became more common and more acceptable, and more women began to enter the professions.

But since market forces are always supposed to determine what happens in a free-market economy, why, since women have always been paid less then men, didn't industry turn to women in preference to men?

The reasons seem to be:

• High levels of unemployment keep people working for minimum wages and few benefits, and women make up a disproportionate number of these workers.

• Many of the best paying male jobs are unionized, so that there is no advantage in hiring women if they have to be paid as much

as men. Men have also resisted women edging in on their traditional territory.

• In many industries in the past, laws were passed specifically to "protect" women, although it is now clear, for example, that jobs that are dangerous genetically for women are also dangerous for men.

• Women are often employed as low-paid, "back-up" workers, to be called at peak periods, or as part-time workers, or piece-workers.

• As technology takes over, more and more jobs can be broken down and filled by low-paid workers and industry often fills these jobs with women.

• Governments and business see little profit or advantage in providing social services such as child care or care of the elderly as long as women do these tasks for free.

• Finally, few societies, except the Scandinavians, have ever tackled the division of labour in and outside the home and the problem of trying to reward it equally. The free-market system defines "work" as paid work. The work done by women in the home isn't valued at all, and women's work outside the home is undervalued because it is done by women. Women's work, therefore, is undervalued in both spheres. Men have always been given a preference in the public sphere, and there are always more able, qualified, women than there are places for them.

Women are caught in the squeeze of working at two jobs, one of which is paid poorly and the other not paid at all. The attitude government and business foster is: if women choose to work as well as have a family it's their own responsibility. Consequently most women put in at least fifteen more hours of work a week than men. If all of that work in the home were counted, women's contribution to the GNP would be 39 percent higher. Yet none of

those vital tasks in the home, including looking after and teaching the next generation of workers, is counted, or paid for.

Women also get very little help from men. North American gadgetry is supposed to render home-making a breeze. It helps, but it also puts pressure on women, in addition to all their other responsibilities, to raise their house-keeping standards, become gourmet cooks and home-decorating experts, as well as informed comparative shoppers.

The bare facts are that more women in North America work, on average, than in Europe. The myth that women are being supported by men hasn't been true for the past forty years, except for a minority of upper-middle-class and wealthy women. Jobs done mostly by women, such as child care and clerical jobs, are low paid because they have traditionally been women's jobs. For all these reasons, more and more single mothers and their children, who often also suffer because of inadequate or no child support, are sinking into poverty. As well, in all three countries under recent conservative governments, proportionately more taxes have fallen on lower income people, the class in which women, married or single, find themselves.

Mythology is always strongest when facts and national beliefs are farthest apart. The North American mythology is that the ideal male is unencumbered, strong, silent, competitive, and aggressively successful. The job of keeping the family together falls almost entirely to the woman, whether she works outside the home or not. Yet, unlike many of the European countries, the U.K., Canada and the U.S. don't help people much in terms of services when a union falters and a family falls apart.

Few men in unhappy relationships want to be held in them—although they certainly should be made to support the children they have fathered. More and more women prefer poverty to an unhappy, often abusive relationship. But the fact is: if the family falls apart, it's the women and her children who are punished with a much lower standard of living.

In Europe most countries long ago accepted the fact that working mothers need child care and maternity leave without penalties for being the sex that produces future workers. In

Sweden, as we shall see, a single mother with children receives a child allowance, a housing allowance, child support either from the father or the state, and a full-time wage that is 80 percent that of men's. This means her total income, working full-time, would be 50 percent higher than that of a similar woman in North America.

The answer then to why so many problems still exist for women in the U.K., Canada, and the U.S., purely from a woman's point of view, is that free-market democracies, with their relatively weak labour unions, mythological views of how society should work, and their emphasis on individual rights, are not particularly good for women. Social-democratic systems have provided many more of the services that women need.

BRITAIN:
WHERE THE BACKLASH WAS LED BY THE P.M.

FACTS

Population: 56.9 million

Government: Bicameral. Membership in the House of Lords is hereditary or through appointment.

Vote for women: Brought in in 1918 for women over thirty who owned property. Extended in 1928 to all women.

Percentage of women elected: 6 percent in the House of Commons, one of the lowest in Europe.

Education: Coeducation since 1870, but fewer women on average have access to higher education than in most European countries.
Percentage of work-force women: 44 percent—45 percent work part-time. Women earn on average only 69.5 percent of what men earn.

Abortion: Performed for physical and mental-health reasons or because the foetus is deformed. Recently reduced from twenty-eight weeks to twenty-four weeks. Covered by National Health scheme. One-quarter of all abortions are on women under nineteen.

Child care: 53 percent of women with school-age children work, but only 37 percent of women with children under five work—the biggest gap in the European Community. One reason for this may be the lack of child care. There are only places for 2 percent of children under three in subsidized child care—and just for severely disadvantaged children. Day care for 37 percent of children ages three and four, but almost half are in pre-primary or primary school for only two and a half hours a day. After-school care for only .5 percent of five- to ten-year-olds. Women resort to neighbours and relatives, or home care by other women, which is often unapproved. A small number of employers provide child care, but women had to include such a service as a tax subsidy until 1990. No tax deduction for child care. Family allowance frozen at the 1987 rate.

Maternity leave: Eleven weeks before birth and twenty-nine weeks after, for a total of forty weeks. Six weeks paid at 90 percent of earnings—the shortest period in the European Community—and the rest at a low flat rate. Britain is the only country in the community where women have to work two years full time, or five years part-time for the same employer, to qualify for maternity leave. No parental leave or leave to care for sick children. A few employers offer better leave, career breaks or flex time.

Birth-rate: 13.6 live births per 1000 population, with one in five parents unmarried

Family law: One of the highest marriage rates in Europe, but also the highest number of divorces on average in the European Community. Close to two in three marriages end in divorce.

Achievements: Vigorous women's movement in 1970s. An Equal Opportunity Commission that has the power to take individual cases of discrimination to court exists, but is hampered by a small budget and staff.

Problems: A political system that is difficult to change, penetrate or lobby. The male establishment controls the judiciary, the bureaucracy, and business. Fractured women's movement today. Has the lowest proportion of GNP being spent on social programs of almost all the European countries.

THE BACKGROUND

Women had always worked on the land and in craft industries in rural England, but with the Industrial Revolution landlords fenced off small tenants' farms for sheep raising, forcing many people off the land and into the cities to work in the new factories. However, there were soon too many workers. With passage of the Factory Act in 1844, which was billed as a protective measure, many of the women and children were sent home.

The Victorian Age and the Victorian concept of marriage had arrived. Home was to be a sanctuary presided over by women. This didn't alter the reality that one-quarter of all women were still in the work-force out of necessity, and in jobs such as domestics, seamstresses, and factory workers.

The nineteenth century brought great gains for ordinary men—the right to own property, the right to vote, new opportunities in the professions. But there were no similar gains for women. By the middle of the 1800s women had less freedom and less control over their lives than they had had for centuries.

The first wave

There is a long and honourable history of British women campaigning for their rights, stretching back two hundred years to Mary Wollstonecraft, who wrote the first English feminist tract, *A Vindication of the Rights of Women*, in 1792.

The movement to get women the vote in Britain, one of the earliest and strongest feminist movements in Europe, started in

Manchester in 1865 and spread to London and other cities. It was more violent in Britain than in most other countries, and by the early twentieth century had become almost a religious crusade under Emmeline Pankhurst and her three daughters.

Suffragettes chained themselves to public buildings, burned railway stations, went on hunger strikes, and had to be force-fed. The Women's Social and Political Union, which the Pankhursts organized, had one hundred paid staff and almost one hundred thousand pounds to wage its campaigns.

In 1918 British women finally got the vote, but only for women property owners over thirty years of age. After World War I women workers almost immediately lost their war-time jobs, as well as the day care that had been set up for them. Then came the Great Depression of the 1930s and another war. Although the movement lost some momentum, it didn't die. Organizations such as the venerable Fawcett Society worked away between the wars for issues such as pensions for women.

The second wave

Ruskin College at Oxford University was the site of the first national Women's Liberation Conference in 1970. Three hundred women had been expected, but twice that many turned up. A co-ordinating committee was set up. The following year there were marches in London and Liverpool with banners proclaiming four major demands: equal pay, equal education and job opportunities, free contraception and abortion on demand, and twenty-four-hour nurseries.

Annual national conferences followed. In 1978, three more demands were added to the original ones: financial and legal independence, each woman's right to define her own sexuality, and an end to all laws and institutions that perpetuate male violence and aggression towards women in and out of marriage.

But even as early as the mid-1970s prospects of a strong national movement were already dying. In 1979, at a Black Women's Conference, many divisions emerged. From then on no real attempt was made to put together a national women's

movement. Working-class women felt the movement was too intellectual and elitist. Black women objected to feminist attacks on the family, which they saw as a protection for women. They also disagreed with white feminists on abortion.

The Greenham Common movement in the early 1980s, in which women campaigned for nuclear disarmament, once again drew women together in mass activism for a single cause.

The situation today

Everywhere in London large bronze statues celebrate the men who built the British Empire. Their modern-day successors are omnipresent as well, in their correct, too tight—by North American standards—suits, and with their unchallenged air of authority. And for the past eleven years, until she was toppled by a rebellion in her own party, the first woman prime minister in Britain, Margaret Thatcher, used her considerable power to support her own economic theories and her own vision of England's glorious past.

Many feminists have believed, perhaps naively, that once they got members of their own sex into positions of power, things would change. Margaret Thatcher knocked that theory out the window. There was room in her vision of Britain for women like herself, who could make it in a man's world. But there was no tolerance at all for feminism and all the changes many other women had been working for since the early 1970s.

Britain's first women prime minister was more traditional, more chauvinistic, more repressive towards women than any male predecessor could probably have got away with being in modern-day politics. She succeeded by acting like a surrogate male—or perhaps, as some feminists have suggested, as a Queen Bee. She rarely even appointed women to her cabinet.

As Jo Richardson, a Labour member of Parliament since 1974, put it: "She's had every advantage herself. She's had a supportive family, a good state education with two university degrees—law and science. She married a rich man, and always had a nanny for her kids, which left her free to go into politics. She could have

been a big help for other women. But instead she systematically shut down all kinds of support for children and women."

Whether you agree with her or not, what Margaret Thatcher, the grocer's daughter who grew up over the family store, tried to do was make Britain more productive and competitive. "Self-reliance" was her watchword, The Best to the Top her motto. And "Wets" was what she called all people who disagreed with her. Dismantling the welfare state as fast as she could, she tried to replace it with a more competitive, entrepreneurial Britain, but without changing any British traditions, such as its parliamentary system or its Imperial system of measurement.

She appealed to the new, young yuppie vote, as well as older Conservatives and working-class Tories, who felt they had lost something with the decline of the British Empire. Although few Britons seemed to feel real affection for her, they admired her will and her determination to reclaim stature for a nation still finding its way in the economic aftermath of a world war.

But her blueprint for women in her upscale model of Britain was depressingly similar to that of other neo-conservative leaders such as Reagan, Bush, and Mulroney. Like them she talked eloquently and reverently of "the family" as a kind of old-fashioned, all-purpose glue that would patch up modern society.

The statistics on British families, however, indicate that Thatcher's concept is far from reality. Less than one in ten British families lives in the traditional style that the Tory party, even its Labour opposition, are so fond of talking about as the norm: the working father, stay-at-home mother, and children. Today in Britain the divorce rate is higher almost two in three marriages—among the highest in Europe. One in seven families is headed by a single parent, the vast majority of them women. One in every five babies is born out of wedlock.

Margaret Thatcher and the Tory party prefer that women be at home, doing good works on the side. Or if women choose to work, that they make enough money to hire nannies or pay for private day care. But for the majority of women who comprise up 44 percent of the work-force—a high figure in Europe—such a plan is impossible. Most of them hold down a narrow range of

"women's" jobs, which means they don't even benefit from better paid, traditionally male jobs when times are good.

Their needs under Margaret Thatcher, except for a tougher law on rape, were ignored. Women were to "carry on", just as they had during the war. They were to do everything: hold down a job if necessary, look after their children and homes, and take on the care of all the old people, the handicapped, and the mentally disturbed whom the government dumped on the private sector as it systematically cut back social services and shut down institutions.

In 1981 the government cut housing subsidies and help for the elderly, and made the time needed to qualify for unemployment insurance longer. While other European countries increased maternity leave to two and three years, Margaret Thatcher's government raised the length of time women had to work to qualify. Today mothers are not allowed even to register for work unless they can prove they have child care—which is difficult when child care is almost impossible to find. Taxes have been shifted proportionately to lower-income people. The bottom fifth of the population's after-tax share has gone down, but for the top fifth of the population it has risen dramatically. Poor women are poorer and rich women richer.

To cope with the double burden of work at home and in the paid work-force, a very high percentage of U.K. women, compared with other European countries, work part-time—about 45 percent. Part-time workers are eligible for pro-rata benefits if they work sixteen hours a week. This means many women who don't work that many hours are in the labour-force all their lives and don't draw one penny of sick leave, holiday pay or pension. According to the Equal Opportunities Commission, there has been an increase recently of African and Asian women who do piece-work at home in the inner cities for low pay and no benefits.

But what is bad for women is good for business. Many employers prefer part-time employees. They can be paid less. The employer doesn't contribute to benefits. The workers are more flexible as far as hours are concerned. This may be why, in

Britain, the unemployment figures for women are lower than in many other European countries. But the down side, according to a report from the Equal Opportunities Commission, is that although female manual labourers earn 70.8 percent on average of what male manual labourers earn, non-manual female workers now earn less than when Thatcher came into power—a depressing 62 percent of what men earn.

Yet none of these factors, including the recession in the early 1980s, discouraged women enough to get them out of the labour-force altogether. They continued working, because in many cases it is the woman's salary that has kept the family above the poverty level.

Even though such a high percentage of women work, availability of child care in Britain is, to quote one academic: "If not *at* the bottom, *near* the bottom in Europe." The government has been pushing child care onto employers. But even when some employers responded, the government then taxed women for this service as a benefit. That was changed just recently. The government also de-regulated after-school care, removing minimum standards and quality controls.

The result of all these measures, according to Professor Hilary Land, who teaches Social Science at Royal Holloway and Bedford New College, is permanent poverty for some people. The rise in the number of children living in poverty in the U.K. over the past ten years has gone up from 7 percent to 19 percent. Two-thirds of all single mothers are now on social security.

Dr. Ann Oakley, a well-known British author, and director of the Social Science Research Unit at the University of London Institute of Education, has written extensively on the way governments (and people) have treated motherhood. She says Britain must accept, but never has, the idea of single motherhood. Single mothers receive little official support or recognition. Research shows that there is no connection between giving women welfare and the number of children they bear. Even though single mothers have less money than when married, they are less depressed because they have more control over their finances and their lives.

A day in the life of...

Among the women struggling to keep out of the poverty abyss are the residents of Swinburne Estates in Ladbroke Grove, one of the poorest areas in London, and overwhelmingly black. Val M., married for nine years, with two children, was born here. She says it was a slum when she was a child, with 100-year-old housing, outdoor privies, cold-water taps, dug-out cellars, and, as the only source of heat, dangerous, smoky oil stoves.

Val's mother, who had nine children, worked every waking hour of her life. She had no washing-machine, even though there were always nappies to be done. She wore the same coat for ten years. She and Val's father both worked shift hours so they could spell each other off looking after the children. Five years ago the Greater London Council tore down the rickety old houses and replaced them with new brick subsidized housing. The area, with its one thousand families, was given the classy name of Swinburne Estates.

Behind brightly painted steel doors, the yellow brick houses rise in two rows, stacked one above the other. Flowers bloom in the windows. Clean curtains defy the heavily polluted air. Yet to most people Swinburne Estates would still qualify as a slum. Graffiti decorates every surface—walls, elevators, doors. The nursery where Val works faces the A-40 motorway, with cars roaring by overhead. One of three nurseries that service the Estates, it is a little oasis in the frightening neighbourhood. "A drop in the bucket," according to Val. And at 30 pounds (U.S. $64.50) a week per child, it costs too much.

A single mother in the Estates is likely to earn around 90 pounds (U.S. $193.50) a week as a clerk or secretary, and receives 7-1/4 pounds (U.S. $15.58) weekly for each child from the government family allowance program. Rent at 150 pounds (U.S. $322.50) a month takes almost half her salary. Child care takes another third. This leaves less than 20 pounds (U.S. $43) for food, lunches, and clothes. Not surprisingly, some women find it easier to stay on welfare, because the rent is paid and they get 27

pounds (U.S. $58) for living expenses, plus family allowance for each child.

The biggest worry Val and her husband have is the future of their children. They fear that the children are being educated to be part of the lower class. "Many of the children aren't being well enough educated to even hold down a job. There are children in the school who can't read or write at eleven years of age," she says. One of her daughter's friends has had five different teachers over the past year. And the government has cut back on remedial reading programs. She criticizes the government's Youth Training Scheme. After two years in the program young people get a certificate, but she questions whether they are being properly trained for anything. She fears that they are just being used as cheap labour for the firms to which they are apprenticed.

When asked what the women's movement had done for her, she was very positive. With better birth control, she said, she was able to limit her family to two children. She feels she has a lot more confidence and independence than her mother. She joins organizations, is active in political parties—things her mother would never have thought of doing. Her mother did all the housework, but Val says she is raising her son to do lots of work in the home, including cooking for himself and doing his own ironing. "But I worry about what's going to be there for my kids," she says. "So many of the boys here get into crime, and girls get pregnant so early."

With a queen on the throne and a female prime minister recently in place for ten years, you'd think women would have made real electoral gains. But today they comprise only 6 percent of the House of Commons, and that's the highest percentage ever, since women first voted in 1918. There were no women in Thatcher's last cabinet and there are no women now in John Major's new cabinet. Thatcher was deposed in November 1990 in one day. A new prime minister and cabinet were named and a government platform announced immediately thereafter. The reason the transfer of governments was so efficiently carried out is that

British political power remains in very few hands. This highly esteemed prototype of Western democracy is itself not very democratic.

With the Tory record so poor, why haven't women joined the Labour party more enthusiastically? Lynne Segal, activist and author, explained this anomaly. In the sixties and seventies when the women's movement was at its peak, anti-government sentiment would have been strong no matter what party was in power. The reigning Labour government was considered old-fashioned, patriarchal, tied to the needs of its unionized male workers, and unsympathetic to women except in traditional roles.

"I was outside my local town hall demonstrating about something almost every week," she recalled. "There were campaigns for more child care, for battered women's and rape-crisis centres, or to prevent a local hospital being closed. Sometimes we just squatted in some building to get a hostel or a nursery set up. The local council was made up mostly of Labour members who were not hostile to the idea of equality for women, and we often were successful."

When the Tories came to power in 1979 British women realized that by comparison the Labour government had been the soul of generosity and understanding. In retrospect Segal says: "The Labour government was a horse that could be flogged, and we flogged it. But we were ungrateful."

Author and social critic Sheila Rowbotham thinks the Labour government's biggest contribution to women was not the legislation it passed but the work it did all over Britain through the local councils, mostly Labour. The Greater London Council (GLC), the municipal authority for London, is a good example. In its heyday the GLC Women's Committee had sixteen million pounds to spend. It set up hundreds of projects, published booklets, held exhibitions, established women's centres and shelters, started women's fire-fighting units, and operated language programs for immigrant women. But the Tories abolished the Labour-dominated GLC in 1986.

Under the Tories, some feminists have turned to Labour somewhat reluctantly as at least a better alternative. Some also

joined the Social Democrats, a new party that split off from Labour and attempted to place itself in a central position and woo voters away from both the Conservatives and Labour. But after ten years without making any real dent in the electorate it has faded away.

Studies prove that British voters have no prejudice against women candidates, but getting the nomination in winning constituencies is still the main hurdle for women—as it is in the United States and in Canada. Since 1979 all four national parties in Britain have tried to encourage more women to run, but with no real control over the local constituencies, they haven't been very successful.

Jo Richardson, the shadow minister for women in the Labour party, admits her party is little better than the Conservatives. Five positions out of twenty-nine on the national executive are reserved for women, but even those are vetted by the male-dominated unions. "There's been a row about that for years," she adds.

She thinks the tedium of party work puts many women off, but she has little patience with women who criticize the system yet won't get involved to change it. Single and childless herself, she concedes that being unencumbered by family ties is a common state for many of the women who are successful in British politics—and a sacrifice few men are called on to make. She also confesses that she worked for the party for years and ran in four hopeless seats before she got a chance at a winnable constituency in East London. Even then, she won the nomination by only one vote. "Women are always nominated for the worst seats," she concedes.

A feminist party is a futile exercise, she believes, in any country as big and diverse as the United Kingdom. She is scornful of the 300 Group, which has as its goal the election of women to half the seats in the House of Commons. "It runs courses on public speaking and so on, then says, 'Go find yourself a party'." But she doesn't criticize the British system to the point of supporting proportional representation, because she thinks parties would tend to select only non-feminist, non-controversial

women. "We don't need any more Margaret Thatchers," she says.

Richardson pins her hope on a promise she has extracted from her own party that if it comes to power again it will set aside one cabinet post for women's affairs.

If British women are outnumbered sixteen to one at Westminster, they are making some progress in local government, with one-quarter of all local council seats held by women. But the power of local government is gradually lessening under the Tories, weakening the only political arena where women now have any power.

Professor Hilary Land firmly believes British women would be in a much stronger position today if more of them were unionized. After World War II women in Sweden and Denmark joined the work-force and also became members of unions. British women, however, opted for part-time work, and until recently British unions have shunned unionizing part-time workers. "Women workers in Britain paid a heavy price by going into part-time work," Land says.

British unions are not nearly as strong as they used to be. In the past few years they have lost two million members, and today less than half of all British workers are unionized. In France, Germany, Sweden, and Denmark the work-force is almost entirely unionized. According to Dr. Land, the Tories want a competitive, low-wage economy with lots of low-paid, non-unionized workers who are disposable in bad economic times. Such workers are usually poorly educated young people, immigrants, and women.

Recently the government got rid of the Wages Council, which for eighty years had set minimum standards in non-unionized jobs. "Now a sixteen-year-old might have to work all night with no break. If you want to claim unemployment benefits you have to take any job that's available, instead of waiting for a job for which you're trained," she explains.

Professor Land has even more ominous criticisms of the system. "People are dispirited. We live in a more and more centralized state. The police have more rights to come into your home and the system is corrosive of civil liberties. Only 70

percent of people vote in general elections and we are more and more heavily constrained in our right to demonstrate and speak out." She also believes the press is being muzzled by the Official Secrets Act.

Although many of the women I talked to were disillusioned with both the Labour party and the unions, unions are finally waking up to the potential of organizing women. The Trades Union Congress (TUC), the biggest union organization in the U.K. with eighty-one affiliates, has had a women's committee for twenty years, but like many such organizations, it's been a passive appendage to the main body. The TUC's declining membership, and predicted shortage of skilled workers in the future, have finally aroused the huge monolith to a reluctant interest in women.

In a modest office in the imposing TUC building off Tottenham Court Road, Jo Morris heads the TUC's new Equal Rights Department for women—as well as racial minorities, the disabled, and homosexuals. She explained that women now make up almost half the work-force, and women with young children are its fastest growing segment. But only a little more than one in four works full-time. There is still a strong feeling in the labour movement—as there is in the political parties—that women belong in the home.

The TUC is now vigorously trying to organize these part-time workers as a new source of members. It is also beginning to implement pay equity. Traditional male and female jobs are being compared—a clerk with a warehouse worker, a nurse with a lorry driver. But in spite of its good intentions, the TUC is decentralized, a co-ordinating and advisory body only. It can't force its member unions to change.

One in every five British women works for the government, which claims it is committed to advancing women in the civil service. But the British civil service is still a pyramid, with large numbers of women at the bottom in low-paid, low-status clerical jobs and only 5 percent of senior civil servants at the top women.

Even in the legal profession, where women make up almost half the law students and 15 percent of all solicitors are now

women, only one in twenty-one judges is a woman. The judiciary is a closed oligarchy in which criteria and appointments are mysterious and secretive.

As for the machinery that deals with women in the U.K., in 1969, Harold Macmillan's Conservative government set up the Women's National Commission. It has fifty members from as many women's organizations, including the major political parties, and a small staff of four civil servants. It is co-chaired by a member of Parliament, giving it links, but not strong ones, to the government. (Margaret Thatcher was once the liaison between the commission and cabinet.)

The commission sponsors activities such as road shows telling school-girls how to get into male-dominated businesses and professions. Its members also undertake research by interviewing experts on subjects such as wife-battering and rape. Staff-produced reports are distributed free to anyone who wants them. The consensus among the women I talked to was that the Women's National Commission is too small, underfunded, timid, and old-fashioned.

There is another much stronger, more substantial piece of government machinery looking after women's interests, the Equal Opportunities Commission (EOC). Set up in 1975 by the Labour government to enforce the Equal Pay Act of 1970, it has the power to investigate cases of discrimination in the work-place. Unlike many other similar commissions in other countries, it can actually charge a company and take it to court. It can also give legal support to women who individually take employers to court.

But like so many institutions that have been set up to help women, the EOC was hobbled by a cumbersome structure from the start. Under a plan to decentralize the bureaucracy, the main office was located in Manchester, the heart of the ruling Labour government's support at the time. It also has a small, unobtrusive London office off the Strand. Other offices were to be added in Wales and Scotland, but they have never materialized.

The EOC is constantly fighting for its life, under attack from both feminists, who think it's far too slow and cautious, and back-bench Tories, who believe there is no need for it at all. The

government doesn't dare abolish it; it prefers to starve it by reducing its budget.

According to Baroness Beryl Platt of Writtle, a Conservative peeress and chair of the EOC from 1983 to 1988, no other country has as strong an equal opportunity commission as the U.K. She points out that critics overlook the fact that more than a thousand cases brought to the commission have been settled out of court. She gives as an example Barclay's Bank, which had been paying its female employees less than men in the same jobs. Faced with the threat of a lawsuit, the bank capitulated and changed its policy voluntarily.

But EOC's critics allege that only twelve court cases in as many years is a dismal record. Each case has to go through fifteen different legal stages and takes an average of four years. The basic weakness in the system is that the onus falls on the victim to complain. Many women are intimidated by the prospect of losing their jobs, then waiting for four years for the case to go through the courts. Another weakness is that the commission is powerless to make employers review their policies and report back. And it can only investigate firms with more than six employes, which cuts out thousands of women who work for smaller firms.

More than one-quarter of the EOC's cases are from men. They complain about swimming pools that are reserved for women, and about special consideration being given to women for jobs. Each case in which a man is the complainant gets great play in the press, while much of the solid, steady work the EOC does on behalf of women is never reported.

The EOC actually enjoys a much higher status in other countries than it does at home. Many women I talked to throughout Europe envy the U.K. women this potentially powerful tool with its ability to take cases into court.

With a weak Women's National Commission and an under-funded, cumbersome Equal Opportunities Commission, help for British women has come in the past few years from a quite unexpected outside source—the European Community.

It is curious that the United Kingdom, with its long history as a pioneer in civil and human rights, is now dragging its heels over

rights for women. The European Community has been a useful prod to the government.

Britain is the only EEC country balking at agreeing to parental leave, paying pro-rata benefits for part-time workers, and instituting a minimum wage. It was pressure from the European Community that finally forced the British government to improve and implement its Equal Pay Act and establish the principle of equal pay for work of equal value. In response, the government brought in new legislation that, according to Jo Morris, "is as complex and obtuse as possible". Even Lady Platt described the new law as "needing improving considerably".

One example of how the European Community has helped British women is the case of Helen Marshall, who worked for the Southampton Health Authority. She wanted the right to work until she was sixty-five, as men did. She appealed her case through the EOC right up to the House of Lords—and lost. She then took her case to the European Court and won. Also due to the European Community, women at home looking after disabled family members can now legally claim benefits such as a pension from the government.

Living under a political system creaking with rigor mortis and an unsympathetic government, the women of the U.K. could be greatly helped by a strong, united, national women's movement. But there is no united women's movement in the U.K. today. The reason, I was told again and again, is that it cracked wide open in the late 1970s over Britain's persistent race and class splits.

Margaret Williamson, lecturer at a college in South London, says the British women's movement did achieve a lot of its goals— shelters for battered women, rape-crisis centres, health-counselling units, women's studies at universities, the end of sex stereotyping in many school textbooks, an impressive body of feminist scholarship and literature, women's bookstores, women's magazines such as *Spare Rib*, a flourishing women's publishing house, Virago Press, as well as programs on the BBC's channel 4 that would otherwise never have been produced.

But in spite of the fact that the women's movement is now institutionalized in schools, libraries, and universities, and anti-

violence-drives and campaigns for rape-crisis centres still go on, Williamson regrets that the conditions under which most women live and work are little improved.

She feels the movement has lost its impetus and that women like her, active feminists now in their early forties, are considered *passé* just as the suffragettes were in the 1920s after the vote was won. "Many young women today are reluctant to be labelled feminists, even though they have attitudes derived from feminism," she says ruefully. (Personally I feel that's a pretty common attitude among all young women. They realize feminism is not particularly attractive to the opposite sex, for whom they often have an all-absorbing interest at that age.)

Jenny Williams, who runs the Women's Centre in Wild Court Place near the Holborn tube station, says the U.K. movement never was a strong, centrally organized operation. British feminists have always been badly split between the socialist feminists, who believe in bringing about change by political pressure within the system, and the radicals, who blame all women's problems on patriarchy.

Michèle Barrett teaches social science at London's City University. Her office was easily recognizable as that of a feminist from the brightly coloured, often humorous, feminist posters on the walls. "I wouldn't decry what the movement achieved," Barrett says. "It achieved quite a lot because it was so radical. A lot of people were distressed because it fell apart, but those sorts of internal divisions look very silly and petty to me now.

"Feminists are still more concerned about arguing with each other than with the forces we should be more united against. U.S. feminists tend to think we're backward. But although child care is deplorable in Britain and women earn much less than what men earn, in both cases the U.K. is well ahead of the U.S.A."

"I'm not pessimistic, although you'll meet many women who are. I subscribe to the sugar-cube theory. The women's movement was the cube of sugar—there and tangible. But now it's in the tea, and the tea tastes completely different. It's dissolved and it's had an absolutely irreversible effect."

I was able to observe for myself the present state of the

women's movement in the U.K. when I attended a feminist conference in the middle of London on New Questions for Feminism: A Celebration of Twenty Years. The turn-out was encouraging. The seats were filled and women were sitting in the aisles. There was a sisterly feeling in the air. The morning began with a panel on mothers—warm, frank personal stuff in the old consciousness-raising style.

One of the panelists, an actress who looked like a young Germaine Greer, told of growing up in a socialist feminist collective in the seventies with her single mother. There were men around, but they seemed to her insignificant among all the dynamic women. She was taken to lots of demonstrations and conferences. Unlike many girls, she was brought up to be independent and tough and capable of looking after herself.

As long as she said she was going to be a doctor or an airplane pilot everyone was happy. But at adolescence her mother and the other women in the collective were appalled when she announced that she wanted to be an actress. "Why aren't you demonstrating or trying to write a novel or something?" they would say in exasperation. Now working as an actress, she says she feels let down by her mother, who seems tired and has lost her radical edge.

Another young woman, daughter of one of the publishers of Virago Press, said she too was raised to feel she could take care of herself. Now if men leer at her on the streets, she swears at them. But she believes women her age don't think they have to fight any more, and she herself doesn't feel part of the movement. She even finds it hard to define herself as a feminist. She was gutsy enough to say that she doesn't intend to work while her children are small, and although she believes women should have a choice in abortion she would not choose it for herself—both near heresies before such an audience.

After lunch, during a panel on feminism and politics, the conference began to unravel at its racial and class seams. Again and again the discussion was interrupted by a woman white with rage who rose to say: "I'm part of the working class, and I don't feel this panel is representative of my class." A black woman

pointed out that although she had status in her classroom as a teacher, she had no status anywhere else in the United Kingdom. By the time the last panel, on the future of the women's movement, began, I was convinced it had no future at all.

In the face of all this name-calling, infighting, and divisiveness one woman is mounting a solo campaign to create a new, united woman's movement. Jane Grant has drawn together 140 women's groups from the women's section of the National Council of Voluntary Organizations to form the National Women's Alliance. She hopes to weld it into a U.K. version of the National Organization for Women in the U.S. She says she's got women from every political party and from a wide spectrum of organizations, from the Women's Institute and Mother's Union to more radical groups such as the Women's Environment Network. She has written a how-to manual on fund raising, which she says has become the Bible for British women's groups.

Her organization has done a detailed critique of the U.K.'s tepid response to the United Nations requests for policy statements on women. It has also protested about the government's housing policy, which allowed tenants to buy their units in previously subsidized council housing complexes. "But they forgot to build new housing for people who can't afford to buy and are forced to move out," Grant complains. "All the new housing is for yuppies, not working people. As a result there are more and more people living below Waterloo Bridge in boxes."

Discouraging, though, are surveys taken all through the 1970s and 1980s that found that the British people—male and female— were generally less aware of and less supportive of the women's movement than people in most other nations of Europe. Feminists worry that the movement is doomed to repeat itself, to see many of the gains made during the past twenty years lost, only to be won all over again by another generation of women.

Still there are a few hopeful signs for British women. Women Against Rape have been campaigning to make rape in marriage a crime for the past thirteen years. Only in Scotland is it forbidden in law. But recently in England a judge sentenced a man to jail for raping his wife after she had left him, even though they were

not legally separated. Now the government has decided to change the law in England and Wales.

Family allowance benefits, which go out to six million families and cover twelve million children, have been frozen for four years. With an election imminent the Tories have raised the rate for the first child only, by one pound, to 8.25 pounds a week (U.S. $16.90).

There was also a slight gender gap in favour of Labour in the voting patterns of men and women in the last election that can be used to convince Labour and the unions that they are on the right path at last in their attention to women's needs. In response, the Tories recently set up a new committee in the cabinet to co-ordinate issues of importance to women and give them a higher profile.

Nevertheless, on the whole for British women advancing women's rights is going to be a long, slow slog.

IF THE U.S.
IS THE BEST OF ALL POSSIBLE WORLDS, WHY ARE WOMEN AND CHLDREN SO BADLY OFF?

FACTS

Population: 241.6 million

Government: Elected House of Representatives and Senate. President elected separately.

Vote for Women: 1919

Percentage of women elected: 5 percent

Education: Half of university students are women, but less is spent on public education than in Italy and Hungary.

Percentage of work-force women: 44.8 percent, high compared with Germany. Women earn only 65 percent of what men earn—one of the lowest in the Western democracies. Only 26 percent work part-time, perhaps because firms are not legally required to pay part-time benefits, although some do.

Abortion: 1973 Roe *v.* Wade Supreme Court decision gave women the right to abortion on demand, but that right is now in danger.

Child care: No national policy. Only around ten thousand

publicly regulated centres. One-quarter of all children are in the sixty-four thousand private centres. The majority of children are looked after by neighbours, relatives, etc. Tax refund for higher-income workers, but no help to poor women who don't earn enough to pay income tax.

Maternity leave: None under federal law. Eighteen states grant some form of paid or unpaid leave and thirty states are considering legislation. One in ten companies has some form of leave or flex time. Sixty percent of women are not covered at all. Most women take time off or use their two or three weeks' holiday time. The 1978 Pregnancy Discrimination Act forbids employers from firing pregnant women if they do not fire temporarily disabled men as well.

Birth-rate: 16 live births per 1000 population

Family law: Divorce is under state jurisdiction, so laws vary greatly. It is estimated that one in two current marriages will end in divorce. Two-thirds of divorced women get no child support from their former husbands. Their standard of living drops dramatically in the first year after divorce. More effort is being made to get fathers to pay child support, but increasingly fathers are suing for custody and winning.

Achievements: The second highest standard of living, on average, in the world. One of the earliest and strongest feminist movements. A more aware public in regard to feminism, but also a bigger backlash than in most countries.

Problems: An inflexible political system in which it is more and more expensive to run for political office. No public health insurance except for the poor and elderly. Although individual Americans are responsive and generous, there is an attitude on the part of society that people must take care of themselves and those who falter deserve what they get. Infant mortality is worse than in many Third World countries.

THE BACKGROUND

Spain established the first European colony in what is now the United States in 1565, followed by the French and British. The British ousted the French and extended their rule over most of the Atlantic coast and the west. Conflict between Britain and the young colonies led to the American revolution, the Declaration of Independence in 1776, and the founding of the United States of America.

The settlement of the west added vast new territories. The annexation of Texas and the Mexican War resulted in the acquisition of California and most of the present southwest. A bloody Civil War in the 1860s culminated in victory for the north over a Confederacy of southern states, determined to secede from the Union over the right to keep slaves.

The remainder of the century brought an explosion of industrialization. More territory was acquired: Alaska; the annexation of Hawaii; and, after winning the Spanish–American War, the territories of Guam, Puerto Rico and the Philippines. After World War II the U.S. became a leading world power. The 1960s saw much student unrest and bitter protests over the lack of integration of blacks into the U.S. mainstream, as well as against the Viet Nam War. Women were involved in this dissent.

The first wave

The fight for American women's rights began in the early 1800s when women started working to help free the slaves. Like their great-granddaughters more than one hundred fifty years later, they resented the secondary role they had to play—for example, not being allowed by male abolitionists to speak publicly. The first women's rights convention took place in Seneca Falls, New York, in 1848, where women draw up a declaration for equal rights in marriage, property, wages, custody of children, and voting privileges.

Women such as Elizabeth Cady Stanton, Lucy Stone, Lucretia Mott, and Susan B. Anthony had been promised their needs would be looked after when the abolition battle was over. They were furious when black men got the vote but their own rights as citizens were ignored, and a group split off to work for women's suffrage, with Stanton as first president of the National Women's Suffrage Association, 1869–90. Stone was president of the less radical American Women's Suffrage Association and edited the *Woman's Journal.*

Susan B. Anthony, who organized the first women's temperance union, worked to get women in New York State rights over their own property and children. Margaret Sanger worked tirelessly and even went to jail to establish the right of women to information on birth control early in this century.

The two women's suffrage associations joined in 1890, and Carrie Chapman Catt carried the fight for suffrage into the twentieth century. The then territory of Wyoming gave women the vote as early as 1869. Eight states allowed women to vote before they got federal suffrage in 1919.

After the 1920s, when a "women's vote" didn't seem to make any difference politically, the government tended to ignore women. The National American Women's Suffrage Association had by then emerged as the League of Women Voters, a nonpartisan organization devoted to educating women and urging them to become active in politics.

A Women's Bureau was set up in the Department of Labor in Washington, D.C., in 1920 to churn out information about the long hours and unsafe conditions under which women worked. It also began to push for equal pay. A National Women's Party was formed by Alice Paul, who had worked in England with the Pankhursts. In 1923 she began a long fight to get an Equal Rights Amendment (ERA) into the U.S. Constitution.

But the League of Women Voters was afraid that absolute equality in the Constitution would take away a lot of hard-won protective legislation for working women, and it fought the ERA. The Women's Bureau and women's unions agreed. Alice Paul, on the other hand, argued that equal pay would undermine

opportunities for women to be hired over men. This division in the women's movement turned into a battle that has carried on through most of this century.

The second wave

In the 1930s depression, many women, particularly married women, were pushed out of the work-force. World War II brought them back to fill war jobs while men were away, only to be thrown out again when the men returned. By the 1960s, women were becoming restless. The U.S. had gone through a great period of prosperity. Labour-saving devices and smaller families made full-time house-keeping seem something less than a life-time career for many a woman who had a university degree tucked away in a bottom drawer.

In 1960 Esther Peterson, an advisor to John F. Kennedy in his presidential campaign, was made head of the Women's Bureau. Peterson persuaded Kennedy to set up a national commission on women chaired by Eleanor Roosevelt. Following its recommendations, all the states except one set up commissions on the status of women. Peterson then invited these commissions to annual meetings in Washington. But women were dissatisfied with the progress being made through the commissions. In 1966 Peterson invited women's organizations to Washington, and the National Organization for Women was formed. Its first president was Betty Friedan, whose 1963 best-seller, *The Feminine Mystique*, had debunked the myth of femininity and motherhood, and had hit suburban kitchens and nurseries like a bombshell. Friedan has called the Women's Bureau the midwife of the women's movement in the U.S.

In 1968 sixty women staged a demonstration in Atlantic City against the Miss America contest, crowning a sheep "Miss America" and throwing their bras in a trash-can. From this act came the image of bra-burning feminists, but no bras were actually ever burned. Women invaded Wall Street and put a "hex" on it. Women took over the office of *Ladies Home Journal* and demanded more coverage of feminism by this former Bible

for American women. In August of 1970 there was a nation-wide demonstration for equality, culminating in a huge march down Fifth Avenue in New York City.

What did American women want? What women all over the world want: equal rights to jobs and education, the right to abortion, twenty-four-hour child care, and more political power. By the 1970s thousands of women were meeting in small consciousness-raising groups in one another's living rooms. Others were organizing politically in groups such as the Red Stockings, the Radical Feminists, WITCH, and Bread and Roses. There were fifty groups in New York alone. Slogans such as The Personal Is Political made it clear that the ultimate purpose was political and social change.

As it does in so many areas, the U.S. media took over and created "stars". Many U.S. feminists became household names throughout the U.S. and abroad. In addition to Betty Friedan there is Gloria Steinem, a founder of *Ms* magazine, who once had worked as a "bunny" in a Playboy club and wrote an exposé about her experiences; writers such as Shulamith Firestone, Kate Millett, Andrea Dworkin, Robin Morgan, Marilyn French, and the early leaders Ti Grace Atkinson and Flo Kennedy.

The situation today

The United States since World War II has taken on the role of leader of the Western democracies. Like other great nations, the U.S. was founded on grand and noble principles, which have come down through generations of Americans as potent national mythology. One of its most admirable precepts is inscribed on the Statue of Liberty: "Give me your tired, your poor, your huddled masses, yearning to breathe free, the wretched refuse of your teeming shore. Send these, the homeless, tempest-tossed to me. I lift my lamp beside the golden door."

Yet what strikes the friendly but concerned observer today is how far this great country has strayed from that great humanitarian promise. Its tired, poor, huddled masses, yearning to be free, can be found in every derelict neighbourhood in every

large city. Indeed, some of them are camped right in front of the White House in Washington, D.C. One in five U.S. children is being raised in poverty. Food banks have tripled in the past few years.

Another paradox in this country that thunders on so much about its democratic institutions is the fact that less than half the electorate bothers to vote. (In the last mid-term election less than 40 percent cast ballots.) There are only two political parties: the Republicans, which have elected the president two-thirds of the time in the past two hundred years and represent the business interests; and the Democrats, who have been responsible for most of the social-welfare legislation that has been passed in this century. Unlike every other democracy, the United States has no mainstream socialist party.

According to Dr. Roberto Spalter-Roth, of George Washington University: "Socialism is out of fashion. There is a lack of left-wing policy and ideology in the U.S. and a cynicism and powerlessness among U.S. people. In fact, the U.S. has trouble with collectivity of any kind."

Fundamental to America's sense of itself is its belief that the U.S. is a classless society. Behind this rampant individualism is the conviction that almost anyone can be a self-made Henry Ford if only he (women are rarely mentioned) tries hard enough.

Hardly. For the past ten years presidents Reagan and Bush, using the same economic textbooks as Margaret Thatcher in England and Brian Mulroney in Canada, have shifted more of the tax burden onto the middle class and the poor and less on the rich. The theory is that by liberating the top earners from taxes, new industries and wealth will be created and some of the riches will "trickle down" to the poor. As for women, it will become more possible for them to once again be supported by the kind of men their mothers called "good providers", and, according to the theory, more of them will go back to their proper place in society as housewives and mothers.

Personal income taxes were cut 6 percent, corporate taxes 23 percent. But ordinary people had to pay 23 percent more in social security payments. Today rags-to-riches success stories are

largely confined to sports heroes, movie stars, and rock musicians. A typical twenty-five-year-old today will live less well by the age of forty than his or her parents do now. Yet the rich are getting richer. From 1979 to 1987 the number of billionaires increased five times. And the gap between rich and poor widened. The proportion of people working for minimum wages increased, and more middle class people slid towards the low end of the income scale.

Far from creating new jobs, a lot of corporate buyouts that occurred were accompanied by wild speculation on the New York Stock Exchange, and some notorious swindlers ended up in jail. The number of lunch-bucket jobs for men in manufacturing dwindled, to be replaced with low-paid service jobs, usually filled by women. Twenty years ago a minimum wage was enough to keep a family of three out of poverty; today that same family is U.S. $3,000 a year below the poverty level.

Out of this same American dream of great riches to be had for the diligent comes a meaner concept—that people should be able to look after themselves, and if they can't it's their own fault. Paula Caplan, a Canadian sociologist educated in the U.S., observes that "even among quite nice, intelligent people in the U.S. there is an idea that social problems shouldn't be their responsibility."

The U.S. has statistics on everything. But in spite of some rather appalling facts, Americans seem to feel it is disloyal to criticize their own national institutions. As Paula Caplan says: "I wish there were something like 'the loyal opposition' as in the British and Canadian systems, where you can criticize the system without being labelled a traitor."

Among some of the most interesting facts: Per capita, the U.S. is the second wealthiest nation in the world next to Switzerland, but, according to the Children's Defense Fund, a Washington-based information centre, it is also the only developed country in the world without a national policy on medical care, child care or maternity leave. Sixty-one countries now have some form of national health care. Family allowances are routine in sixty-three countries and paid maternity leave in seventeen countries. Still

the U.S. provides none of these basic supports for its citizens.

The cost of rescuing America's poor children, which could save billions of dollars later in welfare, social programs, health and crime costs, is estimated at U.S. $26 billion a year, or about 1.5 cents out of every dollar in the U.S. budget. But that 1.5 cents is more than what recent U.S. governments have been willing to spend.

Instead, in the name of decreasing the deficit, which ballooned under Reagan, U.S. $10 billion was slashed from programs to help the poor. Public housing was cut, so that poor families now spend more than half their income on a place to live. The minuscule budget of the Women's Bureau was also slashed. "Workfare" projects, where indigent men and single mothers work for minimum wages—reminiscent of nineteenth century poorhouses—were supposed to help. Yet U.S. $1.9 trillion was found to spend on national defence, and just recently U.S. $500 billion was spent to bail out the scandalous bankruptcies of hundreds of savings-and-loan corporations.

The growing numbers of poor children directly challenge another myth—that the typical American family still consists of a bread-winning father, a brownie-baking mother, and 2.5 well-adjusted kids. Today less than one in four families follows that pattern—which is still high compared with most other countries, but not the norm, even in America.

Today one in every two U.S. marriages among younger people ends in divorce—one of the highest divorce rates in the world. Nearly half of America's children will grow up in a re-constituted family, in which one or both parents have children from other marriages. One family in five is a single-parent family, headed usually by a woman, and that family is very likely to be poor. Yet the U.S. tax system stubbornly gives tax breaks to families with stay-at-home spouses, usually wives. The earner in the partnership can split his or her salary and mortgage as though each partner earned half.

Mixed up with the conviction that the traditional family is the answer to all society's ills is a strong dose of fundamentalist religion. Even though a majority of the U.S. public never go near

a church except to get married or buried, so-called Christian attitudes on such subjects as abortion, sex education in the schools, and teenage pregnancy colour much public thought and political expression. In one of the most hedonistic societies in the world, puritanical attitudes influence legislation to an extent that is baffling to many outside observers.

By the year 2000 women will make up half the work-force. Over the past twenty years women have slightly increased their share of the better jobs, but they still earn only 65 percent of what the average man earns—a much bigger gap than what is common in most European countries. And the future isn't promising. Two-thirds of minimum-wage workers are women. Employers, as in Britain, are replacing costly full-time workers with cheap, easily disposable, non-unionized part-time workers, often women. But unlike women in other countries, who like part-time work because it is covered by pro-rata benefits, U.S. women rarely get benefits for part-time work and resist it for that reason.

In addition to low-paying jobs, two-thirds of all separated and divorced mothers receive no child support from fathers. Because of the growing burden on the state, more effort has been made lately to force fathers to pay child support. A high proportion of single mothers on welfare are African-Americans, who make up 11.5 percent of the U.S. population but 40 percent of single mothers in poverty. Hispanics, who are 6.4 percent, of the population make up, 15 percent of women living in poverty. Trying to enforce child support among these groups is difficult because unemployment is high for both men and women.

Child abuse follows poverty and crowded living conditions. In 1987, 2.2 million children—an increase of 48 percent in five years—were abused, neglected or both. One and a half million U.S. children run away from home each year. The biggest cause of baby deaths is homicide—usually by a parent. Violence is the second leading cause of death among fifteen to twenty-four-year-olds. A whopping 7.5 to 9.5 million U.S. children have serious emotional problems, and one in four of them gets no help at all.

More babies die per capita in the U.S. than in eighteen other countries, including Singapore, Hong Kong, and Spain. More

than half a million are born every year with no pre-natal care. U.S. one-year-olds have a lower immunization rate than babies in fourteen other countries—behind Sri Lanka, Albania, and Colombia. Adding to its other health problems, the U.S. consumes 60 percent of the world's illicit drugs, which costs the country U.S. $200 billion alone in medical care, crime, and lost productivity.

With drug abuse increasing, more and more children are being dumped into the child-welfare system by drug-addicted parents. By 1995, if the current trends continue, the number of children in foster homes, child welfare, mental-health institutions, and juvenile detention centres will nearly double.

A confusing patchwork of federal, state, and municipal programs attempts to cover all these problems. With a federal system it's impossible to get one set of social laws throughout the whole country. Many people get lost in the red tape. Currently the federal government spends U.S. $6.9 billion on a mixed bag of programs aimed at low-income families. Aid to Families with Dependent Children (AFDC) is the main welfare program for children and mothers. It dates back to the 1930s and was supposed to be an emergency program that eventually would be phased out. Today it covers eleven million people and costs U.S. $8.8 billion a year—which is still only 1 percent of the federal budget, and 1 percent of what it's going to cost to bail out the savings-and-loans banks. (Defence alone accounts for 27 percent of the budget.) Although most families do get off welfare in two to three years, some families are third-generation recipients.

Other programs include Head Start, to help deprived children prepare for school; food stamps; school lunches; and after-school care. There is also a tax credit of approximately U.S. $1,000 a year for families earning approximately U.S. $15,000 or less and who have children under eighteen. Some states, as well as various charities and church groups, also provide help.

The U.S. is almost alone among modern democracies in that it has no universal health scheme. Older people, low-income and welfare families are covered by Medicaid and Medicare. Medicaid is financed by the federal government and the states,

and must cover all poor children up to the age of five and adults whose income is below U.S. $10,000 approximately. In 1990 the age limit for children was raised to eighteen. Some doctors, however, refuse to accept the fees. Some states supplement the federal programs. But thirty-seven million Americans—mostly the working poor—have no health insurance at all. Another seventeen million have inadequate coverage. A serious or lengthy illness can wipe out a family's savings.

The U.S. medical system—which fails to adequately cover close to two out of five people—is the most expensive in the world. It absorbs 11.5 percent of the GNP, while other countries take care of all of their citizens with much less: Sweden 9 percent, Canada 8.5 percent, Germany 8.1 percent, Japan 7 percent. "We believe in having expensive machines to look after people when we get sick, but not in spending money keeping people well," explained Pat Reuss, of the National Women's Political Caucus.

The U.S. has some of the finest private schools and universities for those who can afford them, but as a nation it ranks behind Italy and Hungary in public spending on education. Increasingly, employers complain of high-school graduates who can't spell, do simple arithmetic or even read well enough to follow basic instructions.

The pregnancy rate among teenagers is one of the highest in the Western world; yet, due to religious pressure, no TV network will carry birth-control advertising and only one in three states has sex education in schools. Reagan cancelled all population planning aid to agencies that offered abortion as a choice to women either in the U.S. or abroad.

Business claims it would lose U.S. $16.2 billion a year if maternity leaves were made mandatory. But it costs women twice that—U.S. $31 billion a year—in lost wages, and the country another $108 million a year in welfare for women with no other means of support. In practice, most U.S. women take sick leave to have their babies, but only 40 percent of them are covered by leave at all.

With eight million children under the age of five with working mothers, child care is a crying need. But until recently there was

no national policy. Richard Nixon killed a proposed child-care bill in the early 1970s as being "Communistic". And that's been the general attitude of Republican governments ever since. The choice for mothers has been private arrangements in the homes of neighbours or relatives at a cost per week of between U.S. $20 and U.S. $200, or run-for-profit day care. Most such centres provide barely adequate or sub-standard care. This plus recent scandals about child abuse in some centres call out for stricter regulation.

Two-thirds of all U.S. women say that they can't find day care for babies, and half of them have trouble finding care of any kind. But in the fall of 1990 the first legislation on child care since World War II finally passed Congress, and President Bush signed it. Two and a half billion dollars in block grants will be allotted, mostly in tax credits to families with children, which helps middle- and upper-class families. About U.S. $1.5 billion in matching grants for the next five years will help states set up child-care programs for low-income families.

A day in the life of...

Karen and Robert S. had a big wedding about ten years ago that cost them and their parents more than U.S. $10,000. "It didn't seem silly at the time," Karen says as she looks at the big picture of two smiling young people in formal clothes. "It was what everyone did."

They thought they had nothing to worry about. Karen had a wonderful job as receptionist in a radio station. Robert had just started a new job as a computer trouble-shooter. Two years later when Karen got pregnant she decided to take six weeks off. The station manager fired her.

Her baby daughter, Lisa, was premature and the costs ran well over U.S. $100,000 and weren't completely covered by their private medical insurance policy. The money they had been saving to buy a house was wiped out. The baby continued to have problems—recurring bouts of asthma that made it impossible for Karen to go back to work. Pragmatically, they

decided that since Karen couldn't find another job they would have another baby. Robert took on an extra job on week-ends.

Their new baby son seemed fine, and when Lisa was ready for kindergarten Karen went back to work. But the little girl caught every infection going and continued to have breathing problems. The cost of allergy specialists, shots, an inhalator, and two hospital stays a year for three years at U.S. $6,000 a year came to U.S. $18,000.

No matter how hard Karen and Robert worked they never seemed to get ahead. To save money they moved in with Robert's parents in what was to be a temporary arrangement. The strain of living with in-laws whose ideas about child raising differed from hers caused behavioural problems with Karen's son. Guilt-ridden and desperate, Karen demanded they find another place to live. Robert said they couldn't afford it. Then her daughter got ill again.

Desperate, she decided to leave Robert, move in with her divorced sister, quit her job, and go on AFDC until she felt both children could manage without her. Then she began to realize what a paper maze she was trapped in. Her first-month's grant was $40 because it was calculated incorrectly. She borrowed from her sister. The next month, in another foul-up, she got only $66. Far from being able to spend time with the children, she was in the welfare office almost daily, trying to get things straightened out. Then she was told she wasn't entitled to some food stamps she had been given because her daughter had been in the hospital for part of the month.

About this time she and Robert decided to try putting their lives back together. They found another apartment. Once Lisa was well again and the children were settled in school, Karen again went back to work. Robert continues to work at two jobs. "He's really a good man," she says. "And I'm lucky. Lots of guys would never have stuck through all of this."

They still have no prospect of ever buying a house. In retrospect Karen says: "I don't know what else we could have done. None of it seems like our fault. If I had it all to do over again I would have been married down at the city hall and saved the

money. How were we to know then what was going to happen? It sure hasn't turned out to be the Great American Dream."

While Americans don't believe in publicly supported social programs, they do have faith in their courts. In fact, they are the most litigious nation in the world. And it's been through laws, backed up by some famous court decisions, that U.S. women have made some remarkable gains.

In 1964, U.S. women got Title VII of the Civil Rights Act, prohibiting discrimination in employment on the basis of sex. While a bill covering race, colour, and creed was being debated, women campaigned to have "sex" added. Some of the elected males who were against the bill supported the addition in the hope that it would kill the whole bill. But it passed.

In 1965, U.S. women got the right to buy birth-control devices, but not the pill, without a prescription. In 1972, where education was federally funded, discrimination on the basis of sex was forbidden in hiring, as well as money spent on school facilities and activities, for example, sports equipment for boys and girls. In 1974, discrimination in extending credit to women was forbidden. In 1983, the Economic Equity Act made it easier for a woman to join a private pension plan and prevented a husband from signing away the survivor's benefits on his plan in order to get lower premiums without his wife's consent.

To enforce Title VII, the Equal Employment Opportunity Commission (EEOC) was set up in 1964. At first it ignored the sex discrimination amendment. Instead Title VIII was used by the states to knock down laws that protected women from working late, doing heavy work—the very laws the Women's Bureau, the League of Women Voters, and Eleanor Roosevelt herself had fought to protect and believed the ERA would hurt.

In 1965, an Affirmative Action program for blacks, other minorities—and women—was brought in by President Lyndon Johnson. All companies with federal contracts had to have an affirmative action plan that would be reviewed from time to time. If a company failed to advance minorities and women the EEOC could take it to court.

Nothing much happened until the early 1970s, when AT & T, one of the biggest firms in the U.S., was taken to court and forced to pay back wages, as well as institute an affirmative action program for blacks, Hispanics, and women. This seemed like a tremendous gain that would force other companies to do the same. However, Joan Acker, professor of sociology at the University of Oregon, who has spent several years studying labour legislation in the U.S. and in Sweden, says AT & T got around the law by promoting women to positions that were technologically *passé* and were being phased out.

Eleanor Holmes Norton, who became chair of the EEOC in 1977 under President Jimmy Carter, gave Title VII more teeth by cleaning up a huge backlog of cases that had almost made the commission moribund. She set tough new guidelines for sexual harassment and racial discrimination. However, when Carter was defeated she was replaced. She says her greatest disappointment was in not being able to move on pay equity, but under Reagan that was impossible.

In the last few years there have been more legal setbacks than gains. In 1978, the Supreme Court ruled that quotas in affirmative action were illegal. In 1983, President Reagan cut $5.78 million from the Women's Education Equity Grant Program. As well, he cut the budget of the EEOC, gutted the federal affirmative action program, and sabotaged other programs by appointing either anti-feminist women or conservative men in the place of reformers. A lot of energy was spent by women during the Reagan years fighting cases of "reverse discrimination", whereby white males were supposed to have lost jobs because women and males from minority groups were being promoted. As a result, a lot of companies have simply forgot about gender equality. In the final months of the Reagan term, seven decisions on equal employment opportunity laws were handed down by the Supreme Court that make it harder for women and minorities to sue for discrimination.

One of the most important victories for U.S. women was the Roe *v.* Wade case in 1973, in which the Supreme Court ruled that American women had the constitutional right to abortion.

Against an onslaught of challenges from the states, in 1976 the court established that the consent of parents and husbands was not needed to obtain an abortion. In 1983 it decreed that women could not be forced to wait twenty-four hours before an abortion, or be lectured about foetal rights.

Even with abortion rights guaranteed by the highest court in the land, a relentless attack by anti-choice forces continues. Thirty-two clinics have been burned or bombed. One staff doctor was maimed by a booby trap hidden in her morning newspaper. Women going for abortions have been harassed by people standing outside clinics, preaching from the Bible and condemning them to eternal damnation. Still, U.S. women felt that the legal side of the abortion battle had been won.

However, support for abortion rights was eroded with each Reagan appointment to the Supreme Court. By 1986 the balance had shifted from a 7–2 pro-choice majority in 1973 to a 5–4 balance, with Sandra Day O'Connor, the only woman on the court, as the swing vote. Then came the Webster *v.* Reproductive Health Services decision in July 1989. It didn't actually abolish the right to choose abortion, but it allowed states to pass laws that could stop publicly employed doctors from performing abortions and gave states the right to test for foetal viability.

At first this decision seemed like a terrible blow to the pro-choice movement, but as has happened so often in other countries when women have had their right to make decisions about their own bodies attacked, thousands of women with no previous interest in the issue or the women's movement rallied to the cause. The National Abortion Rights Action League doubled its membership from 200,000 to 400,000, and its budget jumped from U.S. $4.3 million to U.S. $11.9 million.

Immediately following the Webster decision, several states introduced legislation to restrict abortion. To the amazement of elected officials, who had been listening mainly to the small, but vocal, anti-choice groups, there were far more people, men and women, against such restrictive laws than they had realized. In a 1988 poll, 78 percent of Americans supported the position that abortion is a private issue between a woman and her doctor and

the government should not be involved. This included 81 percent of Catholics, 72 percent of Southerners, and 69 percent of Republicans. To date, only Utah has managed to pass a bill limiting abortion. Nevertheless the right of U.S. women to abortion today is precarious. The position on abortion of the latest appointment to the Supreme Court, a relatively little heard of male judge, is unknown. Another appointment is to be made, and President Bush is on record as being against abortion, and has already vetoed a bill to allow victims of rape or incest to have abortions at public expense.

Another—not unexpected—bonus of the Webster decision has been the increased determination on the part of women's groups to get more women involved in federal, and particularly state, politics. Women generally don't jump into politics; they work their way up from the municipal and state levels. Even running for mayor can cost millions of dollars, while running for a seat in Congress costs a minimum of $4 million and contesting a Senate seat takes $20 million. It is far more difficult for women to raise such sums, since most of the money comes from big business, than it is for men.

The other big problem is that with the 96 percent re-election rate for incumbents, the U.S. system is almost like getting appointed for life to the British House of Lords. It's extremely hard for women to break into the system at all. Of the 114 women who have served in the Congress, thirty-three have succeeded a father or husband. Of the sixteen who have been elected to the Senate, only four were elected without first filling an unexpired Senate term.

Only Congresswomen Pat Shroeder and Bella Abzug, both feminists with a wide support among women, made it politically, without the support of the Democratic party, by relying on their own political networks. Defying the odds by defeating men, both have been labelled "difficult" by their male colleagues. Abzug was defeated in 1980.

Nevertheless there have been some important political "firsts" for women. In 1974, Ella Grasso was the first woman to be elected governor of any state without succeeding a husband or

father. In 1977, Patricia R. Harris became the first black female cabinet member. In 1979, Jane Byrne of Chicago became the first woman mayor of a major U.S. city. In 1980, under pressure from its female supporters, the Democrats passed a resolution that half of all delegates to future conventions must be women. In 1981, Sandra Day O'Connor was the first woman appointed to the Supreme Court. Jeane J. Kirkpatrick was the first woman appointed U.S. ambassador to the United Nations. Neither O'Connor nor Kirkpatrick are advocates for women, however.

In many other countries politics attracts single women or women with no children, who are able to meet the huge demands on their time and energy. In the U.S. the public wants a woman candidate who is happily married, with a visible and supportive husband and children, who can pass the inspection of a media more relentless and intrusive than any in the world. Women candidates have to be flawlessly groomed superwomen with pasts as unblemished as a Girl Guide's.

In spite of the difficulties facing American women in politics, the National Women's Political Caucus points to notable successes. In 1971, women representatives in the Congress were at an all-time low of 2.8 percent; now they are a modest 5 percent, although still one of the lowest among Western democracies. In state legislatures in 1971, there were 4.7 percent women; now the percentage is 18. In 1971, only 1 percent of mayors were female; by 1990 it was 12.7. But there are only two female state governors, in Oregon and Texas, and the number of female Senators—two—hasn't changed since 1960.

Even when women get to Congress they encounter walls of discrimination, something one doesn't expect to find in the most powerful democracy in the world in the last decade of the twentieth century. There isn't even a woman's toilet near the House floor; and although women have finally been allowed to use the lavish gym facilities, their lockers are two floors down and through a garage.

In a system that rewards people who have been there for the longest time, congresswomen find it hard to get appointed to the best committees, let alone chair them. Often they are left out of

important meetings. A Republican member, Marge Roukema, recalls that in her first days in the House, she was coached on how to get the Speaker's attention not by her Republican male colleagues, but by Geraldine Ferraro, a Democrat.

To combat this exclusion by males, women in the House network with one another. The Congressional Caucus for Women started out with a handful of congresswomen in 1977. Its objective was to support and monitor legislation and programs affecting women. In 1981, the caucus admitted men. Now it has 125 members. The caucus has promoted such causes as the Equal Rights Amendment, employment opportunities for women, programs for displaced homemakers, and child care. Women in state legislatures have also worked together across party lines.

U.S. women keep pinning their hopes for acquiring more political clout on the "gender gap"—the difference in the way women and men vote. In the 1980 election of Ronald Reagan 54 percent of men voted Republican but only 46 percent of women—the biggest gap on record. The difference was not entirely due to Reagan's anti-welfare policies. Reagan had a tough stand on defence, and more women were supportive of peace.

In 1984, NOW endorsed the Democratic ticket of Walter Mondale and Geraldine Ferraro in the hope of defeating Reagan. But the gender gap was smaller, not bigger, and a new gap appeared between the way married and single people voted. Married people on the whole supported the Republicans' pro-family stance, with its tax breaks for mother-at-home and home-owning families, while more single people voted Democrat.

One woman determined to look beyond the U.S. for new solutions is Eleanor Smeal. Twice president of the National Organization for Women (NOW) and presently president and founder of the Fund for the Feminist Majority, Smeal aims to get a commitment that all government-appointed committees be 50 percent women. Two states, Iowa and North Dakota, have agreed. The fund is also questioning election rules and wants a cap on spending.

Following the savings-and-loans scandals, small reforms were recently introduced by both parties. Limits were put on political

contributions. In the past politicians have been able to retire with the money left over from election campaigns. After 1993, there is to be a limit on the amount taken from these election war chests. This might mean some senators and congressmen will retire in the 1992.

Lobbying is one of the most effective strategies U.S. women have discovered to pressure government. Dr. Joyce Gelb, professor of political science at City College of New York, points out that unlike the British and Canadian parliamentary systems, members of Congress often vote independently of their parties. Women have joined big business and other groups in mounting forceful Washington lobbies. With so few women in the Senate and the House of Representatives, Gelb says: "Lobbying is almost all there is. There certainly is no similar situation in any other country where the women's movement operates as an interest group."

U.S. women have done somewhat better than European women in achieving top positions in business. Between 2 and 3 percent of top executives are women. Nevertheless many women feel they are either not in the pipeline to top jobs or that there is a "glass ceiling" beyond which they can't go. In 1986, the *Wall Street Journal* reported that the highest ranking executive women were in non-operating areas such as personnel or public relations, or in financial specialties that don't lead to management. Women are often excluded from the informal corporate networks where decisions are made and business relationships forged. In another *Wall Street Journal* survey, half the women said that being a woman was the most serious obstacle to their careers. Only 30 percent cited family responsibilities as their biggest problem.

Sexual harassment on the job is common. Even on the floor of the New York Stock Exchange, whistles and catcalls greet any attractive woman. In a 1988 survey of *Fortune* magazine's top 500 companies, 90 percent reported sexual harassment complaints. More than a third of the companies had been sued—a quarter had been sued repeatedly—but only one in five of the man involved had lost their jobs. Four out of five of the offenders are simply reprimanded. Companies are, however, putting personnel

through training courses to help eliminate discrimination.

Another constant in the life of every U.S. woman, more so than in most Western democracies, is the fear of violence. Diana Russell a sociologist at the University of California at Berkeley who has been studying criminal violence for the past twenty years, says it is ten times higher in the U.S. than in Europe. The U.S. has forty thousand murders a year—four times as many per capita as in Canada, and more than twice as many robberies and car thefts. Both countries have about the same number of police per capita, but fourteen times as many police officers are killed in the U.S. as in Canada. Children are safer in Northern Ireland than in the United States, where one child is shot dead every day. Each day 135,000 U.S. children take a gun to school. Some inner-city children have been exposed to so much violence they have stress symptoms similar to those of Viet Nam combat veterans.

Many women blame the number of guns in the general population for all the mayhem and bloodshed. In the U.S. 24 percent of homes have guns. In Canada, where there are one-quarter as many crimes per capita, the figure is 3 percent. But the ferocious gun lobby, led by the National Rifle Association (NRA), insists that the right to own guns is enshrined in the U.S. Constitution as "the right to keep and bear arms". The NRA has three million members, including the present U.S. president, George Bush.

In the U.S. there are almost seven times as many violent sex crimes, according to Diana Russell, as there are in Europe. A rape occurs in the U.S. every three seconds. "Violence keeps women in fear," says Russell. "One of the biggest accomplishments of the women's movement was the recognition of all the violence against women—rape, battering, child sexual abuse, sexual harassment. It's strange that as women advance there is no less battering and rape. The statistics on rape are getting worse."

In his first term Reagan canceled a U.S. $65 million allotment for battered-women's shelters, though he restored U.S. $6 million of it in 1984. Some states have levied surcharges on marriage licences to pay for the shelters.

Although the courts have helped women achieve many victories, a disturbing new trend is emerging in child-custody cases. Until recently, eighty-five percent of mothers automatically got custody of children in divorce because fathers didn't want it. But recently more men are challenging former wives for custody, and more and more of them are winning.

Phyllis Chesler, author of *Women and Madness*, believes that women are losing custody of their children in courts not because fathers actually want to look after their children but because they want to punish their ex-wives. Some male judges are overly impressed by any man who asks for custody, feeling him to be an exceptionally caring father, and rule in his favour. Often ex-husbands can offer children more affluent homes; or they have remarried, and have stay-at-home wives to look after the children, while the children's natural mother must work.

A mother fighting for custody in these circumstances is examined almost microscopically. If she fails at any task—doesn't make home-cooked meals every night, leaves the children unsupervised at any time, has a lover who comes into the home, is a messy house-keeper—she may lose the children. Judges tend to dismiss charges of violence and child abuse levied against fathers, as vindictive accusations by vengeful ex-wives.

A recent North American phenomenon is the violently anti-women, men's rights groups, which get a lot of publicity despite their small numbers. Such groups object strenuously to paying child support. They push for mandatory mediation and joint custody, against the wishes of their estranged partners. Experts point out that joint custody doesn't work unless the two parents live close to each other and have equal incomes and a co-operative relationship. Women point out that enforced joint custody leaves most of the day-by-day work to the women, while it gives fathers an unlimited opportunity to harass and interfere.

The men's groups claim ex-wives prevent them from seeing their children—a tactic sometimes used when child support isn't being paid. Legislation enforcing access has been passed in several states. Thirty states also have some form of legal custody that allows fathers to intervene in matters of education, in rules in the

home, and in the raising children. (This almost certainly causes tension, since people who couldn't agree on such matters before a divorce are highly unlikely to do better after one.) Chesler describes these militant father's rights groups as "shock troops", whose tactics make other men look reasonable by comparison.

Women also deplore the flourishing multi-million-dollar North American pornography business, which now dwarfs that of the Scandinavians. With a readership greater than the combined readership of *Time* and *Reader's Digest*, two of the largest American magazines, U.S. pornography is not only big business but a big export commodity.

Diana Russell says that those who defended pornography first labelled women as prudes when they objected to it, then shifted the attack to promoting the right to free speech, which they said was threatened by any attempt to curtail pornography. "If it involves race or religion, such as blacks or Jews, there is no problem recognizing how harmful it is to have people with different-coloured skin or religions being degraded and mutilated. But when it's women, it's okay. The First Amendment, protecting freedom of speech, makes it very difficult to do anything about pornography."

Catharine MacKinnon is a feminist lawyer and legal theoriest, who, along with radical theorist Andrea Dworkin, drafted the Minneapolis ordinance, which allows victims of rape and assault to take civil action against pornographers whose product has been used by their attackers. So far this approach has not been successful in the courts.

Getting power in the most powerful country in the world is not easy, but the U.S. does have the world's most powerful women's movements. Though Americans don't believe in government interference, they do believe in individual action, and they have an organization for almost everything. There are literally thousands of organizations working for women, and with low taxes compared with other countries Americans have a lot more discretionary money to fund their favourite organizations, whether the choice is the gun lobby, the Ku Klux Klan, the environment, or women's rights.

The National Organization for Women is the largest women's rights organization in the U.S. Founded in 1966, with Betty Friedan as its first president, it has 260,000 members, a budget of U.S. $10 million, and a staff of twenty-seven. The thirty-six-member board meets five times a year, and a national conference is held every spring or summer. There are eight hundred community-based chapters. Money is raised through massive direct-mail appeals and bequests from wealthy supporters.

Under the dynamic leadership of Ellie Smeal, it raised its budget from under U.S. $1 million to U.S. $10 million. In April of 1989 NOW staged one of the biggest marches Washington had ever seen to protest the Webster decision on abortion. Altogether 655,000 women from twenty-five different nations, including celebrities and film stars, took part.

Another key effort all through the 1970s and the early 1980s was the massive push to get the Equal Rights Amendment passed. The reason American women have returned to this battle so often is to establish a legal foundation in the Constitution on which discrimination cases could be fought.

Ironically, the ERA continues to be more of a dividing force than a unifying one among American women. After Title VII dismantled most of the protective legislation for women, opposition to the ERA came from another direction, the far right, which had previously supported it. In the 1970s and eighties, a strong anti-ERA faction was formed by Phyllis Schafly, a right-wing lawyer. Schafly and her followers fought the ERA by playing on the fears of women, particularly older married women. Schafly claimed, erroneously, that they might have to share toilets with men, that women would be drafted into the army, that girls' sports teams might be integrated.

Congress passed the ERA in 1972, but efforts by women's groups, particularly NOW, to get it ratified by the necessary thirty-eight states over the next ten years failed. By July 1982 the legislation was dead.

Some activists feel that far too much energy was put into the ERA fight. But Roberta Spalter Roth holds a different view. "It brought women together, mobilized them, and identified their

195

skills. None of it was wasted. We might have done better by putting all that energy into getting better housing, but most of the women who worked on the ERA are now working on something else."

African–American women in the U.S. face the double discrimination of being female and black. In 1851, when there was a lot of talk about women needing protection because of their fragility, former slave Sojourner Truth illustrated the difference between the needs of white women and black women. Before an all-white audience of women, she bared her muscular arm and told how she worked like a man, was lashed along with men, and bore thirteen children, only to see them sold into slavery. "Ain't I a woman?" she said, confronting her audience.

Today white women earn sixty-five cents for every dollar a man earns, an African–American woman only sixty-three cents. From the time of the Civil War to the 1960s no white male was ever convicted of raping a black female, although rapes were common. Today inner-city minority women not only live in fear of violence towards themselves but towards their children.

As women who have always had to work, African–American women have been both more supportive of the feminist movement on the whole than white women, and more independent. Although many belong to NOW and NWPC, most work in organizations dedicated to helping other women of colour, rather than the white middle class. The church is still an important factor in their lives. In 1896 the National Association of Colored Women was founded. The National Black Feminists were organized in 1973, and the National Alliance of Black Feminists in 1976.

There are also many groups with specific objectives. Byllye Avery began the National Black Women's Health Project with a conviction that African–American women could change both their health and their lives by learning how the system and its disparities affected them. Since 1981 the organization has grown to more than ninety self-help groups all over the country.

The women's movement in the U.S. certainly hasn't accomplished everything activists over the past two hundred years

have hoped for, but it is more broadly based than its European counterparts. There isn't a women in North America who is not aware of it. Polls overwhelmingly report that both men (69 percent) and women (73 percent) believe the movement has helped women and been a positive influence on American life.

While it is easy to point to the movement's failures and to all the work that still needs to be done, it is wise to remember, in the words of Catharine MacKinnon: "Male supremacy is the oldest form of structured oppression in the history of the world. It's a brilliant system in the way it draws women in and gets us to define our own success in terms of its standards. I think our lack of success has to be put into the context of how powerful the system is and how much easier it is to do things its way."

CANADA AND WOMEN—
TOO LITTLE, TOO SLOW, AND ALWAYS A COMPROMISE

FACTS

Population: 26 million, one-quarter French-Canadian.

Government: Elected House of Commons, appointed Senate.

Vote for women: 1918

Percentage of women elected: 13.5 percent

Education: Coeducation since the nineteenth century. Half of undergraduate university students are women; 41 percent of medical students, 48 percent of law students, 47 percent of business administration students. Women comprise 17 percent of university faculties.

Percentage of work-force women: 44 percent—20 percent part-time. Salary 66 percent of men's salary; 2 percent of executives are women.

Abortion: Following the decision of the Supreme Court in 1988 that Canada's abortion law was discriminatory under the Charter of Rights, a new law re-criminalizing abortion was narrowly defeated. However, only one in three hospitals in Canada now performs the procedure. Abortion is not available at all in two provinces.

Child care: For every ten children needing child care, only one non-profit, subsidized space is available. The rest are taken care of in run-for-profit, private centres and family homes. Family allowance was de-indexed in 1986, which means it doesn't keep pace with inflation. Income-tax deductions for child care only help the well-to-do, since poor women earn so little that child-care costs exceed what they pay in income tax.

Maternity leave: 1972 law allows seventeen weeks, fifteen paid through unemployment insurance. An additional twenty-four weeks allowed to federal employees. Either parent may choose to take leave.

Birth-rate: 14.8 per 1000 population

Family law: No-fault divorce after one-year separation with mutual consent, three years without consent. Assets of marriage split upon divorce. 40 percent of marriages end in divorce.

Achievements: Strong women's movement representing a wide range of groups. Women won an equality clause in the 1982 Charter of Rights. Pay-equity legislation quite advanced.

Problems: Inadequate child care and maternity leave. A political system that is difficult for women to penetrate.

THE BACKGROUND

Canada's aboriginal peoples were the original inhabitants. The first European settlers were the French, followed by the English. The two skirmished for power until the British won a decisive victory in 1759. The French retained their own language, legal code, and control of their schools. This division of powers set the pattern for other provinces when they joined Confederation.

The first wave

By the 1870s the first Young Women's Christian Association and Women's Christian Temperance Union had been organized. The first Women's Institute, which was started in Stoney Creek, Ontario, in 1887 to help rural women, spread all over the world. In 1893, the National Council of Women, a federation of women's groups, was launched.

Among Canadian firsts: In 1867, Dr. Emily Stowe started practising medicine—even though she had to take her training in the U.S. In 1875, Grace Annie Lockhart was the first woman in the British Empire to earn a university degree. In 1899, Clare Brett Martin became the first woman to graduate from law school. Still, in the late-nineteenth century a man married to a woman who owned property could vote, but she couldn't, even though she paid the property tax.

In 1876, Dr. Stowe and her daughter, Dr. Augusta Stowe-Gullen, started the Toronto Women's Literary Club, a ladylike camouflage for a hotbed of suffrage sentiment. In 1883 the name was changed to the Toronto Women's Suffrage Association, and later to the Dominion Women's Enfranchisement Association. Sir John A. Macdonald's government actually introduced three suffrage bills for women, but all were defeated.

The Women's Christian Temperance Union joined the fight in the 1890s, followed in 1910 by the highly respectable National Council of Women. From 1912 until 1916, the struggle for the vote raged all across the western provinces, led by Nellie McClung and her mother-in-law in Manitoba.

Manitoba was the first to give women the provincial vote, in 1916, followed by Saskatchewan, Alberta, British Columbia, and finally Ontario. In 1917, during World War I, the federal government granted the vote to women in the armed forces and female relatives of soldiers. Finally, in 1918, all Canadian women got the right to vote in federal elections. But women in Quebec had to wait another twenty-two years, until 1940, before they could vote provincially. Agnes Macphail was the first women elected to the House of Commons, in 1921.

In 1928, five women from Alberta—Nellie McClung, Emily Murphy, Louise McKinney, Irene Parlby, and Henrietta Muir Edwards—challenged the Supreme Court on whether women were "persons" under the terms of the British North America Act. If they were, women could then be appointed to the Canadian Senate. The Supreme Court, in the first of many decisions that were to frustrate Canadian women, declared that women were not "persons".

Undaunted, the "Alberta Five" took their case to the British Privy Council in London, England, which at that time was the final court of appeal. In 1929, personhood was bestowed upon Canadian women. In 1931, Carine Wilson, a good faithful supporter of the Liberal government of the day, was appointed Canada's first woman senator. This set a precedent that soon became familiar: those plum positions that women fought for usually went to women who had never been involved in the struggle.

Other firsts: In 1951, Charlotte Whitton was the first woman to be elected mayor. In 1957, Ellen Fairclough was the first woman federal cabinet minister. In 1974, Pauline Jewett became the first woman president of a coeducational university. In 1974, Pauline McGibbon became the first woman lieutenant-governor. In 1982, Madame Justice Bertha Wilson was the first woman on the Supreme Court. In 1984, Jeanne Sauvé, who had already been appointed the first woman speaker in the House of Commons, was appointed the first woman governor-general.

The second wave

After achieving the vote, women seemed to forget about the women's movement for a while. Then the Great Depression came along, with its devastating effect on everyone. Many women had to go back to domestic work. Married women were often fired from teaching and other jobs. Couples restricted their families, and women often kept their families from the ultimate disgrace of public welfare by taking in boarders or doing sweat-shop sewing at home.

Doris Anderson

During World War II women replaced men in factories and other jobs, proving, as their mothers had, that women were quite capable of doing male jobs. Since women were needed in the work-force, good child care was provided by the government. But as soon as the war ended, women were fired and the child-care system was abruptly dismantled by the government. All the jobs were to go to men.

Women were under the great pressure to go back to the home. Many did, and a baby boom was the result. However, many women stubbornly stayed in the labour-force. With the 1960s came the pill and a new wave of student unrest. In 1960, Voice of Women was organized to promote peace. Although not a feminist organization to begin with, like many other organizations, it gradually became a feminist stronghold. At the end of the sixties the second wave of the women's movement took off. Women began forming consciousness-raising groups, health centres, advocacy groups, and shelters for battered women, as well as publishing feminist papers and magazines.

To address all the changes taking place in women's lives, thirty-two women's organizations asked the government for a typically Canadian device—a royal commission—to look into women's needs. When the organizations were turned down, led by Laura Sabia, they threatened to invade Ottawa with two thousand women. The government gave in.

The royal commission set up in 1967 was the first ever to be headed by a woman, journalist and broadcaster Florence Bird. The commission ordered research papers and, in the fashion of royal commissions, began travelling across the country to listen to the public. At first the hearings were treated as a huge joke by the press. But soon it became difficult to continue to make light of the single mothers living on welfare, the battered women, and the abused children who appeared at the hearings.

The commission tabled its findings in Parliament in 1970. It made 167 recommendations, covering everything from equal pay to a woman's right to confer citizenship on her children. In 1971, a cabinet minister was made responsible for the status of women. The fact that this cabinet post has always been a junior one and

202

combined with another portfolio makes one wonder how much importance the government ever attached to it.

During the 1970s some of the provinces set up advisory councils. But in 1982 when the federal minister responsible for women called a national conference, several provinces had to hastily appoint someone, and even today the faces still change quite frequently at this annual meeting.

In 1970 the first women's centres were opened in British Columbia and Newfoundland. Radical groups, Marxist groups, and socialist feminist groups are all part of the Canadian women's movement. Lesbians have not been a divisive element, as they have been in the past in the U.S. The Canadian women's movement is one of the strongest in the Western democracies. It has achieved some quite remarkable victories that U.S. women, when they occasionally become aware of this, envy.

The situation today

In spite of being the second largest country in the world in size, Canada has just one-tenth the population of the U.S. Canadians are exposed to a barrage of U.S. television and press, and they are always comparing themselves with their next-door neighbour. They are generally more conservative, believe more in collective action, are more law-abiding and less flamboyantly individualistic than their neighbours to the south. Because Canada has a mixed economy and is a liberal welfare state Canadians look more to government as a way to get change than Americans do.

Even though Canadian women are not generally as well served as many northern European nations in child care, maternity leave or equal pay, they are better off on the whole than U.S. women. This tends to make Canadian governments complacent about what are really modest benefactions for women.

By any objective standard, services for women in Canada rate pretty low. Although Canada has had universal medicare since 1968, its national pension plan is not enough to keep many women who have worked all their lives out of poverty in their old

age. Family allowances were brought in after World War II both to encourage people to have children and to get money quickly into the economy. The amount is miserly compared with other countries—Cdn. $33.93 per child every month up to sixteen years of age in 1991—barely enough to buy a pair of ordinary running shoes. It was de-indexed by the Mulroney government and no longer keeps pace with inflation. In 1979, child tax credits were introduced. These came to Cdn. $450 per child per year for every family with an income under Cdn. $23,500 in 1986.

Paid maternity leave of fifteen weeks, taken out of unemployment insurance at only 60 percent of the worker's salary, is the federal law. Ontario grants one year—thirty-five weeks for the mother, eighteen for the father. Quebec gives eighteen weeks paid leave and thirty-four weeks unpaid leave. A majority of Canadian women would probably like to be given a choice of whether to stay home with new babies for the first year or two. It would be less expensive to provide more generous maternity leave so women could do this than to provide public crèches. For example, it would cost one-quarter of 1 percent of the total salary budget paid to women postal workers to top up maternity pay to 100 percent. Compared with the far more generous leave of many European countries such as France, Germany, and the Scandinavian countries, Canada is parsimonious. As a consequence, Canadian women pay a heavy price in lost salary, seniority, and benefits, and risk losing their jobs. Part-time employees who work fifteen hours a week or less aren't eligible for maternity leave at all.

Both provincial and federal human-rights codes prohibit the firing of pregnant women, but many women of child-bearing age aren't even hired because they may get pregnant. Others are fired on some other pretext when they become pregnant. It's up to women in these cases to prove discrimination. Since this is difficult, most of them don't bother.

The abortion issue is another example of Canada's ambivalence towards women. The 1969 law, allowing abortions if a woman could prove, before a tribunal of three doctors, that her health was in danger, was unworkable for many women. Two out

of three publicly funded hospitals won't perform abortions at all today. Sometimes it's because they were originally set up by the Catholic church; sometimes it's because the boards have been taken over by right-to-life protesters. Two island provinces, Newfoundland and Prince Edward Island, permit no abortions, and women have to undertake long expensive journeys to other provinces to end pregnancies.

Since 1970, when an abortion caravan from all across the country went to Ottawa and women chained themselves to the House of Commons, women have been demonstrating and marching to get the law changed.

In 1973, Dr. Henry Morgentaler announced that he had performed five thousand abortions in his clinic in Montreal, Quebec, a province in which the Catholic church is particularly strong. He was tried and found not guilty by a Quebec jury, but the verdict was overturned by the Supreme Court and he went to prison. Facing charges again, Morgentaler was acquitted by two more Quebec juries, and the government finally gave up. Today publicly financed health clinics in Quebec carry out abortions quite openly.

In the 1980s Dr. Morgentaler opened clinics in Winnipeg and Toronto. Along with two colleagues he was again charged, then acquitted by a jury. Following another court challenge, on January 28, 1988, the Supreme Court of Canada invalidated the law. In 1991 the province of Ontario began funding abortion clinics, or paying travel expenses for women where clinics are not available.

But the abortion issue continues to drain the finances and energy of Canadian women. The anti-choice forces, representing less than 10 percent of the public, get far more attention from legislators than their numbers would seem to merit. They continue to picket and harass clinics and take over hospital boards. In the summer of 1989, encouraged by anti-choice forces, a man brought an injunction against his ex-girlfriend, Chantal Daigle, to force her to carry his child to term. Horrified, thousands of women protested. The Supreme Court struck down the injunction, but by this time Daigle had arranged an abortion in the U.S.

In 1990, the federal government introduced another bill to re-criminalize abortion by allowing it only for health reasons and with the consent of a doctor. Afraid of being charged or trapped by anti-choice supporters, many doctors declared they wouldn't perform abortions at all. The bill was defeated by a narrow margin in the Senate.

With only one in seven families with a full-time mother at home, one of the biggest needs in Canada today is child care. Responsibility for it is divided between the federal and provincial governments. The federal government collects income taxes, then transfers payments for social programs to the provinces. Between the two jurisdictions there has been plenty of opportunity over the years to pass the buck to the other level of government, and little gets done.

During the past ten years a federal task force on child care was set up, with lengthy cross-country hearings. Finally the government introduced a bill just before the last election. (Child care is one of those items—like a causeway to Prince Edward Island—that is regularly promised just before an election.) Two hundred thousand spaces were to be dribbled out over several years. Women pointed out that this was hardly any improvement over the present rate. Another part of the bill allowed tax deductions for private care up to Cdn. $4,000 per child, and Cdn. $759 per child per year for mothers in the home. After the election the part of the bill that provided new day-care spaces was chopped—due to budget cuts, was the excuse—but the tax deduction and money for mothers in the home went through, completely ignoring the real needs of working mothers.

Another example of government myopia is the growing number—one in five—of women and children living in poverty in Canada. The increase is due to the number of single-parent families headed by a woman. Two out of five of these families are poor because women earn two-thirds of what men earn and many fathers don't pay child support. A new tax of 7 percent on all goods and services, which became law in 1991, is particularly hard on poor people, especially women.

Mothers get custody in 85 percent of all separation

agreements. But child support payments are shockingly low, and in the past, in a country as big as Canada, it has been ridiculously easy to avoid paying just by moving to another province. Even today 75 percent of court orders in Ontario demanding payment are ignored. Only recently, when welfare payments have become quite onerous, have several Canadian provinces started to crack down on defaulting fathers by tracking them down and garnisheeing their salaries. The federal government has helped by opening its files on income tax so that these men can be traced.

Margrit Eichler, professor of sociology in education at the Ontario Institute for Studies in Education, says, after studying different family laws in Australia, Canada, and the U.S., that the results are always the same: poverty for women and children. Women may get half the assets of a marriage, but they also get the children with not enough money to support them. Eichler maintains the problem is that judges, mostly older men, don't award large-enough support payments. Sweden, according to Eichler, has the only workable system. The state makes sure the children are adequately supported and then collects from the parent.

A day in the life of...

Diane R. works as an office manager in a private medical clinic in a medium-sized Ontario city. She has two children, Robin, six, and Kirby, two, and a small three-bedroom house that cost Cdn. $150,000 four years ago. Her parents helped her and her former husband with the Cdn. $50,000 down payment. There is still a Cdn. $100,000 mortgage, and the payments, along with taxes, heating, and electricity, come to around Cdn. $1,300 a month, which is barely manageable on her Cdn. $35,000-a-year salary. She pays Cdn. $150 a week for baby-sitting at the only private nursery she could find for Kirby, but it's located all the way across the city.

Her day begins at seven, when she gets the children up, then, in her five-year-old car, which was a gift from her father, delivers Kirby to his day-care centre and Robin to school. She arrives at

work at 8:30 A.M. A neighbour feeds Robin lunch and takes her in after school. For this Diane pays Cdn. $25 a week. She gets off work at 4:30 and picks up Kirby. Her evenings are spent preparing dinner, bathing the children, catching up on house-work, and watching TV. She's under a lot of pressure at work taking care of the scheduling and billing for four doctors, plus supervising a small staff, and tired when she gets home. She has taken time off when the children are sick, but she knows this strains things at work. Usually she lies and says she is sick.

At first she received Cdn. $400 a month from her ex-husband for child support, which didn't really cover her expenses for the children. But he recently remarried, and since then he has fallen behind over Cdn. $6,000 in his payments. Recently the Ontario government started collecting payments from husbands, even garnisheeing salaries. But when Diane finally heard from the government, she was told her husband's second wife was having a baby. He had also started a new business and had very little money. It was suggested she accept Cdn. $150 a month until he got his business going. "If I were irresponsible enough to get pregnant now and say I couldn't support my children, everyone would treat me like a pariah," she remarks sardonically. "But he gets away with it."

Another big concern is her parents. Her mother used to help her out with baby-sitting, but for the past three years she has been in deteriorating health with Alzheimer's disease. Although Diane's father has been able to take care of her mother up to now, he recently had a stroke. All the worry of finding care for them, and possibly getting them into a home, will fall on her. Diane's only sister lives in Vancouver and is willing to help financially, but can't do much physically because of the distance and her own family responsibilities and job. "Sometimes I feel so pressured that I think, one thing more and I'll break," Diane says desperately.

Diane's problems reflect just some of the social ills in Canada today. A royal commission on child abuse in 1982 reported that one in three girls and one in ten boys are abused before the age of

sixteen. Since then laws have been tightened and an effort made to educate the public, particularly school children. But an investigation of abuse at several Catholic and native schools for boys has provided grim evidence on how widespread the abuse has been and how the system, including the Catholic hierarchy, the police, social workers, and the legal system, all worked to cover it up.

Teenage pregnancy is higher than it should be because some parents and school-boards object to sex education in schools. (Information about birth control was a crime under the Criminal Code up to 1969.) Infant mortality in Canada is also too high. Canada ranks tenth behind such countries as Finland, Japan, the Netherlands, and the Scandinavian countries.

One obvious way to get more action on all these concerns is to increase the number of women in Parliament. Only 13.5 percent of the present House of Commons and around 22 percent of provincial legislatures and municipal governments are women. Up until quite recently the few women who got elected, around 5 percent, carried a double load as MPs and as spokespersons for women. When Grace MacInnis, the only women in the house in the late 1960s, spoke on women's issues, the place emptied. Ten years ago when Margaret Mitchell, another NDP member, mentioned a report on wife battering, male MPs burst into laughter.

There are only three major federal parties in Canada. The Liberals have been in power for most of the twentieth century and have been responsible for most of the social legislation now in place. The Progressive Conservatives are the business-oriented party now in power. The New Democrats are allied with labour and mildly socialist. They have been in power in four different provinces but rarely get more than 20 percent of the vote federally. In 1983, the NDP passed a rule that at least four out of eight party vice-presidents had to be women. In 1989, Audrey McLaughlin was elected leader of the NDP, becoming the first woman to head a major Canadian political party.

Polls indicate that Canadians have no prejudice against women candidates. If they run in good seats they have at least as good a

chance as men. Winning elections isn't a problem of raising money, since the Canada Elections Act limits the amount of money that can be spent and there are funds in each party to help women candidates.

The big hurdle, as in the U.K. and the U.S., is winning nominations in winnable ridings. There is no limit on the amount of money that can be spent in nomination contests, which is a disadvantage for women who are not as well connected to the business community. Nomination meetings are loosely controlled, and often rigged by riding organizations. Their dates are changed without notice; busloads of out-of-riding voters are shipped in and their memberships paid for well-heeled candidates.

Whenever there is a possible landslide, women are elbowed out of the way in the stampede of men to grab good seats. In 1968, when the Liberals won a huge victory, only one woman ran for the party out of 265 candidates, and she already had the seat in New Brunswick or no doubt she would have been pushed aside too. During the 1970s a Feminist party was tried, but it failed, as similar parties in other countries have failed.

Lynn McDonald, a former NDP member of Parliament, suggests doubling the number of members of Parliament and insisting on a male and female member for each riding. Jill Vickers, a social scientist at Carleton University, says proportional representation could be introduced in the Canadian Senate, now an appointed body (and a repository for rewarding the faithful of the party in power), when it's long-awaited reform takes place. In 1991 the NDP became the first major party in North America to decide to intervene in local nominations in an effort to achieve a target of 50 percent women candidates.

As for the machinery that deals with women, in 1954, at the request of women's groups, a small Women's Bureau was set up in the Department of Labour with a minuscule budget. This department still exists. One of the recommendations of the Royal Commission on the Status of Women was that an advisory council be established to report annually to Parliament. In 1973, the government did establish such a council, but it reported to the

cabinet minister responsible for women, not to Parliament, as recommended. Today the Canadian Advisory Council on the Status of Women (CACSW) has a full-time president, an appointed twenty-seven-member board, a staff of thirty-four, and a budget of Cdn. $3.5 million.

Over the years the CACSW has produced some excellent research: the first Canadian report on battering and reports on the poverty of older women and the isolation of immigrant women are but a few of several hundred documents. But, as a former president, I agree with critics of the council that the council's appointed board is its biggest problem. Governments reward the party faithful rather than appointing good, knowledgeable women with useful backgrounds in the labour movement, business, health, and social work. Recently the board actually tried to alter some of the council's research with which they didn't agree.

In 1976, Status of Women Canada was set up. Its mandate gave the impression that the government really meant business. It was to monitor government departments on how fast they were advancing the cause of women through legislation and appointments. But without any real backing from the cabinet, it has gradually become a kind of junior ministry for women. Today it briefs the minister responsible for women and through an interdepartmental committee, tries to vet legislation for its impact on women. It has a budget of Cdn. $2.85 million and a staff of forty-one.

Women from other countries are always astonished that Canadian women's organizations get money from the government. This isn't because the Canadian government is particularly fair-minded and generous towards women. Canada, a bilingual country, funds francophones, other ethnic groups, natives, and the handicapped, as well as "special interest groups" such as women. In fact, many times more is spent on multicultural groups and bilingualism, and thirty times as much on natives, as on women.

The budget for the Women's Program in the Secretary of State, around Cdn. $13 million a year was cut to 11 million

recently and is small by any standard. But over the years it has provided funds for conferences, and core money for rape-crisis centres, women's shelters, and even the occasional feminist magazine. Despite the reams of paperwork it requires of groups to get funding, one of the bonuses of the program is that it encourages women's groups to make contact with other groups across the country.

Over the past six years the Women's Program has been under attack from right-wing members of Parliament and a group called Realistic, Equal, Active for Life (REAL) WOMEN, organized out of the anti-choice movement in 1981. Like similar right-wing movements, REAL WOMEN claim they are working for "the family". They are against abortion under any circumstances, day care, equal pay for women, affirmative action, homosexuality, and family law reform. They are for much tougher divorce laws. In numbers they are much smaller than many mainstream women's organizations such as the YWCA, but they demand equal time on the publicly funded Canadian Broadcasting Corporation and in the press, as well as half of all the funding in the Women's Program.

The budget of the Women's Program was frozen in 1985, and cut by Cdn. $2 million in 1989–90, which meant that eighty women's centres had to be disbanded. This caused such a storm of protest that some of the funding was quickly restored. It is significant that shortly before the budget cuts, REAL WOMEN was given money through another government department for a conference.

One of the strongest aspects of the women's movement in Canada is the National Action Committee on the Status of Women, (NAC) an umbrella group representing around 500 women's organizations and more than four million women.

NAC was born in Toronto in 1972 at a conference called Strategy for Change. Its purpose was to lobby and prod the government to move on the recommendations of the Royal Commission on the Status of Women. Unlike the National Organization for Women in the U.S., which is built on individual memberships and state-based branches, NAC is an organization of organizations.

The twenty-two-member executive is elected, and policy set at the annual general meeting in the spring in Ottawa. The organization publishes a newsletter and sends out bulletins alerting member groups on legislation going through Parliament. It also lobbies, presents briefs, and meets with cabinet ministers to try to influence legislation. But lobbying in Canada's tightly controlled federal party system isn't as effective as in the U.S., and women's organizations today are only one sector out of hundreds pressuring the government. NAC has also formed very useful coalitions with other groups on peace, the environment, and the economy.

The present government's strategy is to wear women's groups down by constantly calling on them for consultations and briefs, then not following their advice. Volunteers from all over the country come to Ottawa, often at their own expense, to appear before committees or task forces or royal commissions. Since all these women have jobs and family responsibilities, the burnout is fierce. Sylvia Gold, past president of the CACSW, had this chilling comment to make after watching the scene from 1984 to 1990: "In spite of all the briefs and work, the government doesn't listen. Today women have made almost no inroads on policy making."

But women's groups, particularly NAC, have had some triumphs in the past. In the 1984 federal election, NAC hosted a national debate with the three party leaders, on the government-owned television network, that focused entirely on women's issues—the first time this has happened anywhere, to my knowledge. Such a debate was repeated in the 1988 election with a one-hour segment devoted to women's issues.

Every year at its annual general meeting NAC holds a public meeting, open to the press, where it grills the government and the opposition parties on their records on women over the past year. Governments, both Liberal and Conservative, have tried to do away with this confrontation, which is embarrassing to them. A former minister responsible for the Status of Women, Barbara McDougall, boycotted the lobby in 1989. It was also boycotted in 1990 and 1991. When queried about it, she said she thought it had outgrown its usefulness. She thought it would be more

productive for NAC to meet with cabinet ministers in private.

Lynn McDonald, a former president of NAC as well as an MP, says: "The lobby is a good thing. Ministers have to bone up for it."

As a past president of NAC, I agree with her. The lobby gets national coverage. As for the suggestion that NAC meet with cabinet ministers and members of Parliament privately, that's done regularly, but with very few results.

Jill Vickers, co-author of a book on NAC, says the organization is unique. It has some formidable strengths and a considerable number of weaknesses. Its main strength is that it can point to a large and varied membership as proof of substantial support from women all across the country, from conservative church groups to Marxist feminists. But, because of lack of money, the regional and committee structure is weak. Far too much work falls on the volunteer executive.

It raises money through memberships, direct mail and other fund-raising activities but depends on the government for almost half of its budget—which makes it vulnerable to cuts at the whim of party in power. The present government cut its contribution in half from Cdn. $600,000 to Cdn. $300,000. That meant that staff was cut from nine to four, the office was moved to free space, and there were fewer meetings of the executive.

NAC has always been critically underfunded anyway and cannot do all the things it is called on to do. There has never even been enough money to set up a good telephone lobby or to buy proper equipment for the office, for example.

Today other, more specialized, groups, such as the Women's Legal and Education Action Fund and Visible and Minority Women, also lobby and compete for the energy and funds of women. Critics of NAC say it needs to re-define its role. Jill Vickers thinks it needs to spend more time on long-range policy and pay less attention to fire-fighting. In other words it should be pro-active, not reactive.

On top of all of its external troubles, it periodically mounts the rack for some internal soul-searching. Three years ago at its annual meeting it went through an organizational review and a

self-flagellating public debate over whether a flatter, less hierarchical organization without constraints such as Roberts Rules at annual meetings might be better. In the course of the discussion, the entire staff quit.

Linda Briskin, assistant professor in social science at York University, points out that often women want a "feminist" process and are critical of traditional organizations, but in trying to achieve a flatter organization, politics frequently takes over and the organization often becomes dysfunctional.

As for French-Canadian women's groups, French-Canadian women have had, on the whole, a good, co-operative relationship with English-speaking Canadian women, but they really are quite separate—as Quebec itself is. Quebec has its own civil code, separate schools, a separate pension plan, and a different way of delivering its social services. At present Quebec is threatening to become a separate state, or at least form a "sovereign" association with the rest of Canada. This has also caused rifts in the woman's movement, although NAC still has around forty groups from Quebec as members.

In spite of our two solitudes, the women's movements in each culture have worked together for the benefit of both. Because of Quebec, Canada has put more emphasis on the diversity of its population than the U.S., with its melting-pot approach to its immigrants. Both French and English groups have learned to deal with cultural and political differences, and to work for compromises. Women have also learned that they are more effective if they approach the federal government in Ottawa as a united body.

The French were defeated on the Plains of Abraham by the British, but in the nineteenth century, politicians and the Catholic church believed French-Canadians would eventually outnumber the English because they had a much higher birth-rate. In the vigorous promotion of large families in the nineteenth century, the death-rate for women thirty to forty years of age was much higher than for men because child-birth was often fatal. Infant mortality was also high.

At Confederation only one-fifth of Quebec's population lived

in cities. But by the nineteenth century 27 percent of Montreal's labour-force were women—who worked mostly as domestic servants or in factories. The first important textile strike in Canada, at the Hudon mills near Montreal in 1880, was led by five hundred French-Canadian women.

One escape French-Canadian women had from from domesticity and child-bearing was to take the veil. One woman in every hundred became a nun. Some of these women set up hospitals and schools and became intellectuals in their own right. But women were not allowed into the classical colleges that prepared them for the professions until 1908, and the government only funded women's colleges after 1961—forty years after they funded colleges for men.

Quebec women with property briefly voted from 1807 to 1834. But while other provinces were granting women the vote, the Quebec government, backed by the church, refused. Several groups had agitated for the vote, but in 1928, Thérèse Casgrain, who came from an influential and political Quebec family, became head of the League of Women's Rights in Quebec. In 1940, women finally were allowed to vote in a provincial election.

By 1940 the average French-Canadian family had only three children. By the 1960s, when the whole of Quebec society began to change in what has since been called The Quiet Revolution, women were already flocking off to get higher education and to join the work-force full-time. Now the Liberal government of Robert Bourassa has tried to bump up the birth-rate by offering a bonus of Cdn. $500 for the first child, Cdn. $1,000 for the second, and Cdn. $1,500 for each additional child, as well as tax credits, extra maternity leave, and interest-free housing loans.

Louise Vandeluc, a professor at the University of Quebec, was in the student movement in the 1960s. She has lived in France and Italy as well as in Quebec. She says Quebec women were always very aware of themselves as women. In contrast to France, where intellectual women held sway in the salons and rarely ventured into activist endeavors, in Quebec women exerted influence from the kitchen, which was the centre of activity and information, in the French-Canadian home.

Lise Payette, minister of Consumer and Financial Affairs and Quebec's first minister responsible for the Status of Women, learned the power of traditional French-Canadian women in the Quebec referendum on separation from Canada, in 1980. She made a caustic remark about "Yvettes"—stay-at-home housewives meekly voting *non* to Quebec independence. Fourteen thousand self-declared "Yvettes" came to protest at a rally at the Montreal Forum. Payette later admitted the remark destroyed her credibility as the voice of women in the Quebec cabinet and ended her political career.

Though French-Canadian women were much slower than their English-speaking sisters to start independent women's groups, today there are 1,600 women's groups in Quebec, and most of them have good links with the provincial government, as well as with other groups in the province. Quebec has its own umbrella organization, Fédération des femmes du Québec, which was formed in 1966.

In the early 1970s Quebec women lobbied for a council and were spectacularly successful in that their council was given a larger staff and a bigger budget than its federal counterpart. Women also got the right to keep their own names. Quebec was the first province to bring in family law reform.

All told, the Canadian women's movement can take credit for some solid gains. One of these is restored rights for native women. Half of Canada's one million native Indians live on reserves, where unemployment is often 50 percent and problems of poverty, alcoholism, suicide, wife and child abuse are exacerbated by bad housing and unsanitary conditions. But over the past century, native women suffered an even greater disadvantage. Under the terms of the 1876 Indian Act any native woman who married a non-native was deprived of her status as a treaty Indian and forced to leave the reserve. Native men who married non-native women retained their status. In 1973, Janet Lavell challenged the legality of the Indian Act before the Supreme Court and lost. Then, in June 1985, after 100 years of protesting and with a lot of help from women's groups, non-status women were finally given back the right to keep their native

status and bestow status on their children.

Other successes for the Canadian women's movement include a new sexual assault bill in 1982, rape-crisis centres, and 280 shelters for the one in eight Canadian women who are battered. Shelters were first set up by women and are now funded by various levels of governments. But there is a need for twice as many as there are now, and without training to help women become more independent and without subsidized housing, often they feel they have no alternative but to return to the abusive home.

Family law reform is another area in which the women's movement has made strides. In 1973, Irene Murdoch, an Alberta farm wife who had worked side by side with her husband, indoors and out, for twenty-five years, was denied any part of their ranch when he divorced her. She fought the case right up to the Supreme Court of Canada and lost. Women were shocked to discover how badly protected they were and they began to agitate for change.

During the 1970s, under pressure from women, province after province changed family laws to define marriage as a partnership of equals, whose assets should be divided equally upon divorce. Some provinces now include pensions and financial assets. In the late 1980s, Rosa Becker, a common-law wife, won her right to the financial assets of a twenty-five-year partnership—establishing a legal precedent. But when all the money went to legal fees, she shot herself in despair.

Over half of all university students and almost half of all graduate students today are women. But only a little better than one-third are in sciences and only a little better than 10 percent are in engineering. Today women's studies courses flourish at half the universities. Only 6 percent of all judges are women. Three out of nine judges on the Supreme Court were female until Bertha Wilson retired last year and was replaced by a man.

The federal bureaucracy is the largest employer of women in the country. And although the present Conservative government has cut the civil service, it has improved the government's record on the appointment of women to boards and commissions—from

15 percent to more than 30 percent. The number of deputy-ministers now stands at six. The number of women ambassadors is thirteen.

One in three Canadians belongs to a union and one third of all union members are women. Although not many women get onto the executive of unions, two of the biggest unions in Canada have been headed by women—Grace Hartman for the Canadian Union of Public Employees and Shirley Carr, who now heads the Canadian Labour Congress.

Women have not really penetrated the big executive suites of large corporations—a generous estimate is less than 2 percent. Instead, more and more women are starting businesses themselves. Today one in three businesses is started by a woman, and women have a much higher success rate than men. They are more cautious and tend to prepare themselves better, but the main reason is that women are willing to take much less money in salary and profit for themselves.

The Canadian Human Rights Act of 1977, which forbids discrimination on the basis of sex, has also been another court of appeal for equality in Canada. Human rights commissions were set up federally and in most provinces during the 1970s, although most of them have been weak and underfunded. Nevertheless, cases of sexual harassment, and discrimination in pay and access to jobs, have slowly begun to be won. A group of seamstresses and cleaning women working in federal institutions took their employer, the federal government, to court and won substantial sums in back pay. In another famous case a small women's group in Montreal took on the Canadian National Railway. As a result, a quota of one women for every four men hired was set to give women a chance at the better paid jobs. After more than a decade and a trial before the Supreme Court, a cleaner, Bonnie Robichaud, won a sexual harassment case against the federal Department of Defence. The principle that an employer is responsible for protecting employees against sexual harassment was established.

But all these cases dragged on for many years before they were settled. Even though the commissions pay the costs, it takes a

very determined woman with a lot of emotional stamina to stick with the whole process.

Following another royal commission, headed by Judge Rosalie Abella, the federal government introduced the Employment Equity Act of 1986. All government-owned or regulated corporations with more than one hundred employees have to report annually on employment and salary levels of women and minorities or face a Cdn. $50,000 fine. Companies bidding on government contracts of more than Cdn. $100,000 also have to commit themselves to employment equity.

Yet the legislation doesn't work because there is no real way to enforce the bill. There are no timetables and no fines for not making changes. The already over-burdened Canadian Human Rights Commission is supposed to be the watchdog, but it has neither the budget nor the staff to do the job. Without any real will on the part of the government, nothing much has happened.

Several provincial governments have introduced, or promised, employment equity bills—Manitoba, Ontario, Newfoundland, New Brunswick, Nova Scotia, Prince Edward Island, British Columbia, and the Yukon Territory. Ontario's bill is the most advanced because it includes not only the public sector but the private one as well. The newly elected New Democratic government has moved vigorously to enforce the legislation and to improve the salaries of groups such as nurses.

The eighties saw a backlash against feminism by Canadian men and conservative women. As in the U.S., men's rights groups have demanded mandatory mediation and joint custody. When men fight for custody they frequently win. Often women lose everything in the effort to get custody of their children. In Ontario, the Canadian province with the greatest population, men were successful in getting a bill on access passed, but it was repealed when the NDP took power in 1990.

Violence and rape in Canada have increased dramatically. In December of 1989 a young man separated out fourteen young women in a Montreal engineering school and shot them in cold blood as "feminists". This rocked Canadian society and started a national debate that is still ongoing. Journalist Michele

Landsberg put the solution to the problem correctly: "If enlightened men would speak up, everything would change. But today nice guys are regarded as nerds and wimps. Cold macho men are supposed to be sexy."

One of the most difficult problems for the women's movement in Canada has been to confront prejudice within its own ranks— in particular towards doubly disadvantaged, immigrant and visible-minority women. Several organizations, such as the Congress of Black Women, have been in existence for many years, operating quite separately from mainstream women's groups. But as new groups started up tensions developed.

Immigrant women were angry and hurt that they had to bring up problems about language training, domestic work, and deportation with mainstream groups. They felt this shouldn't be necessary with women, who should be aware of these problems. They felt that they were in the same position white women had been in in men's organizations.

In 1981, the Women's Program at the Secretary of State put up money for a national conference bringing together five hundred groups. In November of 1986, the National Organization of Immigrant and Visible Minority Women was formed. Today it has an office in Ottawa with a staff of two people.

But strains with other organizations have continued. One of the biggest disasters occurred with the Women's Press, which was accused of approving a number of racist stories for an anthology of short fiction. Women who had worked for the press for twelve years left and formed another publishing house. Susan Cole, a long-time activist, says: "There hasn't been a single organization that hasn't had problems on racism. A lot of the screaming and yelling is because feminists at least listen."

Strangely, the biggest and most surprising triumph of the Canadian women's movement happened almost by accident. In 1980, Prime Minister Pierre Trudeau announced he planned to introduce a new constitution with an entrenched charter of rights and freedoms. But when the proposed charter was introduced, the clause dealing with discrimination on the basis of sex, race, and religion, which would affect women, was totally useless. It

employed the same language that had been used in the Canadian Bill of Rights, which had done nothing to help women all through the 1970s.

I was president of the Canadian Advisory Council on the Status of Women, at the time. Along with other groups, we worked hard to make women understand that substantial changes had to be made in the charter. The council commissioned eleven major papers on the constitution to inform women. In response to briefs from women and other groups, the government instituted major changes in the charter.

The council had also planned a conference on the charter. But the government was afraid it would be taking place just as the charter was being debated in the House of Commons. The minister responsible for the Status of Women put pressure on the government-appointed board to cancel the conference. When the board agreed to this unprecedented interference, I resigned.

This situation, my resignation, and the publicity around it, enraged Canadian women from coast to coast. Led by groups in Toronto and Ottawa, they decided to stage their own conference. Over one thousand women travelled to Ottawa on February 14, 1981. They passed several resolutions, including one calling for the inclusion of a separate clause in the charter on the equality of men and women.

Instead of going home after the conference, women lobbied the government for the changes. Among several additional changes that were made, Section 28 was added. It guarantees the rights and freedoms in the charter "equally to male and female persons". It, along with Section 15, which deals with racial, religious and sexual discrimination, is the equivalent of the Equal Rights Amendment in the U.S., which U.S. women have been working to get into their constitution since 1923.

In the final days of getting the approval of nine provincial premiers (Quebec's Parti Québècois government, which was committed to separation, refused to sign) the premiers tried to put a restraining clause on Section 28. Women from coast to coast rallied furiously, and the premiers caved in almost overnight, removing the clause.

I think this major triumph for Canadian women came about due to the great deal of preparation that went into the CACSW conference. Women were informed about the issues. The publicity of my resignation, the hard work of the lobbyists, and the fact that the government wanted the charter pushed through quickly all helped as well. The kind of opposition that rallied against the ERA in the U.S. never got organized in Canada.

The charter is changing the lives of Canadian women. In the future there will be more emphasis on individual rights and the legal process. After the charter was passed, the federal government put up Cdn. $9 million for discrimination cases to be tested in the courts. The Province of Ontario put up Cdn. $1 million dollars for the same purpose. In 1985, the Legal Education and Action Fund (LEAF) was set up to test these cases.

At first the charter was used enthusiastically to protect the interests of men who challenged any special treatment of women as being against the principles of the charter. For example, a man was defended successfully in an alleged statutory rape of a fourteen-year-old girl because there was no similar law on the books forbidding the statutory rape of minors by women.

But slowly a whole new definition of equality is being formulated through court cases, allowing women to get at the ways they are disadvantaged. Mary Eberts, a legal expert who has taken several of these cases before the Supreme Court, says LEAF is slowly developing the theory that unequal cases are not necessarily to be treated equally. It will frequently be necessary to make distinctions, which is the essence of true equality. For example, LEAF argued that banning publication of a victim's name in a sexual assault case is necessary because publication of a victim's identity under such circumstances denies them equality.

In the overall picture of feminism in Canada, what else has changed? When I entered my second year of university, having won top marks in history in my first year, I visited the dean of the department to ask if I should switch to an honours course. He took what seemed to me great pleasure in telling me that he had never given a woman a first in more than twenty years. That kind of blatant discrimination couldn't happen today.

Before 1979, political parties scarcely bothered to mention women in election platforms. Today women's concerns are part of the political rhetoric. Not just child care and equity pay, but everything—the GST, the Meech Lake accord, free trade, privatization.

In a survey taken a few years ago by sixteen companies to find out what women wanted, 96 percent of women knew about the women's movement and 90 percent believed it had been good for women. Feminism has become part of the consciousness of Canadian society and imbedded in its vocabulary.

Slowly we have come to realize that bringing about fundamental changes is going to take much longer than some of us have left in a lifetime. Understanding the problems ourselves, and explaining them as clearly as we can, which we naively believed was all we had to do, certainly is only a beginning.

THE NORDIC WAY—
EGALITARIAN AND PRAGMATIC, BUT IS IT BETTER?

Today people, particularly in North America, tend to regard Scandinavia as a socialist, tax-ridden enclave, too close to Communism to be seriously considered as an alternate way of life or any kind of model. They also make the mistake of confusing controlled economies like that of the USSR with socialist governments that have been freely elected, or have been the chief opposition party, in most European countries over the past fifty years. Heavy taxes, critics claim, must stifle enterprise and initiative and cripple the economy. The high rate of suicides is also invariably mentioned.

In reply to these criticisms, Scandinavians point out that Sweden, a country of nine million people, is the fourth largest trading nation in the world on a per capita basis, behind Germany, Japan, and the United States, and it operates extremely well against free-market economies. It is true that Scandinavians pay steep taxes, but although they complain, they believe they get a lot of service for their money—such as universal health protection, free post-secondary education, unemployment insurance, good child care and parental leave. They also enjoy a low rate of crime, which saves millions in rehabilitation and law

enforcement, and have fairly low unemployment and few "unemployables", which saves money in welfare.

The fact that Scandinavian countries are small, homogeneous societies without large black, Hispanic or immigrant populations is cited as an advantage, making it much easier to impose uniformity and a collective life-style. But are the achievements of Scandinavian countries transferable in any form to other countries? Or are they peculiar to this northern, rather insular and pragmatic part of Europe?

From early times Sweden, Norway, and Denmark were rural, seagoing nations. Vikings, an early Scandinavian group, were the first Europeans to discover North America. While they were off on marauding expeditions or voyages of discovery for long periods of time, the women were left in control as equal partners. Later, Scandinavian women worked side by side on the land with men.

Women took part in the nineteenth century struggles for freedom and more democratic forms of government in all three countries. In all three countries principles of equality, justice, and solidarity were deeply rooted, and women learned to work collectively with one another and with men. Thus, once the hold of the old governing bodies was broken and suffrage was brought in for men, it was a relatively easy step, compared with other countries, for women to then gain suffrage.

Although the Lutheran church certainly tried to suppress women, it was more open to dissent than the Catholic church, not as secretive and not as powerful. Independent women's organizations began in the middle of the nineteenth century to work for better education for women, to acquire some control over property and to secure the vote for women. In Scandinavia women got suffrage early, as well as the right to control their own money and property and the right to attend university. They ran for public office, operated their own businesses, and organized in powerful women's groups long before women in most of the rest of Europe.

For most Americans, whose rugged individualism is a cherished national characteristic, the collective behaviour

demanded in a welfare state would probably be intolerable. On the other hand, Scandinavians would be equally dismayed to have large numbers of homeless people wandering around in the middle of their large cities, and increasing numbers of children being raised in poverty.

Today there are more billionaires in North America than ten years ago, but there are also more people living in poverty, with little chance of ever getting out of it. For the average woman or man, the Scandinavian way seems to offer most people a secure, middle-class life with more protection and better services for everyone. Certainly for women, who are even less likely than men to be billionaires, the Scandinavian model is tempting.

But Scandinavian women feel that in some ways the state has replaced patriarchy. The system tends to keep everyone conforming to the rules and working for the collective good. The state penetrates all spheres of life, and is the biggest employer of women. Yet the bureaucracy is elitist and mostly male. Few women make it to the top jobs. Even in unions and universities, where women make up half or more than half the numbers, they are a decided minority in positions of power—a depressing 5 percent of top faculty in universities, for example.

But it's not just the state that reinforces the secondary position of women. In the private sector, particularly in Sweden, the most industrial and competitive of the three Scandinavian countries, few women are found at all, except in banking, insurance, and traditional service jobs. "We have to fight discrimination in the private sector and social paternalism in the public sector," one feminist told me.

And this brings up another, more serious, problem. Because women have been used to working within the system, in some Scandinavian countries—Sweden, for example—the women's movement has had far less impact. As a consequence, problems such as battering and sexual harassment were slow to be acknowledged.

It's also interesting that, comparing the three Scandinavian countries, women and men seem to have a very good and easy relationship in Denmark. In Norway, which was slower to

develop industrially, where the services are fewer, and where women suddenly achieved a lot of political power, some women report that there is a small backlash. In Sweden, which is the most highly developed, where there was an aristocracy and a class system, and where socialism has reigned almost continually for more than fifty years, the women's movement in the early seventies didn't develop into the mass movement that characterized so many other countries.

Scandinavian men, particularly the younger ones, are much more involved with their children than men in other countries. Almost all of them take some parental leave. However, they have not made much progress is sharing house-work, although they are slightly better than men in most other countries. Still, most of the planning and work in the home is where it has always been—with the women.

Today the women's movement is fairly quiet, even in Norway and Denmark, where it has been quite active. Women who were involved in the movement in the 1970s are now working for peace, the environment, and other single-issue causes. But Scandinavian women point out that feminist principles have penetrated almost all the country's institutions—government, trade unions, universities, the bureaucracy—even though real power at the top in all of these institutions still eludes women.

Unlike the rest of Europe, the impending European union is more of a worry to Scandinavian women than a promise of better things to come. Once economic boundaries are down manufacturers might be tempted to move to countries with lower taxes, less stringent occupation health standards, fewer social programs, and lower salaries. At present only Denmark is a member of the European Community, but if social programs are harmonized Danish women fear standards will drop, not rise. "Free competition and the so-called free market have never been a benefit of women," one feminist told me.

SWEDEN—
REALLY THE BEST OF
ALL POSSIBLE WORLDS?

FACTS

Population: 9 million

Government: Unicameral parliament, the Riksdag. Proportional representation. Some parties have quotas.

Vote for women: In municipal elections in 1862. In national elections in 1919.

Percentage of women elected: 30 percent in the Riksdag and county councils. One-quarter of the cabinet women. Ninety percent of Swedes vote.

Education: Women comprise 50 percent of Sweden's doctors and lawyers, 95 percent of its pharmacists, and one in three of its dentists. More than half the university students are women, but faculties are still largely male dominated, with only 5 percent of professors women; however, five universities have special research units for women.

Percentage of work-force women: 50 percent—of which 43 percent work part-time. With seventeen hours a week they are entitled to full pro-rated benefits. The gap between men's and women's salary is 10 percent, one of the lowest in the world.

Abortion: The decision is the woman's, and the procedure is paid for by the state up to twelve weeks' pregnancy. (All but 1 percent take place in this period.) From twelve to eighteen weeks, the woman must get the agreement of a doctor and a social worker. After eighteen weeks, an abortion is possible only with the permission of the Board of Health. Nurses and doctors have the right to opt out of performing the procedure.

Child care: Government-run child care began in the 1940s. Centres are operated by each municipality with funds from the state, and fees are on a sliding scale according to the parents' income. Open from 6:30 A.M. to 6:30 P.M. for all children from one-and-a-half years on. Some family child care is paid by the municipality. Priority is given to single parents and students.

Maternity leave: Either parent at 90 percent of their salary for one year. To be extended to eighteen months with full pay soon. It is illegal to fire a woman when she is pregnant. Eighty-five percent of all fathers take ten days' leave when a baby is born. Seven percent take the full parental leave. One in five—mostly civil servants and middle-class men—take some leave. Three out of four men, aside from the ten days' leave when the baby is born, take almost no parental leave.

Birth-rate: 19 per 1000 population

Family law: Instead of tax deductions for dependents, the government pays bonuses and housing subsidies directly to families. A mother gets 485 krona (U.S. $92) a month per child in family benefits for the first two children and more for subsequent children. All fathers contribute to the support of children. If they fail to do so, the state pays the support and then collects it from the father.

Achievements: Probably the best social-service system in the world. A high standard of living. An established custom of

working out problems with all parties, of which women are very much part.

Problems: Since there was no strong feminist movement, Sweden was slow to deal with problems such as sexual harassment and battering. Women hold few top jobs in the bureau-cracy or the private sector.

THE BACKGROUND

By the tenth century Sweden had extended its influence to the Black Sea. In 1523 it broke out of a union with Denmark and Norway and established a separate kingdom. By the end of the seventeenth century it controlled Finland, Latvia, and Estonia and was one of the great powers of Europe. In the Napoleonic wars it lost Finland to Russia, but, in another conflict with Denmark, gained control over Norway.

In the nineteenth century Sweden made great industrial progress, but because of high unemployment many Swedes emigrated to North America. Sweden kept out of both world wars, and although it is now considering joining the European Community, it is not yet a member. From the 1930s on it has, under Social Democratic governments, brought in a whole range of very progressive social programs. Today it is one of the most prosperous nations in the world.

The first wave

In 1894 a powerful women's organization, Frederika Bremer, named after a famous Swedish author, was established. It remained active for nearly a century and is still going. It worked to get women ministers into the church and the vote for women, but its main accomplishment was that it got good women of all parties to run for parliament. During the 1970s, the number of women in the Riksdag went from 11 percent to 30 percent.

There were many other women's organizations, as well as women active in unions and in political parties. But women have been so well integrated into the system that there never has been a widespread women's movement in Sweden the way women in other countries have experienced it.

The second wave

During the 1970s a small Swedish feminist movement called Group 8 started. Far to the left of the Social Democrats, and far more radical and daring than Frederika Bremer, it campaigned for the rights of illegitimate children and lesbians, and against pornography. It published *Quinnobulletinen* (Women's Bulletin) and got a lot of media attention with publicity stunts. But the movement was never as broad or deep as in most other European countries. I was told that most Swedish women weren't interested in the kind of confrontations Group 8 went in for. The group still meets and still publishes its bulletin.

The situation today

Sweden has long been famous as the world's model social-democratic state with the world's best social-welfare system. It also has one of the world's highest standards of living. Yet Swedes work fewer hours than almost all other Europeans, and it's almost impossible to fire anyone. Until recently business and unions have been able to settle their differences with very few strikes.

Although it is the world's fourth largest trading nation, so far it has not become a memeber of the European Community. Sweden gets one-quarter of its energy from nuclear power, but is committed to ending that dependency and is experimenting with energy from the sun and the wind.

Stockholm's graceful, turreted, buff-coloured buildings take advantage of splendid vistas of the sea, which surrounds the city on all sides. The windows have iron balconies and boxes of geraniums. People proudly inform you that they can safely swim

in the harbour and eat the fish they catch there. Sweden has only six hours of light in winter, but its summer days stretch from four in the morning to eleven at night. Swedes rush out into the sun at the earliest opportunity after the long dark winters.

Half the couples in Sweden don't bother to marry and half the children are born out of wedlock. "That doesn't mean a thing," a visiting American told me. "Although almost everyone lives with the other person before they marry, they behave exactly as though they are married whether they legalize the union or not." Half of legal marriages end in divorce, and the term *illegitimate* was banned as long ago as 1917. Homosexuality was de-criminalized in 1944 in this open and tolerant society.

In social legislation, particularly for women and children, Sweden has a record of being light years ahead of many other nations. In 1862 single women who paid taxes could vote in local elections, but they lost that privilege if they married. In 1873 women were allowed to attend university, but they couldn't take theology or law. In 1909 they could stand for local elections. In 1921 marriage was declared an equal partnership. In 1923 the civil service was opened up to women. In 1953 the first woman cabinet minister was appointed. In 1958 the first woman Lutheran minister was ordained. In 1968 the first woman Supreme Court judge was appointed.

Sweden has enjoyed universal medicare for years. Maternity leave was introduced in 1937, legal contraception in 1938; equal pay for state employees was ratified under a union contract in 1960, parental leave for both parents in 1974, and short six-hour work days for parents with young children in 1979. Children get sex education from kindergarten on, and Sweden has the lowest teenage pregnancy rate in the world. Home-makers are paid for looking after disabled family members. Sweden has such a good support system for children that it now has the highest birth-rate in Europe, which is expected to reach twenty per thousand of the population in the 1990s.

How do the Swedes do it? Aren't they burdened with unreasonable taxes that inhibit industry? Doesn't the government invade private lives too much? Can you compete in

the world and still spend close to half the national budget on social programs?

Monica Boetius, of the Swedish Work Environment Fund, says: "Sweden has never competed better. The labour force is healthy, well educated, and although big corporations complain about taxes, they rarely have to worry about turbulence in the work-force, or that there won't be enough educated, healthy workers for the jobs. Companies stay in Sweden. They may complain, but they like the stability."

Almost everything in Sweden is expensive. A flat with around 1,000 square feet in a good neighbourhood in Stockholm can fetch U.S. $60,000 in a non-refundable deposit—which is, of course, illegal. Most people live in rent-controlled flats. The government has initiated much of the subsidized housing, but there still isn't enough. A translator, for example, who earns 14,000 kroner (U.S. $2,800) a month, pays 6,500 kroner (U.S. $1,300) in income tax, and is left with 7,500 (U.S. $1,500) to live on. Her tiny flat, where she lives with her daughter and granddaughter costs 3,000 kroner (U.S. $600) a month. Although the daughter gets a rent subsidy, which helps, they want a larger flat. But they must wait two years because priority for available units is given to the homeless and others in need.

Even Sweden has made some concessions to the kind of economic conservativism that has taken root in major Western nations such as Britain and the United States. The Social Democrats recently cut the top bracket of income taxes from 72 percent to 50 percent because it was felt heavy taxes discouraged top earners from working harder. Cutting taxes will also discourage credit buying. A consumer tax of 25 percent was brought in in 1990 on everything from hair cuts to concert tickets, though ballet and theatre are exempt.

Early in 1990, as a result of an effort to stave off inflation through a freeze on wages and prices, the government fell, although it quickly managed to take power again with a new budget. After debating about it for thirty years, the government will allow one TV channel to carry advertising in 1991. But no ads will be allowed on radio.

Karin Ahrland, a former minister of Health, and Liberal MP in the Riksdag, is critical of the tax system, which, she believes, discourages working. In spite of the fact that there aren't enough doctors, Ahrland says, they work short hours because of high taxes. People can't get anyone to do such jobs as house-cleaning unless they pay cash so that the workers don't have to declare the earnings on their income tax. But Ahrland's views are still those of a minority. Most Swedes appear willing to pay high taxes for the high-quality services and social protection they receive.

Most of Sweden's social programs were introduced by Social Democratic governments when they came to power half a century ago. They were generally supported by one or more smaller parties in a coalition government. Pensions were introduced in the 1930s. By 1956 they were based on the highest earnings fifteen out of thirty working years. The time women took off to have children (maximum three years per child) was later put towards their pensions. If a woman starts work early and only takes three years off for each child she ends up with a full pension.

By the 1960s women were joining the work-force in great numbers. In typical Swedish fashion, both men and women sat down and worked out how this changing ratio of male and female workers should be dealt with. In Sweden, this kind of collaboration has a special name, *Jamstalldhet*, which means working side by side. Everyone was greatly influenced by a study entitled "The Conditional Emancipation of Women", written by Eva Moberg, who edited *Hertha*, a magazine published by the biggest women's organization, Frederika Bremer. Her thesis was radical for the time: that women couldn't be fully emancipated unless men also changed their attitudes and actions.

In 1962, an extremely influential group started meeting every second month. "We called ourselves the Group of 222," former member Annika Baude recalled. "The 222 came from the number of my house. I had small children, and because it was hard to get a baby-sitter we met at my place."

There were politically active people from various parties, including, at the first meeting, future prime minister Olaf Palme;

journalists from the leading papers, radio, and TV; union leaders, academics and activists of both sexes. The catalyst was a new book called *Women's Life and Work*, by a group of Swedish and Norwegian researchers. The book said stereotyped roles of the sexes in society were created by society and could be changed by society, but to do this, men also had to change. The purpose of the group was to educate people and create a more gender-equal society. Both women and men should have "double roles" as providers and parents.

This high-powered think-tank debated and worked out many of the changes that were later implemented. Some of the things pushed for were individual taxation for husbands and wives, marriage law reform, and better town planning. At each meeting a paper would be presented for discussion. One of the people invited to come and speak was American feminist Betty Friedan. Another was Vance Packard, the American sociologist.

Issues that in other countries cause rancorous debate and take endless delay before even inadequate programs are launched proved straightforward within Sweden's more open, consultative environment. Research read by the Group of 222 indicated that children benefited from being in groups. "It was very positive stuff," recalled Monica Boetius, who was also a member. "And since unions and politicians had an interest in more women working, they took over the child-care debate and pushed child care through. The middle class was interested because good child care was desirable for them too."

Abortion has been an open topic of discussion for both sexes in Sweden since the 1930s. An organization with the utopian name of The National Organization of Sexual Enlightenment was started by chemist Elivi Ottesen-Jensen. She travelled around the country on a bicycle, talking to both men and women about birth control and abortion. Although the Lutheran church opposed abortion, it was not strong enough in Sweden to stop it.

Wealthy Swedish women had always been able to get an abortion by going to Poland. Middle-aged women in Stockholm today say that when they were growing up there was also a clinic, which, though not strictly legal, had two social workers who gave

out advice on birth control. By the end of the sixties you could get an abortion through an elaborate procedure of counselling, obtaining a prescription from two doctors, and getting final permission from the National Board of Health and Welfare.

In the 1970s a board was set up by the Department of Health and Welfare to look into the abortion law. Typically, the board had doctors and academics, but also people from county councils, the municipalities, and the political parties. Annika Baude, who worked in the department at that time, said that when the board finally presented the argument for a more liberal abortion law before parliament it stated the case for the individual rights of women so convincingly that there was hardly any rebuttal when the law came up for a free vote in 1974.

The decision to give both parents paid parental leave went through the same process. Landsorganisationen (LO), the dominant blue-collar union, issued a report in 1969 recommending maternity leave for both parents. The white-collar workers made a similar recommendation in 1970. By 1974, when the law was introduced, it quickly went through with the backing of the trade unions.

Although almost all men take the ten days' leave they are entitled to when the baby is born, only a few take full parental leave. Some women would like the law to go a lot further. Yvonne Hirdman, a professor of history, thinks it should be mandatory for men to take their share of the leave. She doesn't believe children should be primarily women's responsibility. "Women are being punished for something the country needs— the future generation of workers," Hirdman says.

Hirdman sees a trend in Sweden towards bigger families, and a new romantic attitude to motherhood. A few conservative politicians have even made the unusual suggestion that women be paid to stay home and have children. "But they can never pay women enough to entice them to go back to the kitchen," Hirdman says matter-of-factly.

Sexual harassment wasn't even taken seriously in Sweden until recently. Since jobs were plentiful and almost all women belonged to unions, the unions would protect women, it was

thought. But by the mid-1980s, there were so many complaints that the women's Social Democratic League put out a report demanding the government make civil-service jobs "erotic peace zones". At first the report was regarded as a huge joke. "All kinds of pent-up obscenity poured out," one union woman recalled. A working group of government, unions, and employers was put together, and after six months it produced a sexual harassment policy for the civil service.

A topic that comes up again and again in North America and Sweden, but is discussed only superficially in southern Europe, is the changing role of men. The debate in Sweden began in 1985, when the former minister of state for equality created a special working group. Stig Ahs, a charismatic and popular man, headed the project. Lectures and media events kept the subject before the public. After a year and a half a book, *The Changing Role of Men*, was published. The government felt the work had been so valuable that instead of disbanding the committee, it has maintained it. Since then similar projects have been launched in Norway and Finland.

But despite this ongoing discussion, Swedish women, like women everywhere, still do the major share of the household work by far. According to a recent survey, women put in thirty-five hours a week, while men put in seven.

Swedish co-operation between the sexes has also had its drawbacks. Because *feminism* is a bad word in Sweden and there hasn't been a strong women's movement, feminist viewpoints are also missing. Although battering, rape, and child abuse exist in Sweden, Swedes have been slow to recognize and move on these problems.

Wife battering was being publicized in North America by the late 1970s. Although the first hostel for women was opened in Sweden in 1978, Swedes only started talking about the problem openly in 1982. Today there are more than 100 hostels, and batterers are charged without the victim's consent. Rape-crisis centres have also been slow to get support, although ten thousand rapes a year take place in Sweden.

Child pornography is illegal in Sweden, and pornography

cannot be publicly displayed. In 1982, live shows were banned, and in 1985 public showings of pornographic videos were banned.

Another vexing problem is the low numbers of women in positions of influence in universities. Only 5 percent of professors are women. All across North America in the 1970s, studies identifying sexism in various faculties came tumbling out. But in Sweden such studies were thought unnecessary.

Even Sweden's work-force is one of the most segregated in the Western democracies. Under Sweden's policy of full employment, 86 percent of all women work, including nine out of ten mothers with young children. But most work at stereotyped women's jobs, at lower pay, in day-care centres or hospitals; or in boring, sometimes dangerous jobs like fish processing. A great many women—43 percent—work part-time and get pro-rated benefits.

And few Swedish women make it into the executive suite. Joan Acker, an American professor on leave from Oregon University who has been studying working women in Sweden, reports the percentage of women in top jobs in private corporations is less than 2. In banks 60 percent of workers are women, but only 10.2 percent are in upper management. Women tend to work for the government, where 57 percent of all employees are women. But the private sector is almost a male reserve, with 73 percent of all employees men. And, says Acker, more and more power is going to the private sector.

Solveig Nellinge, director of Trevi Publishing and the only women heading up an independent publishing house of any size, says the stress on career women is very heavy. "They work all day and then they have to come home and cook meals and do the housework." She says it's almost impossible to get help, and she thinks the problems will increase as more and more people get old. Because of the lack of room in institutions, the burden of home care will fall on women. In fact, she feels Sweden's social system could be in danger of failure.

Almost all working women belong to unions, but the unions are still male-oriented, with only 11 percent of the top union

positions held by women. This may have contributed to a recent major defeat for women. Women in the Social Democratic party have been arguing for a six-hour workday since 1972. They reasoned that if everyone put in a shorter workday, work in the home would be more equally shared. They argued that it would be better for children to have a shorter time in day-care centres. All told, a shorter workday would result in a better quality of life for the family.

But men in the party and in the union voted for longer holidays rather than a shorter workday. The six-hour day has been put off as a future goal. The women think they lost partly because they won an earlier fight for parental leave, which they describe as "a hole in the balloon", making the six-hour day more difficult to achieve.

Until the 1970s female representation in the Riksdag was fairly low. Then Frederika Bremer put on its big drive to get more women elected. Today the number of women stands around 30 percent. Sweden's five parties run the gamut from centre left to extreme left. All of them except the Communist party have a woman's section and all of them get financial support from the government.

Since consensus plays such a big role in Sweden, appointments to boards and commissions that advise the government are more important than in many other countries. Boards are carefully representative of political parties, including the opposition, unions, business, and the public sector. Women make up only 16 percent of these boards. The women in the five political parties are pushing for quotas. The Liberals have allotted 40 percent of their executive positions to women, but the Social Democrats have so far resisted the quota system.

A five-member Advisory Council on Equality, reporting directly to the prime minister, was set up in 1972. One hundred people were hired for employment offices and given the priority of helping women find jobs. Companies were allotted grants to train women. Any company getting government money to start businesses in depressed areas had to reserve 40 percent of the jobs for women. In 1976, equality in the civil service was decreed

a goal. Municipalities also set up equality commissions.

In 1980, the Act on Equality between men and women at work was passed. It forbade job discrimination on the basis of sex in hiring, promotion, training, working conditions, and salary. But since the unions are the ones who must press for change in labour agreements, the act isn't always enforced.

The position of ombudsman is very common in Sweden. There are separate ombudsmen for such things as ethnic minorities and consumers. An equal opportunity ombudsman for women was established in 1980. Gun Neuman, the present ombudsman, was appointed in 1988 for three years. A lawyer and former legal adviser to industry, she has eight people working in the department and a budget of 3.5 million kroner (U.S. $700,000) a year. She gets around sixty-five complaints annually, often about discrimination or about ads that aren't "gender neutral".

A typical complaint might come from a middle-aged woman who has been passed over for promotion in the firm where she has worked for the past twenty years, in favour of a young man with fewer qualifications. Rarely does this kind of case come to labour court—perhaps only two or three do a year—and for good reason. Only nine out of thirty-six have been won in the past nine years. If the woman loses, she pays not only her own costs but the costs of the other party. Cases covered by a union contract are supposed to be handled by the union on behalf of the employee, but Neuman says that most unions don't push very hard for women.

Neuman generally takes a mediating role, talking to the employer to find out why the man was chosen. Often the firm will give the complainant financial compensation, or more training, or an additional incentive or holiday. "There's no sense clashing with the employer," Neuman says with astonishing equaninimity. "Most employers want to co-operate because good help is hard to get and they don't want to get the reputation of being a bad employer."

She told me of two other cases. One involved sexual harassment of a young woman by a co-worker. When the woman

complained the employer moved her, but she continued to be harassed. The ombudsman took it to the labour court and lost. In another case they tried to compare a woman's job with a man's job that was similar. Again they lost. It didn't sound encouraging. I was told by several women that the labour court is dominated by males and that the former ombudsman was more aggressive in pushing cases. Solveig Nellinge said the ombudsman is useless: "People are told how to complain and they are consoled, but beyond that, they are not helped much."

A day in the life of...

Anna L. is twenty but looks a lot younger with her short spiky haircut and her black-and-white striped miniskirt. She passed high school with good enough grades to get a scholarship to university, and enrolled for one term. Then she took a job as a mail carrier in Stockholm. It's boring, but it qualifies her for maternity leave, which she will take in October when her first baby is born.

The father is Peter, twenty-three, her boy-friend of two years. He has a job as a hospital orderly, for which he earns 5,600 kroner (U.S. $1,120) a month after taxes. He also works in his spare time on a radical paper, for which he doesn't get paid. The couple have lived together for almost a year in a small one-bedroom apartment they rent for 1,300 kroner (U.S. $260) a month.

Anna gets up at 4:30 and delivers mail from 6:00 to 11:00. She earns 7,200 kroner (U.S. $1,440) a month and her take-home pay is about 5,200 kroner (U.S. $1,040). She and Peter have no plans for marriage and they get no pressure from either set of parents. "If ever we want to divorce, it's too difficult and expensive. Hardly any of my friends get married," she explains.

When the baby is born, she will be entitled to 270 days' maternity leave at 90 percent of her pay; then, for the next three months, she will get 60 kroner (U.S. $12) a day. She plans to stay home for six months; then Peter will do the same and she will go back to university. After the first year she plans to take out a

student loan and put the baby in a nursery, or perhaps make arrangements with friends, since it's hard to get infant care in Stockholm.

The university is free. All university students receive 1,300 kroner (U.S. $260) and can get a loan of 4,000 kroner (U.S. $800) a month for five years. She says a lot of her friends have decided to have babies while they take their courses at university. After she is established she may have another baby. Her sister, twenty-two, who is studying to be a doctor, plans to wait until she is established and have her babies when she is in her thirties.

Anna is supremely confident about her future, whether she and Peter stay together or not. The kinds of difficulties faced by single mothers in North America are hardly problems with Sweden's social-service system, and unlike most North Americans, Swedes are not fazed at all at a young unmarried woman living with her lover and having a child "on the public purse".

Anna realizes that the relationship might fail and she might want out of it, so why legitimize it with a marriage certificate? The attitude is a common one in Sweden. In fact, when I mentioned that Nancy Reagan is greatly admired by many North American women as a kind of role model, Swedish women were astounded. "Most people here would consider her a total ass," I was told bluntly by one woman.

But Sweden seems to be on the brink of change. Its famous system of compromise has shown some threatening cracks lately. There was a general strike in 1980, and more strikes in 1990. Some people think the system is too big, too impersonal, and too costly. There is concern that government is too intrusive in everyone's personal life. Other people complain about Swedish work habits—with parental leave, five weeks' holiday every summer, sick leave and re-training leave, the average Swede is off one day in four. Others complain that it's too hard to get rid of the deadwood in companies.

The Swedish habit of conforming can drive you crazy. You take a number and line up for everything—railway tickets, booze

in a shop, banking. It makes for fairness and eliminates disputes, but it results in long queues everywhere. Some nurses are leaving the profession because the pressure to be a team player is too relentless.

Some feminists fear that with all the worries about the environment, new strains on the welfare state, and pressure to join the European Community women's issues will be pushed to the bottom of the agenda for the next few years. Others feel that whatever re-alignment the Swedish system takes, women, who have always been good team players and have gained much in the past from taking that position, now need to be more individualistic and aggressive in putting forward their demands.

And there are signs that this may be happening. Courses in women's studies are now available. In 1982 a women's university was established. On the nuclear issue, women formed a coalition that crossed party lines. Women in unions are getting together on their own, taking courses, holding consciousness-raising meetings.

Sweden has always had a genius for dealing with change through its traditional way of bringing everyone into the discussion and then arriving at a consensus. Most of the people I talked to, men and women, are supremely confident that the Swedes will manage to make the necessary adjustments to their system once again and find satisfactory solutions.

NORWAY:
WOMEN IN CHARGE AT LAST, BUT IS THE POWER MOVING SOMEWHERE ELSE?

Facts

Population: 4.2 million

Government: Parliamentary system. Upper and lower houses. Proportional representation in elections and quotas for women in the Socialist Left, Labour, and Agrarian parties, but not in the Christian People's party, the Conservative party, and the Progressive party. Women must have 40 percent representation on all government-appointed public committees, boards, and councils, according to the Equal Status Act.

Vote for women: 1913—the second country in Europe to give women the vote and the fourth in the world, after New Zealand in 1893, Australian in 1902, and Finland in 1906.

Percentage of women elected: 34 percent in the Storting (lower house), 40.6 percent on county councils, 31.2 percent on municipal councils.

Education: Women won the right to attend universities in the 1880s. Ten percent of university professors are women and 50 percent of the students are women. A woman's university has been started.

Percentage of work-force women: 44 percent

Abortion: Up to twelve weeks, the decision is the woman's and the abortion is covered by national health insurance. Doctors and nurses can opt out of doing the procedure. Birth control and pre-natal care are free at health centres. Sex education doesn't start as early as in Swedish schools, but all school-children have it.

Child care: Day care less available than in either Sweden or Denmark. Only one in three children is able to get into kindergartens, which are subsidized by municipal and national governments. Parents pay 20 percent of the cost. Kindergartens vary according to the community. Some are open only two or three hours a day or on alternate days. Twenty days' parental leave a year for care of sick children.

Maternity leave: Twenty-eight weeks with full pay. Either parent can take the rest of the year without pay, without loss of his or her job. This is better than Denmark, but not as good as Sweden.

Birth-rate: 13 live births per 1000 population

Family law: One in every three Norwegian marriages ends in divorce, but fewer and fewer people are marrying. The number of single mothers has doubled in the past ten years. Divorce, if there is mutual consent, can take place after one year of separation. If there is no mutual consent there must be mediation; then divorce can occur after two years. Family allowance increases with each child and there is a special allowance for single parents.

Achievements: Stunning success in working the political system to get more women elected. Fairly good social services and a strong women's movement.

Problems: Not enough child care. School and shopping hours are difficult for women.

THE BACKGROUND

After the union of the three Scandinavian countries ended in the sixteenth century, Norway and Denmark remained united until 1814, when Sweden took over Norway. In 1905 Norway became completely independent, but until the twentieth century it was a poor agrarian society, with fish and lumber its chief exports. Certainly it was less industrial and urbanized than either Sweden or Denmark. During World War II it was occupied by the Nazis, while Sweden was not.

Ten years after most Swedish women were flocking into the labour-force in the 1960s, most Norwegian women were still mostly housewives. Norwegian women began to join the paid work-force in large numbers in the 1970s, after discovery of oil and gas in the North Sea. Norway not only greatly expanded its industries then, but spent a great deal more on social services.

Although Norway had its own king and constitution, it was never a feudal society, nor did it have an aristocracy. Small in population, egalitarian and homogeneous, it has had a long tradition of settling its differences through negotiation, and this still holds true today for competing interest groups, whether they be business, unions, bureaucrats, parties in the government, or special interest organizations affected by a particular issue. "We are reformist, not revolutionary. We value the common good in this country," a cabinet minister explained. Another activist feminist put it more humorously and cynically: "We settle everything by a thousand little battles, until consensus is reached."

The first wave

Both men and women fought for social change from the early 1840s. In 1842 unmarried women could go into business for themselves. In 1854 daughters could inherit equally with sons— the first country in the world to pass such legislation. In 1889

women working in a match-works factory—where many of them died from sulphur poisoning—staged a strike for better working conditions.

In 1884 the Norwegian Association for the Rights of Women was formed, and it immediately began agitating for women's right to control their own money. The National Council of Women (NKN), which became the umbrella organization for Norwegian women and eventually boasted half a million members, started in 1904.

Besides organizations working for suffrage, many other women's organizations date back to previous generations. For example, the second largest women's organization in Norway today is a housewives' organization started in 1915 to set up child care for single mothers. The Norwegian Women's Public Health Association was unique in that it administered the country's hospitals. There were also separate women's organizations in the unions and others attached to most of the political parties.

By 1901, women with property could vote in municipal elections. In 1913 Norway granted women the right to vote nationally—the second nation in Europe, after Finland, to enfranchise women. In 1915 illegitimate children were given equal rights with legitimate offspring—a first in the world. In 1920 the word *obey* was removed from marriage vows. In 1936 maternity leave of six weeks before and after birth was brought in. After World War II the work of women in the home was counted in the Gross National Product for three years, until Norway was forced to take it out to comply with international standards. In 1952 the Lutheran clergy was opened up to women. On 1964 women could keep their own names after marriage.

The second wave

Inspired by women in the U.S. in the 1970s, a myriad of new organizations sprang up. The New Feminists, launched in 1970, were anti-establishment and non-hierarchical, and went in for consciousness raising and lots of direct action. Among socialist

women, the Women's Front, organized in 1972, was concerned with the oppression of women and the class struggle. Other groups were Bread and Roses, organized in 1976, and the lesbian movement, organized in 1975.

But these new groups didn't try to supersede the older women's organizations, as similar groups did in other countries. Instead, the older organizations became more radical themselves and the different generations of women worked together on important issues. There was a solidarity among women that would have been inconceivable in countries such as France.

One of the first things the Norwegian women's movement did was to get rid of the old abortion bill, which required women to appear before a board. It was changed in 1978, later than in other Scandinavian countries because the Lutheran church, which opposed the reform, is stronger in Norway than in Sweden or Denmark.

The situation today

In May 1986, Norwegian women made the front pages of newspapers all over the world—even the *Wall Street Journal*—when the prime minister, Gro Harlem Brundtland, appointed eight women cabinet ministers and nine men. One hundred years after the suffragettes had started campaigning for the vote, their dream had finally come true: women were actually running things. Would it really make a difference? And why had it happened in Norway of all places, which compared with its social democratic neighbours, Denmark and Sweden, had always been a bit backwards?

There are three good reasons why this revolution took place in Norway: In common with other Scandinavian countries it was an egalitarian society, with a history of equality for women dating back to the Vikings. It had a strong women's movement. And it had an electoral system that women learned to use to their own advantage.

Relatively late to become industrialized, compared with Sweden and Denmark, Norway had been largely a rural society.

It was more religious, more conservative, and had fewer women working outside the home. One-third of the houses had no running water; one-fifth had no electricity. "Life was really hard for women," says Birgit Wiig, who wrote a history of Norwegian women.

During the World War II Norway was occupied by the Nazis. Women experienced great hardships, often being left to fend for themselves, while the men joined the resistance. Eva Kolstad, a prominent businesswoman who became a deputy member of parliament, head of the country's oldest women's rights organization and Norway's representative to the United Nations, recalled that she used to wear men's work boots and carry a stick, to try to look like an old man so that she wouldn't attract soldiers when she went out at night.

Some women raised rabbits and cultivated vegetable gardens to feed their families. Clothing was mended over and over. "Our clothes were in rags," Wiig remembers.

After the war the country started to rebuild with the help of the Marshall Plan. But most of the money went to industries such as steel and ship building. "Women got a few items like needles," Wiig said with disgust. "There was underwear for the men, but none for the women. We had a baby boom like everyone else in the late 1940s. The government brought in only 250 washing-machines."

By the late 1950s the economy had recovered, and by the 1960s, with the discovery of oil, there was an economic boom. Women began joining the work-force in droves. Yet the Storting, Norway's parliament, was still heavily dominated by men, as were the local municipal councils.

In the 1960s the Storting had 150 members, and only 8 to 9 percent of them were women. Municipal councils were also dominated by males. With the new surge of feminist groups in the seventies, women began to look at Norway's political system, which had unique features that could be manipulated, and Norwegian women learned to use that system to their advantage.

The system is multiparty and has proportional representation, but voters are also able to change the candidate lists in local

elections by crossing out a name high on the party's list and substituting another name from lower on the list, or even a name from another party's list.

Before the 1967 municipal elections, Birgit Wiig organized nine women's groups and approached both the prime minister at the time and the leader of the Labour party to ask them to agree to put more women on the party lists for the municipal elections.

In 1967, women in the small town of Modum scratched out men's names and substituted female candidates. They elected fourteen women to the council, where formerly there had been one. Overall the number of women in municipal elections went from 6 to 9.5 percent. But women weren't about to stop there. Before the next municipal elections in 1971, the women's organizations again canvassed the two big parties, as well as the other five parties, to get more women on the lists. This time the parties turned them down. But the women got the word out through the National Council of Women and other groups. The number of women elected went up to 15 percent, and three municipal councils, including Oslo, actually elected a majority of women.

This "women's coup", as it became known, was a great surprise to male politicians, who felt they had been outmanoeuvred, and claimed women had acted "undemocratically" to elect "incompetents". Changes were made to the electoral system to tighten it up so that it would be harder to use in the same way again. In the 1975 municipal elections, women lost their majority in Oslo and other cities.

At the same time, during the 1970s Eva Kolstad, president of the Norwegian Association for the Rights of Women and an elected member of the Oslo City Council, became the first leader of a party, the Liberals, on the council. In the meantime the newly formed Socialist Left party, an alliance of groups aimed at keeping Norway out of NATO and the European Community, had attracted a number of feminist supporters, including Berit As, a university professor, who became the second woman leader of a party. Gradually, through the Norwegian collective process, both these parties established quotas of 40 percent women on all executive boards and committees.

As a result of all this activity, in the 1973 national election 16 percent women were elected to the Storting. By the summer of 1976, Berit As, a member of the Storting, persuaded all the women in the house to support a motion to raise the quota to 50 percent and entrench it in the constitution. The resolution, considered a joke by male parliamentarians but supported by women's organizations, didn't pass, but in the election of 1977 the number of women elected went from sixteen to twenty-four.

And women continued to make gains. In the municipal elections of 1979 the numbers increased from 15 percent to 22 percent. Then came the big breakthrough. The Labour party, one of the biggest parties, was now led by Gro Harlem Brundtland, who had briefly been prime minister in 1981. In 1983, it adopted a 40 percent quota for women on all its lists. Today only the conservative parties have no quotas, although when a conservative coalition was in power two years ago, it appointed eight women out of nineteen ministers—proof that politics in Norway had changed forever.

When Gro Brundtland's party was returned to power in 1990, as high a percentage of women as before were elected, and she appointed women to half the positions in her cabinet. Both the Agrarian party and the Conservative party are proposing women as leaders in the fall of 1991.

To explain the unique success of Norwegian women in politics, Birgit Wiig says: "I don't think we were cleverer than the rest of the world. To do what we did, our electoral system was absolutely necessary. Besides, Norway is a small country and you can reach out easily." She also gives full marks to Gro Harlem Brundtland, who, when she became prime minister for the second time in 1986, had the courage to appoint women to form half her cabinet. "Lots of people thought the government couldn't possibly work with all those women in the cabinet, but she proved it could. Still, women are not in the heavy portfolios like justice and finance."

I met many women who admired Gro Brundtland, but several questioned whether she was really a feminist. In the 1970s she was very active in the fight for self-determination in the abortion

issue, but she is typical of successful women politicians everywhere: any woman who makes it to the top of the political system must compromise on many of her feminist convictions (if she has any).

Brundtland was raised in a political family. Her doctor father was minister of Health in a Labour government. Her mother worked outside the home. Brundtland took her medical degree in Norway, then studied public health at Harvard in the U.S. She was active in the Labour party from an early age.

In 1974, she was picked to be minister of the Environment. That portfolio gave her valuable media exposure. In 1981, there was a crisis in the Labour government and the former prime minister had to resign, and Gro Brundtland got her chance. In 1986, Norway's economy was in trouble after a consumer-spending binge in the aftermath of the oil discovery. "We were brought in to do the dishes after the party," she said of the 1986 election.

Wiig says of Brundtland: "She's rather conservative—and pragmatic. She's never been a fighter for women. But the most important thing was to have a woman at the head. When women look for a job now the whole climate has changed."

Berit As was more critical: "People all over the world called it the women's government. But it was a minority government, and had to rely on the centre parties to stay in power. It was very limited in what it could do for women. She wrote the *Brundtland Report* [a landmark United Nations document on the looming global environmental crisis], but the Labour party did very little even to diminish the exhaust from cars."

Although no one can dispute the success of Norweigian women, throughout my travels in Europe I heard a pessimistic refrain that was also put forward in Norway: as soon as women get power, power moves elsewhere. And to some extent this analysis is true enough to worry feminists They give as examples the fact that women only began to get power in the Protestant churches after religion no longer had much power in society, and that when women comprised the majority of doctors in the USSR, the profession no longer was prestigious, and today pays less than many menial jobs.

In many countries, political institutions have lost power, which has shifted to business. The multinational corporations particularly can move all over the world, opening and closing factories at will, with almost no restrictions from national governments.

Torild Skard, director-general in the Ministry of Foreign Affairs, is the former president of Norway's upper chamber and its representative in UNESCO. She has a different view: "I don't agree with the statement that power moves somewhere else. That's far too glib and general. It's difficult to get into institutions where there is a lot of power because there's more resistance from the men in stronger institutions. There's less resistance to getting women into the system than to getting active feminists in who want to change the system.

"The other problem for feminists is how much do you push as a feminist. It's a very complex issue, and a feminist might well say, 'There's no point in getting in at all. There's no power and I can't achieve what I want.' But I don't think that's true. Feminists can rarely do as much as they want to do, but neither can men, by the way."

The fight for a quota in politics has had a spin-off for women in Norwegian universities and in the bureaucracy, both of which were also dominated by males. Lower-level faculty in universities, which tended to be mostly women, have been elevated. The number of female professors is still very low, but the number of research fellowships and assistant professors has raised the overall percentage of women to 10 percent of university faculty members. A women's research centre was set up by the academic authorities in the 1970s—the first in Scandinavia. Now centres for women's research have been established in all universities. A brand-new women's university has been located in a beautiful setting about a two-hour drive from Oslo—another brain child from the active mind of Berit As.

In spite of their success politically, Norway's women are still the least advantaged in terms of services for women of the three Scandinavian countries I visited. Day care is much less available than in either Sweden or Denmark and parental leave less generous. In Oslo alone twelve thousand children are on the

waiting list for child care. Brundtland's new government has responded by setting up a new ministry for children and promising to have enough child-care spaces by the year 2000.

Under the Brundtland government there was a proposal to extend parental leave, provided it was taken by the father. But the bill was never passed. "Poor women working in badly paid jobs in factories would never understand why their husbands, who earn more, should stay home, while they had to leave their babies. It wasn't a good bill," I was told by one bureaucrat.

Children don't start school until they are seven. School begins at 8:30 in the morning and children are let out at 2:00 in the afternoon, creating problems for working mothers. Brundtland's new government is considering extending school hours. Stores stay open only until 6:00 at night and close on Saturday at 1:00, making it difficult for working women to shop. Unions still oppose any change in the hours because women employees also want to get home to their families.

Abortion up to twelve weeks of pregnancy and birth control are covered by the health scheme, but sex education doesn't start as early as it does in Swedish schools. The incidence of rape is the lowest of the Scandinavian countries and marital rape is recognized in law. Hostels for abused women are supported by the Ministry of Health and the municipalities. Pornography is legally restricted but easy to get, even though it's not nearly as available as in Denmark.

Some women claim there is currently a backlash among Norwegian men. Some men claim ex-wives are keeping their children from them. But compared with the violent and well-organized men's rights lobby in North America, Norway has few problems. It used to be that women automatically got full custody of children under three when a couple divorced, but parliament recently passed a law giving fathers visiting rights, even though child support is often paid irregularly. The new Brundtland government, it seems, has a slight but distinct tendency to downgrade sex equality and to emphasize children and their needs.

The government has set up a committee on the new role of

men in society. It appears that men have not taken on any more of the burdens of housework. Although younger men are spending more time caring for children, women still have the main responsibility for the household. "Men are not paying the price of the stress in our society. Women are," says Torild Skard. "A lot of women are exhausted carrying two jobs."

A day in the life of...

Gerd S. works for a small independent research firm. She and her husband, Karl, are not married. He is divorced from his first wife, and supports and sees two children from that marriage. Gerd and Karl have one daughter and live in a two-bedroom apartment not far from the centre of Oslo. They have a comfortable life. Karl owns a sailboat and belongs to a sailing club. Although he works for a shipping firm and has a good job, they find they are always under pressure both financially and time-wise. "I'm rushing from morning to night," Gerd complains. "We would like to buy a house, but at the moment we just can't afford it. I would like another child, but I don't see any prospect of that either at the moment."

Although Karl is determined to assume more responsibility for his second family than he did for his first, Gerd still does most of the planning and arranging. They have divided the household chores though. "He does things much more quickly than I do," she admits. "And he just eliminates a lot of details. But that's the bargain. If I don't like it, I'll end up doing everything myself. I just shut my eyes and keep quiet. That's the only way it works."

She admits she would never want the life her mother led. A university graduate, which was unusual for her time, her mother stayed home after she married, and raised four children. "She always regretted it, felt inferior, and was dominated by my father. She was determined I was going to lead a more independent life."

Gerd says that one out of three children in Oslo is living in a broken home, and related a joke that has been going around: "One little boy says, 'I've got a new daddy, Mr. H.' 'Oh,' his friend replies, 'you're lucky. He's nice. We had him last week'."

The situation today

As for government machinery to look after women, an Equal Pay Council was set up in 1959. A ministry for the family was formed in the 1960s—to get at least one woman in the cabinet, a woman bureaucrat cynically told me. Its emphasis was on the family and the education of girls, not equality.

In 1972, an Equal Status Council was established. It has a small staff of ten to fifteen people to serve both the council and the ombudsman. The council's job is both to advise and to criticize the government, and to get information on equality out to the public. In what I was told was a typically Norwegian approach, council members are appointed to represent all points of view: that of the unions, employers and other members of the public, and political parties. Lately a researcher has been added. But the big weakness is that in an effort to be fair to everyone else women are lightly represented. The representative from women's organizations was cut out in 1977. Often the member representing unions doesn't even come from a union with a lot of women members.

A recent report criticized the council for trying to do too many things without having the money to do them. It recommended that the council either concentrate on getting out information to women or become a negotiating agency between women and employers, with the power to investigate firms that are not paying women equally, much as the Equal Status Council does in the United Kingdom. Almost every community in Norway has had a local equality council since the late 1970s.

In 1978, an Equal Status Act declared that women were entitled to equal pay for work of equal value, but although quotas had been introduced as early as 1873, enforcement was lax. The Office of the Ombud was also set up in 1978 and Eva Kolstad was appointed. The Ombud investigates discrimination cases. If a woman complains that she is being paid less than a man in the same job and the employer refuses to pay her more, the Ombud can take the case before the Equal Status Appeals Board and the board can order the employer to pay more. But if there is a

collective agreement and the union won't take up the case, the Ombud can do nothing about it.

Sigrun Hoel, director of the Equal Status Council, wants the ombud to be able to take cases before the labour court, as the ombud can in Sweden. She would also like her own office to be able to interfere with and criticize collective agreements while they are being negotiated. For example, in pay equity, women can only be compared with men employed in the same job and by the same employer. This is very limiting, since there are often no similar jobs held by both men and women. As well, important female-dominated professions such as teaching and nursing are being ignored.

In 1982, the cabinet passed a law requiring all appointed boards and councils to meet the quota of half men and half women. Although women have had a stunning success in using quotas to improve their numbers in parliament, breaking down sex-segregated jobs in the private sector has been a lot more daunting. Even where women dominate a profession, as in teaching, a proposed affirmative action program to get more women administrators in the school system failed.

Today the oil boom of the 1970s has slowed down, and Norway's economy is no longer expanding. The country is in the middle of another debate over whether Norway should enter the European Community, a course Brundtland favours. There are more difficult economic times ahead, and a possible erosion of the welfare state, which has been very beneficial to women.

Torild Skard is one of those who fears that the welfare state may have reached its limits. "Some people fall through the cracks—immigrants, drug addicts, people not attached to the work-force." She says Norweigian women are better off than North American women in terms of support systems, but she thinks people may be feeling the burden of too many taxes.

When I was in Norway some women were bemoaning the demise of the venerable National Council of Women, the eighty-five-year-old women's umbrella group. But other women were full of renewed energy as a consequence of the Nordic Forum of 1988, which included all Scandinavian countries. The woman's

movement in Norway, then, is alive and well and evolving in a typically Norwegian way.

DENMARK—
WHERE THEY LOOK AFTER EVERYONE

FACTS

Population: 5.1 million

Government: Unicameral parliament called the Folketing. Proportional representation, with quotas that ensure parties run not more than 60 percent or less than 40 percent of either men or women.

Vote for women: 1915

Percentage of women elected: 30.7 percent of the Folketing and one-third of elected local councils.

Education: One in four doctors and church ministers are women. About 10 percent of associate professors are women, but only 3–5 percent of full professors.

Percentage of work-force women: 45.58 percent—41.9 percent part-time. Women earn 85.6 percent of what men earn. There is only a very small number of full-time housewives, since women make up almost half the work-force, including four out of five women with young children—the highest level of this group of women who work outside the home in Europe.

Abortion: 1973 law allows for abortion up to twelve weeks, paid for by the national health scheme. The time may be extended in cases of rape, social and physical stress, or if the foetus is defective. Doctors, nurses, and midwives may opt out of performing abortions, but small hospitals must have staff willing to do the procedure.

Child care: Among the best in the world. From six months to two years 55 percent of all Danish children are accommodated in either a crèche or municipally supported "child-minding" homes. From three to six years most Danish children are in publicly run kindergartens. There is almost no private care.

Maternity leave: One month before the birth of the baby, twenty-four weeks after, at 90 percent of salary, up to a maximum. The first fourteen weeks after the birth are to be taken by the mother; the last ten may be taken by either parent. Public servants get full salary for fourteen weeks. In the private sector pay depends on the union agreement; it is paid for by social security and with a ceiling limit. About 50 percent of men take the two weeks' paternity leave at the birth of the baby, but only 3 percent take the ten weeks off. All workers in the public sector and most workers in the private sector have the right to stay home for the first day of a child's illness.

Birth-rate: 11 live births per 1000 population

Family law: One in three marriages ends in divorce, but many couples don't bother to marry; 44.5 percent of children are born to unmarried parents. Division of property in divorce includes stocks, bonds, and businesses. Child support has been strictly enforced for more than fifty years. Family allowance is provided for all children under sixteen. Special help for single mothers.

Achievements: Excellent services for women. Very few destitute people. Men are involved with their children. No anti-abortion movement or backlash against women.

Problems: High taxes. Social services take up one-third of the budget. Women are not in powerful positions in corporations or government.

THE BACKGROUND

In the ninth century Vikings from Denmark briefly conquered England. In the sixteenth century Denmark, Sweden, and Norway were united into one kingdom, but Sweden broke away in 1523. By the nineteenth century in Denmark, agitation for land reform had resulted in Danish peasants becoming some of the most prosperous small farmers in Europe.

During World War II Denmark was occupied by Germany, and in 1972 it joined the European Community.

The first wave

In the nineteenth century women were part of the reform movement to wrest control of government from the ruling conservative elite. The same split that occurred in other European countries between middle-class women and working-class women also occurred in Denmark, but wasn't nearly as divisive as in Germany.

The Danish Women's Association was founded in 1871. It worked for better education for women, control over their own money, and women's suffrage. It still exists. But when a reform bill in 1898 made no mention of votes for women, a splinter group broke away to form the Danish Women Association's Suffrage Federation. With more than twelve thousand members, it worked for municipal suffrage, and in 1908, everyone, male or female, who paid taxes—property or income taxes—could vote.

The National League for Women's Suffrage carried on the fight. Though not as militant as the British organization, it enrolled eleven thousand members. In 1913, a coalition of Liberals

and Social Democrats took power. A bill introduced to give women the vote was defeated, but in 1915 another bill passed.

The struggle for equal pay in Denmark goes back a long way. In 1919, a bill was passed making it mandatory that all women working for the government—for example, teachers, who were paid two-thirds of what men were paid—be paid the same salaries as males. But municipalities changed the jobs slightly, fired the women, and hired men.

In the 1920s, Thit Jensen, a novelist, and Marie Nielsen, a social worker, campaigned for sex education in the schools, contraception, and clinics for working women. But none of these came to pass until after World War II.

The second wave

The Danish women's movement took off in April 1970 when three journalists got together and talked about forming a woman's movement. The Red Stockings became the biggest feminist organization in Denmark. It made headlines right from the start and scandalized Copenhagen society by marching through the streets with its members dressed bizarrely as sex objects. The organization initiated lots of direct action, such as demonstrating against the transportation company that wouldn't allow women with prams on public buses. Its members invaded male-only bars, and arranged marches and rallies about battered women, rape, abortion, and equal pay.

The Red Stockings organized three big campaigns that involved thousands of women. The first was over abortion. Although the 1970 law was quite liberal, women campaigned for, and got, abortion on demand. Next they fought against Denmark joining the Common Market because they believed the country's social programs would be dragged down to the level of some of the other, less progressive countries. They lost that campaign in the 1972 referendum. The third campaign was for equal pay, an issue over which they are still campaigning.

In the early seventies feminists took over a downtown building in Copenhagen and used it as a centre to show feminist movies

and put on plays. (This also happened in about forty other towns in Denmark.) A feminist radio station operated for a time. Every summer for years there has been a big summer camp for women on the island of Femo. For a time a women's restaurant flourished. In 1974, a group of women started a feminist magazine, *Kvinder* (Woman), which was published six times a year. The magazine dealt with subjects not being treated in the mainstream press, such as menstruation, menopause, immigrant women.

The situation today

"This isn't exactly paradise here," a Danish feminist warned me. But compared with Canada, Britain, and the U.S., where there is an acute shortage of good child care and not even legislated maternity leave in the U.S., Danish women are in heaven. Denmark provides excellent services for its women, and women make up one-third of the Folketing, the Danish parliament.

Denmark is a cosy country—its solid brick houses with their long low attached barns are built snug to the ground against the fierce wind that blows in from the North Sea. One of the most densely populated nations in Europe, it has a countryside that is flat, often wet, and brilliantly green. Denmark has no nuclear plants. Engineers are working on harnessing energy from the winds and the ocean.

The Danes enjoy one of the most egalitarian societies in Europe. Conductors talk to passengers; waitresses chat with customers. The Danes even speak matter-of-factly of their tall, but slightly ungainly queen, Margrethe II, who, they point out fondly, sometimes trips at public receptions. Tips are included in fares for taxi-drivers, who still get out and open doors for you—a courtesy that disappeared along with running boards on cars in North America. Folketing security is charmingly relaxed. Even the prime minister uses the old wooden elevator, which resembles a dumb waiter and goes up and down constantly between floors.

Between 70 and 80 percent of the workers are unionized, and there are slightly more women union members than men. A

union for unskilled women workers is the fourth largest in the country. Although unemployment ranges around 8 percent among women—not a large figure by the standards of many countries—Danes consider it very high and try to keep everyone working. Single mothers get special training to get back into the work-force. They also get subsidies and free child care until they can support themselves. Only about thirty thousand people are considered unemployable, and they are supported on welfare.

Since as far back as the 1930s, Danes have believed people should be responsible for their own children, both legitimate and illegitimate, and paying child support is strictly enforced. Unlike in North America, where a man can claim all of his child support as a tax deduction and a mother has to pay tax on the support she receives for her children, in Denmark a man may deduct only half his child support on his tax return, and the mother isn't taxed on child support at all.

Danish men seem genuinely to like Danish women, who are able to go everywhere without being harassed. There isn't the exaggerated flirting that goes on in southern Europe, where men make a great fuss over women before marriage, then treat them like servants after. Nor is there the smouldering resentment and thinly disguised public violence against women that exist in North America.

Young Danish women stride around like a new breed of Viking women—attractive, competent, able to handle anything. On a ferry a young woman was being bothered by a drunk. She told him off and went on reading. There was no suggestion in her manner or from the people around her that she needed help or couldn't handle the incident herself.

Still, Denmark's happy welfare-state skies have a few clouds, and even some ominous thunderstorms rumbling on the horizon. Traditionally a homogeneous country, Denmark is having trouble accommodating immigrants from Turkey—brought in during the 1960s, when employment was high, to do the menial jobs Danes don't want to take on any more. Incidents of racism and bigotry have increased. There is a growing number of homeless people and beggars on the streets.

Even with a child-care system that is one of the best in the world, problems still exist. In big cities such as Copenhagen there aren't enough crèches and they are too expensive. For babies under three it costs from 1,300 to 1,900 kroner (U.S. $250 to U.S. $360) a month, even though the government pays most of the cost. But once the child is three the child is in kindergarten and the cost drops dramatically.

Everyone complains about high taxes. One women I talked to pays 78 percent income tax on everything she earns above 216,000 kroner (U.S. $41,080) a year. Rent for a Copenhagen apartment runs around 5,000 to 7,000 kroner (U.S. $950 to U.S. $1,330) a month, although poor families are eligible for subsidies. A Volkswagen costs 120,000 kroner (U.S. $22,800). Borrowing is easy, so that many Danes carry a big load of debt.

A day in the life of...

Although she and her husband are considered very well off, Marianne C. thinks her family is too heavily taxed. She got married in her late teens to Carl, whose parents helped him start his own business and bought them their first house. They made the decision—which was unusual in Denmark, where almost all women work, even women with young children—that Marianne would stay home with their three children. Although some of her friends felt isolated and cut off at home, she has never regretted her decision.

The children are now eighteen, fifteen, and eleven, and the family lives in a suburb of Copenhagen in a spacious house with four bedrooms, two living rooms, a kitchen, two baths, and a rec room for the children. Three years ago Marianne started working as a secretary at the university twenty hours a week. (Close to half the women who work outside the home are part-timers.) Between their two salaries Carl and Marianne earn more than a million kroner (U.S. $190,000) a year. He pays 65 percent income tax and she pays 51 percent, which means a take-home pay of around 368,000 kroner (U.S. $70,000). However, before people are taxed, they can deduct interest payments on their

mortgage. Under this system two-thirds of all Danes—including many young couples—own their own houses.

Everyone in Denmark pays indirect consumption taxes of 22 percent on everything. And Danish prices are high. Two pork chops cost the equivalent of U.S. $5. A small ham of two and a half kilograms was $17. A wedge of torte U.S. $3, a large bag of frozen peas U.S. $5, round steak U.S. $12. Medicine is cheap, but cosmetics, which are considered a luxury, are heavily taxed and expensive. Taxi meters in Copenhagen start at U.S. $2.50.

Marianne's father and mother are well off, and they pay even more in taxes—85 percent on interest from investments. They are both ill, and they live in a nursing home, for which they have to pay part of the cost, although less affluent residents live there free. "People don't save any more. You use your money while you can," Marianne complains.

Carl and Marianne own a car, but many people get around by biking, often with a baby seat behind them. There are special biking paths everywhere, and public transportation is excellent.

There are few women in any positions of real power in either government or business. Only 2 percent of executives in business are women, 4 percent of top executives in the bureaucracy, and 10 percent of middle-management civil servants. Just 4 percent of Danish school inspectors—a profession women usually dominate—are female. Although Denmark appointed the first woman ambassador in the world in 1949, there is still only one woman ambassador today. Two of the fifteen members of the Supreme Court are women. Only 7 percent of university professors are women, and only about 10 to 15 percent have tenure. "Everyone thought this would correct itself, but it hasn't improved at all," a woman professor said ruefully.

With a Conservative government in power after many years of Social Democrats, changes that worry women are being made in the social system. To cut back on social-service costs, which now take up one-third of the country's budget, people have to pay for using record libraries and for part of the cost of medicines. Even the budget for day care was cut in 1989. There are two new

private hospitals in Copenhagen and people take out special insurance to use them. More and more Danes are sending their children to private schools.

Although relations between the sexes appear to be healthier than in North America, rape and battering haven't been eliminated. Police are specially trained to deal with domestic battering, and hospitals are required to report suspicious injuries. Community-supported houses for battered women exist, but there aren't enough of them. Since the law deregulating pornography was passed in 1968, explicit sex dominates every newsstand. Women worry about the effect on children. "My daughter used to be shocked and deeply offended by it. Now she seems almost to accept it," one woman complained.

Danish men really are involved with their children, and they do work their fathers never would have dreamed of doing, such as laundry and diapers. But housework isn't equally divided. Wives with full-time jobs work a total of eighty to eighty-five hours a week on the job and at home. One feminist commented: "Men will shop, cook, carry out the garbage, wash dishes, but they don't seem to be able to do things like planning meals." She was quick to add about her own marriage: "We absolutely share everything. I never would have got into it under any other circumstance."

In Denmark there is none of the relentless pressure from anti-abortion groups, as there is in North America, but a conservative minority is beginning to grumble that too many abortions are performed, even though only 3 percent occur after the first twelve weeks. Due to good sex education in the schools, only two thousand births a year occur among women under twenty-one.

Many young women complain that they don't have enough time with their children—a legitimate cry echoed everywhere by mothers, particularly with their first child. In a country where 80 percent of women with young children are in the paid work-force, this is a new concern of the women's movement. One feminist said: "I'm afraid, especially if unemployment increases, that women will end up back in the home again. Nevertheless women do need longer maternity leave. I can hear those voices,

and it's important to turn their concerns into claims both for work for women and time for the family for both parents. Still, for an old feminist like me, it's scary."

Danish feminists are convinced that parental leave has to become a matter of course not just for women but for men as well. "Fathers have to be thrown into the nursery. Unless men take half the responsibility for children, women will never get equality." Some are pushing for obligatory paternity leave, as well as for more men being able to take time off for a child's illness. And there's quite a lot of support from men. In a research study of sixteen hundred men, more than 50 percent of them would like to do part-time work while their children are small.

Suzanne Brøgger is a renowned Danish feminist writer, whose first book, *Deliver Us from Love*, was about "the oppressive, repressive, and irrational family and how harmful it has been for women." According to Brøgger, the family has been disrupted in the past twenty years and is close to disappearing. "A whole value system has lost its prestige. Now the nuclear family is only one style among many others," she said.

"But the problem is that this leaves a lot of lonely people without a network. Even though the family was oppressive, it took care of all the misfits in society. The young and the beautiful can always find other people, but the old and ugly can't. They have to stand in line for help from the state. And women still do all the nurturing jobs, both in the work-force and at home.

"That leaves nobody in the home. This isn't being addressed by women because it's too dangerous. Dangerous because there's so much guilt. And women are afraid that if they express it directly, people will ask, Why don't you go home and look after your kids? It's a painful problem, but we have to talk about it and find solutions. The whole concept of work is run on male conditions, and that has to be changed. Women have to be more aggressive about this."

Although Brøgger lives in a charming converted schoolhouse in the country with her companion of many years, a university professor and writer, and their three-year-old daughter, Lucia, she worries that "So many women of my generation are mothers

living alone with children. They've given up trying to cooperate with a man. It's too much trouble. Even when men are very helpful, women still feel they have all the psychological responsibility of the relationship."

That psychological responsibility has been the subject of a study by Dr. Birgit Petersson, a psychiatrist and senior lecturer at Copenhagen University. The biggest problem for women, Petersson argues, is that they are always on a fixed schedule. Men can decide when to do chores such as cutting the grass, taking out the garbage or shopping, but the jobs women do at home, such as meal preparation or caring for an ill child, can't wait until the mood strikes.

She found that unmarried women have fewer psychiatric problems than married women, and married men fewer problems than unmarried men. Women who live with men and are unmarried have the most problems of all. They aren't sure of anything. They reported having three times as many headaches as single, unattached women.

As a doctor and university professor, Petersson is worried about the increasing emphasis on technology in medicine, which is happening, she believes, because men are more comfortable with technology. It used to be that the medical profession would tell women to wait two years before worrying about getting pregnant. Now if a woman doesn't get pregnant after one year, she is made to feel abnormal and encouraged to use technological methods such as artificial insemination and in vitro fertilization.

Petersson objects to the effort that is being put into saving smaller premature babies, who often have serious health problems later. She says small babies are often the result of the mother working too hard or living in bad conditions, and that better pre-natal care, not complex technology, is the right approach.

Petersson says she became a feminist at twenty, when she got pregnant and had to go to Poland for an abortion. To get the money, she took a job as a nursing aide while continuing her medical studies. When she came back from Poland she was enraged to have her boy-friend meet her with a new car. In 1974, she helped start the feminist magazine *Kvinder*, and since it

ceased publication she has been writing a column on psychology and medicine for women in a mass-market magazine with the non-feminist title *All for the Ladies.*

Today many Danish feminists complain that the movement is too dispersed, unfocused, and not radical enough. Drude Dahlerup, an associate professor at Arhus University, author and an activist for many years, says it's essential that younger women get involved. She takes comfort in the fact that in 1988 more than ten thousand Scandinavian women came together in Oslo, Norway, for a Nordic conference that included all kinds of traditional and radical feminists, as well as women from all the political parties.

Dahlerup says she became involved in the movement quite naturally. Her mother was a member of parliament and later, due to her experiences, became a feminist. Because European women tend to be more closely attached to political parties than women in North America, she doesn't think an umbrella women's organization that crosses party lines, such as NOW in the U.S. or the National Action Committee in Canada, would work in Denmark. In North America, she believes, there isn't that much difference among the large political parties, and many women are disenchanted with the political process anyway.

She says the days of marching and demonstrating are mostly over. Young Danish women prefer to get together to work on a festival or on specific issues such as equal pay. "As long as women keep working on issues, the movement isn't dead," she says. "We believed that once we fought, a new generation would be born into the new high level of the feminist consciousness we had created. But teenage girls, now as always, are disturbed by feminist talk. It's when women have their first child that their situation hits them."

An issue she would like to see disappear from the feminist agenda is the problem of rape. "Why do we assume it's always going to be there? Why can't we deal with it so that our daughters never have to worry about it again?"

Today in Denmark the closest thing to an umbrella organization is the Danish Women's National Council, with forty-one

member organizations and more than a million members. Although both the Swedish and Norwegian national councils have disappeared, the Danish council, which is ninety years old, is still a going concern. It includes women of all ages from all the political parties; as well as trade union women; farmer's wives; Jewish, Protestant, and Catholic women.

One feature of Danish government policy is the funding of special projects for the unemployed. This has been a boon for women, and they have come up with such innovative projects as a computer training centre for women, which they called a "living room" and decorated with plants to make less formidable for their clients; and a "folk" school—a high school for adult women that they can attend during the day.

Another unique effort is the Women's Museum in the former city hall of Arhus. Using women's unemployment insurance and a grant from the government, it employs from six to eight permanent staff and forty to fifty women for as long as seven months at a time. With a budget of 5 million kroner (U.S. $950,000) a year the museum trains women to work on archives, make papier mâché figures for displays, design posters, do promotion, and operate a cafeteria. Run as a collective, it stages different shows every month. One was on a forgotten woman artist, another on the history of a local family, illustrated through family photographs and possessions.

KVINFO, or Women and Information, is also unique institution in Denmark, and one of the few women's archives and libraries in the world. Started in 1982 by a staff member of the Royal Library, Nynne Koch, who began classifying and cataloging women's writing out of a small flat, KVINFO now occupies a spacious office in the middle of Copenhagen. There is a library, as well as offices for the two full-time librarians, three academics, and a secretary, plus meeting rooms that are used by women's organizations, artists, and musicians. KVINFO puts out a magazine and a calendar of activities, and keeps a registry for women who are experts in various subjects. The budget is 2.3 million kroner (U.S. $437,000) a year.

Danish women got the vote early—in 1915. There are nine

political parties and the government is always a coalition, with either the Social Democratic party or the Conservative People's party as the dominant parties. The Social Democrats have been out of power for seven years. The Conservatives have stayed in power by forming coalitions with other smaller parties. "It's almost like Italy, with an election every second year all through the seventies and eighties," Helle Degn, a Social Democrat member of parliament told me.

Denmark has a system of proportional representation, and at the last congress of the Social Democratic party a decision was made to have a woman among the first three candidates on the list, with at least 40 percent of every list made up of women. Today there are fifteen SDP women out of fifty-six members in the Folketing and 40 percent women on the party executive. Other parties, such as the Radical Liberal party, have declared that they will run 50 percent women, but the Radical Liberals get less than 6 percent of the vote.

In 1985 a law was passed requiring all government-appointed boards and commissions—which used to be overwhelmingly male—to have both men and women on all future lists. The proportion of women has gone from 11 percent to 38 percent, according to the prime minister. But women say a more accurate figure would be 24 percent, which is the overall average of all committees, not just the newly appointed ones.

Some women are trying to launch a women's political party along the lines of Iceland's feminist party. But unlike the Icelandic women, who previously had almost no representation in parliament, Danish women are quite well represented. Many feminists doubt that the party will make much headway for this reason.

Denmark has an Equal Status Council, which was set up in 1975. It operates with a government-appointed board of six women and two men. Women's groups put forward women candidates for the board—three from the national council, one from another women's group, a woman from the skilled trades, and a feminist academic. The male members tend to come from business and unions.

The board meets once a month. Grethe Fenger Møller, a former minister of Labour in the Conservative government, was appointed chair by the prime minister. The budget is a fairly modest 2.8 million kroner (U.S. $530,000), although it is possible to get extra money for special projects such as projects on sexism and sex stereotyping in schools and textbooks.

The council is supposed to be independent enough to complain to the press about incidents of discrimination, but since the chair is almost always a member of the government in power, it's usually not very vocal in its criticism. Two equality acts have been passed in response to directives from the European Commission: the Equal Pay Act of 1976 and the Equal Treatment Act of 1978. But the Danish Equal Status Council can only act on this legislation if there is no collective agreement. It has no budget to take cases to court. It was given a little more muscle in 1989 with a law that forced government departments and private companies to answer any enquiries by the council or be fined. Two recent court rulings that were lost proved that the law has some serious loopholes. The women's equality committee in the Danish trade union LO wants the onus to be put on the employer to prove unequal pay is not due to sex.

Grethe Fenger Møller says the biggest problem in Denmark, even after twenty years of feminism, is that the labour force is still segregated, with women holding the lower-paying jobs. One of the council's major concerns is closing the overall 30 percent gap in wages between men and women. Even after taking into consideration education, age, and the dissimilar work that men and women do, there is still a wage gap of 13 percent between men and women in unskilled labour, and 9 percent in skilled labour.

Another current concern of the council is the structure of family/work responsibilities. Unlike North Americans, Fenger Møller says, the Danes didn't ignore the fact that women have children. The council's research shows that when couples have children men work longer hours on the job and women work shorter hours. Women's risk of being unemployed rises to 18 percent and men's risk drops to a little more than 5 percent. The council is doing further research, holding seminars, and working

to identify companies with good policies towards their female staff.

Denmark isn't a feminist paradise, but it's still a very comfortable place for women to live. Danish women have a solid base of social supports and one of the strongest women's networks in Europe. They have had some success in getting quotas in some of the political parties, and in closing the wage gap. They are determined to involve men in the care of children, since they are convinced that is the only way to change society, and they are succeeding to some extent.

Denmark is a country where compromise and working things out are the traditional means of achieving change, and that's the way women are attacking their problems. Some of their demands—longer parental leaves, more sick leave for both parents of an ill child, 50 percent quotas in political parties— would be regarded as revolutionary in other countries.

Today Danish women are in the unusual position of having to worry more about what they could lose in the future—for example, through membership in the European Community— than what they still have to gain.

SO WHERE DO WE GO FROM HERE?

In my travels from country to country while researching this book, I met many women—strangers, yet they were as familiar to me as myself.

A young blond student on the train to Slagelse in Denmark tossed her haversack in the luggage rack and curled up to sleep for the next two hours as though dead. I wondered what on earth she had been doing to need to sleep so soundly on such a beautiful day. Then, as the train drew into a little station, she started up as if an inner clock had gone off. On the platform were two older women, eagerly searching the cars. The young woman hastily pushed a comb through her hair, adjusted her face into a composed and happy smile, and stepped off the train to meet those searching, questioning, loving eyes of what I imagine were her mother and grandmother. We have been there. We have all been there.

I was having dinner in London at an outdoor café. An aristocratic Indian and his wife sat down at the next table. We smiled politely at one another. After consulting with her, he ordered their dinner. She was unhappy with her first course. He called the waiter. Although she spoke excellent English and was the one complaining, he did all the talking. I finished my meal and called for the bill. There was an error, which I pointed out to

the waiter. As I paid the bill and got up to leave, I caught her expression. She looked at me with complete disdain. With a shock I realized that she pitied me and felt superior to me—a woman alone with no man to fight my battles. I naturally bridled. We stared at each other for a moment and then we both looked away in embarrassment. A cultural canyon gaped between us. It was clear neither of us would have traded places with the other for all the gold in India. We have been there. We have all been all been there.

There was the owner of a feminist bookstore located on one of the most beautiful piazzas in Rome. Suddenly she stopped our conversation, went out of her way to include in the conversation another woman, evidently her partner, who had been working in a corner of the room. Later crossing the room to look for a book, she touched the other woman, once again including her. A scarcely noticeable gesture but eloquently thoughtful. We have been there. We have all been there.

Again, there was the Swedish mother on a train. With her were her two young sons. The younger, Gustav, five, was unhappy. Used to his mother's complete attention, he now had to share it with his elder brother, who was telling his mother a fairly complicated story. Gustav kept interrupting. He complained that he didn't get his half of the soft drink. He kept pointing out objects from the passing train. Each time his mother stopped the conversation and reassured him. He gradually calmed down. Then a drunk caught the little boy's attention by holding up a coin. Gustav's wide grey eyes lit up, then immediately flew to his mother for guidance. She gently shook her head. He looked away, content and secure for the moment. A simple-enough tableau, but an illustration of what happens a million times a day, day after day, in the care and teaching of the young—and most of it is done by women. We have been there. We have all been there.

Almost every feminist I met spoke of her husband as a very special man, a treasure, who shared equally in all the household tasks, cared equally for the children, and understood and agreed with what she was working towards. A prince among men. I met a few of them, and they really didn't seem that extraordinary—or

that co-operative. Privately I questioned the need for this public-relations exercise. Did he really do his fair share of planning grocery lists, ferrying children to lessons? Did he do his half of the drudgery—cleaning toilets, washing dog dishes, sorting dirty clothes—as well as the more creative jobs—cooking, for example? And I wondered, sourly, why this woman had to spend so much time publicly praising him for only doing his share of the work in their life together. We have been there. We have all been there.

I had hoped that I would find some never-before-thought-of answers to the dilemma of why it has taken so long to bring about the changes so many women have been working towards for so long. Although I found no such answers in all our collective experiences, I did see some clear directions to take.

And there is a great deal to be encouraged about—even jubilant. In addition to all the legislation that has been passed, the infallibility of centuries of male thought has been challenged—in medicine, justice, psychology, philosophy, history, economics, theology. A whole generation of men and women simply think differently. Sexist jokes and comments that would have been considered banal but commonplace a generation ago are now regarded as in extremely bad taste.

In the past one hundred years women have come so far in this revolution of ours that I am convinced there is no going back. It is still possible that there may be setbacks and temporary reactionary backlashes. This could take place in times of economic stress or under military regimes, as has happened in the past.

Much more likely, under the present shift to a world economy, is an erosion of the support systems women and men had built up in the Western democracies. As multinational corporations seek cheaper labour and less stringent environmental controls in the Third World, national governments everywhere will have less and less power to protect their citizens and regulate such corporations. To combat exploitation in the Third World and pressure to diminish hard-won support systems in the developed world, there will have to be more international co-operation,

more involvement by the United Nations, as well as a world-wide supportive and active women's movement.

It is clear that progress for women has been impeded, and will be impeded, when:

1. There is a long tradition of an elitist, rather secretive central government, bureaucracy, and institutions, as in the United Kingdom and France, in which "old boy" networks are still strong. Women, as outsiders, find it difficult to penetrate such systems.

2. There is a weak federal system where powers are divided between the central and state governments, as in the U.S., Belgium, and, increasingly, Canada. Women have to pressure at both levels of government for change.

3. There are no left-wing parties, nor is there any socialist tradition, as in the United States. (Socialist governments have, on the whole, been better for women than conservative governments, which tend to support the status quo, or, if they bring in supportive legislation, tend to be paternalistic.)

4. There is a weak labour movement, as in the U.S. and, to a lesser extent, Canada.

5. There is a deeply entrenched class system, as in the United Kingdom, or deep language and regional divisions, as in Belgium, Italy, Spain, and Canada.

6. The influence of the church is strong, as in Italy, Belgium, Spain, Canada, and the U.S. Although in some countries the church has been progressive and fought for human rights, generally speaking, on women's rights the fundamentalist and Catholic churches have hindered progress. In almost all Catholic countries, for example, the church opposed higher education for women and the vote came a whole generation later than in most Protestant countries. In Canada and the U.S. groups from fundamentalist religions and the Catholic church continue to

harass women and make free access to abortion difficult, even when the law supports it.

7. There is a militaristic tradition and a history of emphasizing women's biological—or inferior—status, as in Germany and France. Or there is a strong military/business/government alliance, as there has been in the U.S. for decades.

8. There is an electoral system in which each candidate has to contest individual constituencies, as in the United Kingdom, Canada, and the United States, rather than some system of proportional representation, as in most European countries.

9. The right is on the rise in a country, as it has been in the past ten years in many countries in Europe, and in the U.S. and Canada. (The agenda in these countries has focused on the problems of business, not the welfare of people. Even in good times "conditions" for bringing in child care and other support systems are never right. In any downturn in the economy, services are cut even further. Unemployment, particularly among women, is not even considered a problem.)

10. International organizations such as the International Monetary Fund and the World Bank, while supposedly helping the Third World, throw up roadblocks. (For example, deeply in debt, such countries are pushed to produce cash crops to earn U.S. dollars to pay off debts, something often done at the expense of raising the food their own people need; moreover, the work is performed mostly by women.)

11. There is a real lack of support services for women, making it particularly difficult for them to work outside the home and look after children. (This is especially true in the U.S., Canada, and Germany.)

12. The basic inequality that exists almost all over the world between the power of women and men remain unchallenged and

280

women continue to be kept in dependent relationships economically and physically.

What are the next big steps that must be taken for the liberation of women?

1. Patriarchy has never served the needs of women and children, nor has it served the needs of most men. Women are now demanding, as men did in the Renaissance, the right not only to control their own destinies, but to determine what choices are being made.

Under male-run systems the world has been brought to the brink of annihilation through nuclear war. We are rapidly depleting the world's resources and polluting the environment. One in three people in the world goes to bed hungry—not just in the Third World, but in growing numbers in the great cities of our richest nations.

Women have sometimes experienced the greatest opportunity for change during a period when many changes were taking place. Now is one of those times of change.

Much of our effort so far has been spent in tinkering with individual environments and political structures. Yet in country after country, women told me how frustrating that process has been. They would prefer to change the whole structure, as well as the process. In other words, they want an entirely different world with different priorities.

Over the past thirty years women in the movement have been absorbed in the past and the present. We have re-discovered our history, shared our experiences, defined our needs. After four thousand years of patriarchy we have tried to expand human experience beyond male-dominated thought, aeons of history where half the human race was not counted, not written about, and existed only in the shadowy margins of men's lives. This has meant testing, and being critical of, every system, and all assumptions, values, and definitions.

Women have spent a great deal of time discussing, defining, and arguing over the different ideological positions of different

groups of feminists. It is time now for women to put aside those kinds of discussions and to delineate the kind of world we would like to see if we were given the chance to create it.

And the concept has to be global. The object has to be the betterment of all people all over the world. Anything less is self-serving or tokenism. We can't continue to export our problems and discards to the Third World in the form of garbage, toxic wastes, unsafe medicines, pesticides, and technologies, as well as working conditions that would not be tolerated at home.

In this new world order that women must begin to define we must permanently rid ourselves of war, stop the destruction of the environment, preserve the delicate balance of the ecosystem, and look after people better than we have ever done in the past.

All these things are possible with the knowledge and technology we now have. Given all the proof of how wasteful, both of people and resources, the old ways have been, envisioning a new world order is an urgent necessity, not some capricius "feminine" dream.

2. Better care and concern for children must be cornerstones of our new approach. The starvation of children all over the world must end. It is intolerable that in societies as rich as North America, one in five children is raised in poverty, and one in four girls endures sexual abuse.

Allowing these atrocities to continue is one of the most profligate and irresponsible acts of society today and the governments people elect. We pay billions of dollars trying to rehabilitate physically and emotionally scarred adults, when we could have spent pennies and avoided many of the problems.

Trying to turn back the clock to a mythical past when the so-called ideal family supposedly solved all problems is futile. Some of the most flagrant abuses took place behind the polished doors of what appeared to be the most exemplary and respected families. Women will never go back. Nor will they expose children to conditions created by their inequality. And men, either individually or collectively, can't afford to pay the cost of keeping half the human race in a state of financial dependence.

The only solution is equality for both sexes and equal sharing and responsibility for parents. Parents, in whatever family combination they think works for them, must be given much more support in this important task.

Providing good child and infant care must be a top priority. Shorter workdays for parents, leave for looking after sick children for either parent, without the threat of job loss and a loss in benefits and seniority, now law in some European countries, must become mandatory in all countries. Sex education and the value of co-operative living must be taught in schools from an early age. If this seems wildly extravagant, consider the cost of not doing it will be in terms of lost human potential, in higher crime rates to name but two things.

And make this comparison: In the name of defending a nation, young men and women have often served a compulsory term in the army, for which they receive compensation, re-training, and help in re-establishing them in the work-force. Parents of children are performing a service to their country that is at least as important as army service. Children are the future workers. Yet we treat child bearing as the personal whim and responsibility of individual mothers. We actively punish women financially and in terms of their future options for taking on this totally natural, very necessary, and desired role.

3. Few nations have faced up to the unequal way we count labour all over the world. The work women do—which is more than half the work of the world—is simply not counted and not valued, and this colours the treatment of women, the payment of women and contributes to discrimination against women everywhere. All the work women in the Third World do, including almost all agriculture—isn't counted. All the caring for children, making meals, cleaning, sewing, caring for the elderly and sick isn't counted as "work" because it is unpaid, and therefore not valued. On the other hand whatever men do—waiting for a signal to launch a missile or dumping wastes into rivers—all unproductive, but paid activities—is counted. To dignify and recognize the work that is done by women it must be counted.

Because work in the home is not counted or valued, the work that has been mainly performed by women in the public sphere—nursing, child care, secretarial, for example—is undervalued at almost every level. And resourceful, innovative, highly trained and brilliant women are undervalued as political, business, bureaucratic, scientific, theological, and academic leaders—simply because they are women.

4. It has been found all over the world that when women have access to education and have more control over their own lives they make good decisions about when to have children. Very few women make the decision to end a pregnancy lightly. All women, therefore, must have access to good, safe birth control, and absolute control over their own bodies, which means the right to choose when and how to have a child.

5. Women must have control of the rapidly changing reproductive technologies—complex innovations that will affect all women in the future. Women must be involved in the debate and the decisions that will so directly affect our daughters and granddaughters. If women are not involved, they will once again—as they were in the nineteenth and early part of this century—be used as guinea pigs, and controlled by male technology.

6. We must do a much better job of educating our young. We have concentrated our efforts on encouraging girls. Now it is time to work on the boys. We must root out—once and for all—sex stereotyping and sexist attitudes on the part of teachers in schools, where it still flourishes. Moving girls to separate classes for math and science is regressive. Schools must be sex neutral—not segregated. Quotas must be established at universities to increase the number of women professors and to eradicate entrenched sexism in these highly influential institutions.

Education in the advantages of co-operating and sharing tasks must start for both boys and girls at a very early age. Our North American confrontational ways of settling all difficulties is costing

us dearly in comparison with countries that work more co-operatively, such as Germany, Japan, and the Scandinavian countries.

All through society we must stop glorifying macho males and "sex-object" females, or we will never be able to deal with the fall-out from such attitudes: on the one hand, women who have been degraded and have little self-respect, and on the other hand, violent, irresponsible, women-hating males.

7. All violence against women must end. It still exists because there is a great deal of misogyny in our society. Violence keeps women afraid and under control. The solution is not to return to capital punishment or to build more prisons, but to change public attitudes. Men themselves have to speak out forcefully against violence. Laws have to be passed that either make the streets safe for women or impose some hardships on all men, if necessary, to make the point.

Degrading and violent pornography must be controlled. The link between violent pornography and overt action among some psychotically violent men is becoming more and more clear. Society must confront the false argument that controlling violent pornography is an attack on freedom of expression. We control all kinds of harmful activities in our society—defecating and spitting in public, smoking, racial hate literature—to name a few.

8. The work-place must change. Instead of a division between men and women in the work-place, we must begin to make the distinction between workers without children and workers with children. Workers with children must be given parental leave, shorter workdays, and leave to look after sick children. There is no reason why, with computers, fax machines, and cellular phones, that everyone has to work from nine to five every day. There is no reason why hours can't be more flexible to allow parents more time at home, including longer hours some days and fewer hours on other days. Pro-rata benefits for part-time workers should be made mandatory in North America, as they are in the European Community.

The latest research shows that genetically unsafe work-places for women are also harmful genetically for men. Any protective legislation has to be gender neutral.

9. A strong women's movement is needed, and it must be world-wide. It is significant that the strongest women's movements are to be found today where they are still most needed—in North America, where support systems such as child care and maternity leave are less generous than in most comparable European countries and where the gap in salary between men and women is wider.

Today women have many allies—the peace movement, environmentalists, and unions, to name the most obvious ones. We can increase our strength through alliances and coalitions, but it is important that the women's movement remain autonomous, and not be subsumed or co-opted—something that has happened so often in the past in similar situations. It's also important that groups within the women's movement, such as minority women, women of colour, and native women, remain autonomous, to keep the rest of us aware and alert to their individual needs. All voices and points of view must be clearly heard.

As a movement, women should avoid aligning themselves with any particular political party. In the past women have lost their effectiveness as a reforming force when we made this mistake. The women's movement has to deal with governments no matter what political party is in power. We are much stronger as a non-aligned political force.

10. In the meantime pressures must continue to be put on the present system, although often the system seems so flawed that women would like to start all over again. Proportional representation and a wider choice in political parties have been shown to work to the advantage of women and other minority groups in country after country in Europe. West Germany's system is a good compromise. Each voter has two votes, one for the local candidate and one for the party of his or her choice. Only parties with 5 percent of the vote or a majority in three district seats are

represented in parliament. A combination of votes cast for individual candidates and for the party determines the number of seats any one party gets.

In the meantime, to make sufficient inroads into the present system to bring such a major change about, women must insist on other major reforms. Women in first-past-the-post systems must insist on stricter rules for nomination meetings, membership eligibility, and ceilings on the amount of money that can be spent. Otherwise candidates with the most money to spend win, completely defeating the democratic process.

Quotas of women candidates are extremely difficult to establish with first-past-the-post systems, although they have been useful in establishing equity on the executive of party organizations, and numbers of delegates to leadership conventions. Reserved seats are less useful as a way of making sure women have some representation, because they tend to become the ceiling, rather than the floor, for more representation.

Women's parties have been tried in almost all Western democracies at one time or another, and almost all of them have failed. In a small country like Iceland, with a population of less than half a million, a woman's party has achieved some success, but in other countries it has just siphoned off a lot of energy and has rarely elected a single candidate.

11. After twenty years, much of the government machinery that was set up for women needs a complete overhaul. I hesitate to suggest this, because often, having little input into the restructuring process, we risk losing components that are useful. There is no guarantee that funds cut from ineffective programs will be well directed elsewhere. I would, however, scrap advisory councils filled with government-appointed members. I would also dismantle equal opportunity offices that have no power. These structures, aside from providing work for a few women, have outlived their usefulness.

Instead, the money should be augmented and directed at putting real teeth into human rights commissions, equality commissions, offices of ombudswomen, and legal test cases, as

well as providing language and training courses for immigrant women, women's studies, adult education, transition houses, and rape-crisis centres, to name a few.

12. We must reach out to younger women, or once again we risk our daughters and granddaughters having to learn all over again the lessons we learned with so much effort and pain in the past.

This revolution of ours is unlike any other in the history of the world. Because it is a women's revolution, it has been, and continues to be, non-violent. There will be no pitched battles, no decisive assaults where institutions that have oppressed and ignored women—the 80 and 98 percent male-dominated courts, or the 66 to 95 percent male-dominated parliaments, or the 98 to 100 percent male-run business conglomerates—will suddenly be taken over in a coup, with former leaders executed and new leaders installed.

The women's movement has no armies, no secret caches of deadly instruments. All we have are numbers—potentially more than half the population of the world, a movement both broad and deep that is more than a century old, and the conviction that we are right and that what we want is not only for the liberation of women but the liberation of men too. Men can be liberated from early heart attacks, from being forced into the strait-jacketed role of macho-ism, from a tradition of learned violence that ends in death for so many men at the hands of other men.

And the third wave of the women's movement? There must be no third wave; neither the world nor women have that much time.

Some parts of the women's agenda are already having some effect. There is no longer the threat of war among the great powers. This is due, at least in part, to pressure from thousands of peace groups, which have always been disproportionately composed of women. Concern for the environment has been spearheaded by women's groups for the past twenty years.

Our victories have been won mainly through two routes: the public route of legal action and the individual route of attitudinal

change. The legal route has been like building a road, brick by brick, over shifting sands. For example, equality laws have been defined and redefined again and again. Each time the foundation shifts. And each time we build again on a more solid base.

Direct action might achieve results more quickly than lobbying, petitioning, and working for legislative change. If all women refused to do any more work in the home until it was shared equally, how the domestic scene would change! If all men were subject to a seven o'clock curfew until violence towards women ceased, how quickly our streets would become safe! If all women refused to have children until their demands for day care and maternity leave were answered, how quickly the money would be found!

Some long-term choices by women are already having an impact. In the industrial countries over the past one hundred years the birth-rate has fallen as women have reduced the number of children they have. Today more and more women postpone having children until their mid-thirties, and then they only have one. (Significantly, this is not happening in countries where there is good child care and maternity leave.)

Women are gradually becoming more selective in the partners they choose. In the past violent, irresponsible men have always been considered more attractive, and have propagated more children—and often abused them and abandoned them—than caring, responsible men. In a recent survey, Canadian high-school girls stated that they realized they would probably work all their lives and that they could not depend on a man to support them. They may be turning away from the "macho" man, towards a more responsible, nurturing model. If all women decided to have only the children of men who were caring, committed, and responsible, what a change that would make!

Aside from the public route, the other route is the individual one. It means establishing the kind of intimacy everyone yearns for with people we love. More honest, more open, nurturing, and supportive for both partners, with the possibility for both sexes to explore their individual potential free of the distortions of four thousand years of patriarchy and traditional stereotyping.

Doris Anderson

What women want is so simple and just. How can anything so sensible take so long to accomplish?

BIBLIOGRAPHY

Adamson, Nancy, Linda Briskin, and Margaret McPhail. *Feminists organizing for change: The contemporary women's movement in Canada.* (Toronto: Oxford University Press, 1988).

Anderson, Bonnie S., and Judith P. Zinsser. *A history of their own, Vol. II.* (New York: Harper and Row, 1988).

Badcock, Christine, tr. *Unfinished democracy: Women in Nordic politics.* (Oxford: Pergamon Press, 1985).

Barrett, Michèle, and Roberta Hamilton. *Politics of diversity.* (Toronto: The Book Centre, 1987).

Bashevkin, Sylvia. *Toeing the lines: Women and party politics in English Canada.* (Toronto: University of Toronto Press, 1985).

Birnbaum, Lucia Chiavola. *Liberazione della donna: Feminism in Italy.* Middleton, Conn: Wesleyan University Pres, 1986).

Black, Naomi. *Social feminism.* (Ithaca, N.Y.: Cornell University Press, 1989).

Black, Naomi, and Alison Prentice, Paula Bourne, Gail Cuthbert Brandt, Beth Light. *Canadian women: A history.* (Toronto: Harcourt Brace Jovanovich, 1988).

Bridenthal, Grossmesen and Kaplan. *When biology became destiny: Women in Weimar and Nazi Germany.* (New Feminist Library, 1984).

Brodie, Janine. *Women and politics in Canada.* (Toronto: McGraw-Hill Ryerson, 1985).

Campbell, Beatrix. *The iron ladies.* (London: Virago, 1987).

Chantal, Maille. *Primed for power: Women in Canadian politics.* (Ottawa: Canadian Advisory Council on the Status of Women, 1990).

Children's Defense Fund. Children 1990: *A report card, briefing book and action primer.* (Washington, 1990).

Children's Defense Fund. *S.O.S. America! A children's defense budget.* (Washington, 1990).

Cohen, Marcia. *The sisterhood: The true story behind the women's movement.* (New York: Simon and Schuster, 1988).

Cohen, Marjorie Griffin. *Women's work, markets and economic development in nineteenth century Ontario.* (Toronto: University of Toronto Press, 1988).

Commission of the European Communities Publications:
> *Childcare in the European Communities 1985–1990.*
> *Social Europe.* 1988. Luxembourg.
> *Women of Europe.* 1986–1990. Brussels: Women's Information Service.
> *Women of Europe: 10 Years.* June 1988. Brussels.
> *Women in statistics.* December 1989. Brussels.
> *Women of Europe Supplement, No. 27.*
> *Women of Europe Supplement, No. 30.*
> *Women of Europe Suplement, No. 31.* Brussels.

Cornelissen, Waltraud, Ulla Bosse, and Anne Pfuhlmann. *Institutional conditions for the promotion of equal opportunities.* Short Reports for EC. (Hanover: Institute Women in Society, 1988).

Dahlerup, Drude, ed. *The new women's movement: Feminism and political power in Europe and the USA.* (London: Sage Publishing, 1986).

Doerr, Audrey, and Micheline Carrier, eds. *Women and the constitution in Canada.* (Ottawa: Canadian Advisory Council on the Status of Women, 1981).

Duchen, Claire, ed. and trans. *French connections.* (Amherst, Mass: University of Massachusetts Press, 1987).

Dumont, Micheline, Marie Lavigne, Jean Michele, and Jennifer Stoddart. *Quebec women: A history.* By the Clio Collective. (Toronto: the Women's Press, 1987).

The Economist. June 1990. "Europe's women: How the other half works."

Eichler, Margrit. *Families in Canada today.* (Toronto: Gage Publishing, 1983).

EOC Commission, 1987. *Women and men in Britain.*

Ericsson, Ylva, and Ranveig Jacobsson. *Side by side.* (Stockholm: The Swedish Institute, 1985).

Evans, Sara M. *Born for liberty: A history of women in America.* (New York: The Free Press, 1989).

Evans, Sara M., and Barbara J. Nelson. *Wage justice: Comparable worth and the paradox of technocratic reform.* (Chicago: University of Chicago Press, 1989).

Farley, Jennie, ed. *Women workers in fifteen countries.* (Ithaca, New York: ILR Press, Cornell University, 1985).

Feminist Review. "The past before us: Twenty years of feminism" No. 31, Spring, 1989.

Gelb, Joyce. *Feminism and politics.* (Berkeley: University of California Press, 1989).

Gelpi, Barbara, Nancy C.M. Hartsook, Clare C. Novak, and Myra H. Strober. *Women and poverty.* (Chicago: University of Chicago Press, 1986).

Gunderson, Morley, Leon Muszynski, and Jennifer Keck. *Women and labour market poverty.* (Ottawa: Canadian Advisory Council on the Status of Women, 1990).

Halsaa, Beatrice. *Policies and strategies on women in Norway.* (Paper presented in Lima, Peru. September 1989).

Harrington Michael. *The next left: The history of a future.* (Toronto: Fitzhenry and Whiteside, 1986).

Harrison, Cynthia. *On Account of sex: The politics of women's issues, 1945–1968.* (Berkeley: University of California Press, 1988).

Hartmann, Heidi. *The economic realities of Childcare.* (Washington: Institute for Women's Policy Research, 1988).

Haug, Frigga. "The women's movement in West Germany." *New Left Review.* No. 155, 1986.

Hause, Steven C., and Anne R. Kenney. *Women's suffrage and social politics in the French third republic.* (Princeton: Princeton University Press, 1984).

Hellman, Judith Adler. *Journeys among women: Feminism in five Italitan cities.* (New York: Oxford University Press, 1987).

Hewlett, Sylvia Ann. *A lesser life: The myth of women's liberation in America.* (New York: William Morrow, 1986).

hooks, bell. 1989. *Talking back. Thinking feminist—thinking black.* (Toronto: Between the Lines, 1981).
— *Ain't I a woman: Black woman and feminism.* (Boston: South End).

Jensen, Jane, Elisabeth Hagen, and Reddy Ceallaigh, eds. *Feminization of the labor force.* (New York: Oxford University Press).

Katzenstein, Mary, and Carol Mueller, eds. *The women's movements of the United States and Western Europe.* (Philadelphia: Temple University Press, 1987).

Kome, Penney. *Women of influence: Canadian women and politics.* (Toronto: Doubleday, Canada, 1988).

— *The taking of twenty-eight.* (Toronto: Women's Educational Press, 1983).

Koonz, Claudia. *Mothers in the fatherland: Women, the family and Nazi politics.* (New York: St. Martin's Press, 1987).

Leira, Arnlaug. *Day care for children in Denmark, Norway and Sweden.* (Oslo: Institute for Social Research, 1987).

Leira, Arnlaug, ed. *Work and Womanhood.* (Oslo: Institute for Social Research, 1983).

Light, Beth, and Ruth Roach Pierson. *No easy road: Women in Canada, 1920s to 1960s.* (Toronto: New Hogtown Press, 1990).

Lovenduski, Joni. *Women and European politics.* (London: Wheatsheaf Books, 1986).

MacKinnon, Catherine A. *Toward a feminist theory of the state.* (Cambridge, Mass: Harvard University Press, 1989).

Maclean's magazine. July 3, 1989. Portrait of two nations: The dreams and ideals of Canadians and Americans. (Toronto).

Mansbridge, Jane J. *Why we lost the ERA.* (Chicago: University of Chicago Press, 1986).

Marks, Elaine, and Isabelle de Courtivron. *New French Feminisms.* (New York: Schocken Books, 1981).

Maroney, Heather Jon, and Meg Luxton, eds. *Feminism and political economy.* (Toronto: Methuen Publications, 1987).

Mitter, Swasti. *Common fate, common bond: Women in the global economy.* (London: Pluto Press, 1986).

Morgen, Sandra. *Common grounds and crossroads: Race, ethnicity and class in women's lives.* (Chicago: Signs, 1989).

National Council of Welfare. *Women and poverty revised.* Ottawa, Summer 1990).

National Women's Law Center. *Women, poverty and child support. The child support enforcement program.* (Washington, 1989).

National Women's Political Caucus. *National directory of women elected officials.* (Washington, 1989).

Newkirk, Caroline D., Ellen J. Vargyas, and Marcia D. Greenberger. *Title VII's failed promise: The impact of the lack of a damages remedy.* (Washington: National Women's Law Center, 1990).

Norris, Pippa. *Politics and sexual equality.* (London: Wheatsheaf Books, 1987).

Oakley, Ann. *Telling the truth about Jerusalem.* (Oxford: Blackwell, 1986).

OECD: *Integration of Women into the Economy,* (Paris, 1985).

Pearce, Diana M. *The feminization of poverty: A second look.* (Washington. Institute for Women's Policy Research, 1989).

— *The Invisible homeless: women and children.* (Washington: Institute for Women's Policy Research, 1988).

— *Welfare is not for women: Toward a model of advocacy to meet the needs of women in poverty.* (Washington: Institute for Women's Policy Research).

Phillips, Kevin. *The Politics of rich and poor, wealth and the American electorate in the Reagan aftermath.* (New York: Random House 1990).

Rix, Sara E. ed. *The American woman: A status report.* (New York: W.W. Norton, 1988).

Rowbotham, Sheila. *The past before us.* (London: Pandora, 1989).

Seager, Joni, and Ann Olson. *Women in the world: An international atlas.* (London: Pan Books, 1986).

Segal, Lynne. *Is the future female?* (London: Virago, 1987).

Sivard, Ruth Leger. *Women: A world survey.* (Washington: World Priorities, 1985).

Skard, Torild, and Elina Haavio-Mannila. The Nordic Enigma. (Cambridge, Mass: Vol. 112 *Daedalus,* 1984).

Skjeie, Hege. *The feminization of power: Norway's political experiment (1986–).* (Oslo: Institute for Social Research., 1988)

Smeal, Eleanor. *Feminization of power: An international comparison.* (Washington: The Fund for the Feminist Majority, 1988).

— *Why and how women will elect the next president.* (New York: Harper and Row, 1984).

Salter-Roth, Roberta. *Feminism vs. familism: Research and Policy for the 1990s.* (Washington: Institute for Women's Policy Research, 1988).

Stamiris, Eleni. The Women's Movement in Greece. No. 158. *New Left Review.*

Stats Canada. Women in Canada. (Ottawa: Minister of Supply and Services, 1990).

Stevens, Rosemary. *In sickness and in wealth: American hospitals in the twentieth century.* (New York: Basic Books, 1989).

U.S. Department of Health and Human Services. *Child Health USA '89.* (Washington: Office of Maternal and Child Health, 1989).

U.S. Department of Health and Human Services. *Child Support Enforcement.* Thirteenth Annual Report to Congress. (Washington, 1988).

Vickers, Jill, Chris Appelle, and Pauline Ranken. *Politics as if women mattered.* (Toronto: University of Toronto Press, forthcoming).

Waring, Marilyn. *If women counted.* New York: Harper and Row, 1989.

Wiltsher, Ann. *Most dangerous women: Women's international league for peace and freedom.* (London: Pandora, 1985).

Wilson, Elizabeth. *Hidden agendas.* (London: Tavistock, 1986).

Wistrand, Brigitta. *Swedish women on the move.* (Stockhom: The Swedish Institute, 1981).

Woloch, Nancy. *Women and the American experience.* (New York: Knopf, 1984).

Women's Bureau. *Employers and child care: Benefiting work and family.* (Washington: U.S. Department of Labor, 1989).

Women's Bureau. *Facts of working women.* No. 89-3. (Washington: U.S. Department of Labor, 1989).

Women's Bureau. Pregnancy and Employment. Fact Sheet No. 87-1. (Washington: U.S. Department of Labor, 1989).

Index

A

Abella, Rosalie, 220
abolition of slavery, 173-74
abortion
 Belgium, 127-28, 131-32;
 Britain, 150; Canada, 198,
 204-06; Denmark, 261, 263,
 268; France, 84, 108, 113;
 Germany, 87-88, 93, 102, 106;
 Greece, 28, 35; Italy, 61-62,
 69-71; Norway, 246, 249;
 opposition of church, 130,
 131, 236; pill, 108; politics of,
 205; Spain, 44-47, 52;
 Sweden, 230, 236-37;
 U.S., 171, 182, 186
Abzug, Bella, 188
Acker, Joan, 186, 239
advertising: sexism in, 123
African–American women, 196
Ahrland, Karin, 235
Ahs, Stig, 238
Aid to families with Dependent
 Children, 191
André, Michèle, 123, 125
Anselmi, Tina, 67-69
Anthony, Susan B., 174
anti-feminism
 Canada, 220; France, 125;
 Norway, 255; U.S., 193-94
As, Berit, 251, 252, 253, 254
AT&T, 186
Atkinson, Ti Grace, 176
Auclert, Hubertine, 111
Avery, Byllye, 196

B

Balbo, Laura, 68, 79
Balletbó, Ana, 56
Barclay's Bank, 165
Barrett, Michèle, 167
battering
 Belgium, 137; Canada, 218;
 Denmark, 268; Germany, 93;
 Greece, 35-36; Italy, 76;
 Norway, 255; Sweden, 238
 U.S., 192
Baude, Annika, 235, 237
Beauvoir, Simone de, 112-14, 123,
 131
Becker, Rosa, 218
Beebe, Carole Tarantelli, 75
Belgium
 abortion, 127-28, 131-32;
 battering, 127; birth control
 and contraception, 132; birth-
 rate, 128; child care, 83, 128,
 133; divorce, 128-29, 132-33;
 education, 127; elected
 women officials, 127,138-39;
 equality legislation, 136-37;
 family law, 128-29; maternity
 leave, 128; pensions, 133;
 political history, 129-30;
 politics, 134; rape, 132;
 suffrage, 82-83, 127, 130;
 women's movement, 129-32,
 135-36; work-force, 127
Bird, Florence, 202
birth control and contraception
 access to, 284; Belgium, 132;

299

Belgium, 128-29; Britain, 151;
Canada, 199; France, 109,
120; Germany, 8; 9; Greece,
29, 33-34; Italy, 62, 69;
North America, 132-33;
Norway, 246; Spain, 45, 47,
53-54; U.S., 172, 179, 193
Dolle Mina groups, 130
drugs, 76, 181
Durán, María Angeles, 54-55
Dworkin, Andrea, 176, 194

E

Eberts, Mary, 223
education
Belgium, 127; Britain, 150;
Canada, 198; Denmark, 260;
France, 108; future of
women's movement, 284-85;
Germany, 87, 100-01; Greece,
28, 34-35; Italy, 61, 66;
Norway, 245; Spain, 44, 47,
52; Sweden, 229, 243; U.S.,
171, 182
Edwards, Henrietta Muir, 201
Eichler, Margrit, 207
elected women officials
Belgium, 127, 138-39; Britain,
150, 161, 162; Canada, 198,
209-10; Denmark, 260;
France, 108, 121; Germany,
87; Greece, 28, 37; Italy, 61,
74-75; North American
political system, 144; Norway,
245, 249-52; Spain, 44, 55;
Sweden, 229, 240; U.S., 171,
188-90
Employment Equity Act (Canada),
220
entrepreneurs, 219

Equal Employment Opportunity
Commission (U.S.), 185-86
Equal Opportunities Commission
(Britain), 164-65
equal pay. See pay equity
Equal Rights Amendment (U.S.),
174, 197
Equal Status Council (Denmark),
273-74
Equal Status Council (Norway),
257-58
equality legislation
Belgium, 136-37; Canada,
219, 223; Denmark, 273-74;
France, 122-24; Germany, 99;
Greece, 33; Italy, 67-68;
North America, 146; Norway,
257-58; Sweden, 240-42;
U.S., 174-75, 185-86, 197
European Commission, 27, 132-
33, 139-40
European Community, 23-24, 84-
85, 285
Belgium, 130, 135; Britain,
106, 165-66; Denmark, 228,
263; Germany, 106; Greece,
34; Norway, 258; Sweden,
232, 244
European Women's Lobby, 139-
40

F

Fairclough, Ellen, 201
Falcón, Lidia, 53
family allowance, 143-44, 170, 204
family law
Belgium, 128-29; Britain, 151;
Canada, 199, 217, 218;
Denmark, 261; France, 109;
Germany, 89; Greece, 29, 33;